# DATE DUE

| | |
|---|---|
| | |
| | |
| | |
| | |
| | |
| | |
| | |
| | |
| | |
| | |
| | |
| | |
| | |
| | |
| | |

BRODART, CO.                    Cat. No. 23-221

*"Griffin, Mouse, and Moscoso
are not only the scions of
Toulouse-Lautrec, Mucha, and
Chéret, but their peers as well."*

*—Phil Cushway*

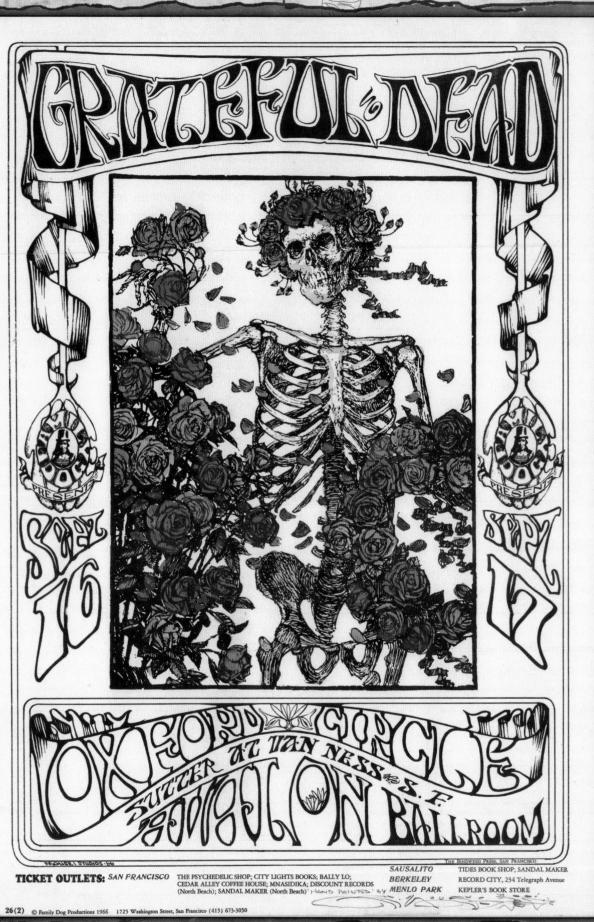

FIG. 1
STANLEY MOUSE & ALTON KELLEY "SKELETON & ROSES" (PROGRESSIVE PROOF)
OFFSET LITHOGRAPH AND WATERCOLOR (50.6 CM X 36.1 CM)

# ART
## OF THE
## DEAD

# CONTENTS

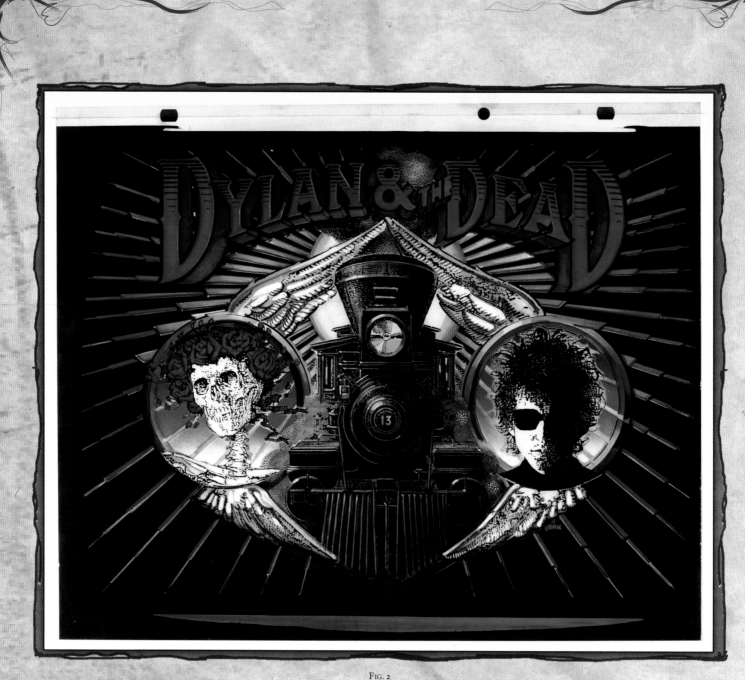

Fig. 2
RICK GRIFFIN "DYLAN & THE DEAD"
PAINT PEN ON ILLUSTRATION BOARD

IN JULY OF 1989, Rick Griffin and I were in New York. While we were there, Rick wanted to go see the Grateful Dead and Bob Dylan in concert. They were playing a joint show at an arena in New Jersey. He asked me if I wanted to join him for the show. I said I would, although I was initially reticent—it was a hot day, we had no tickets, and from experience I knew what an incredible hassle this could end up being.

How wrong I was. After arriving, we burrowed through throngs of Deadheads to find the backstage door. In an instant, this impossible door opened; we were greeted and were immediately led to and seated at the side of the stage, where we watched the show from better-than-front-row seats. Later that day, when Jerry Garcia came to meet us backstage, it dawned on me: In Garcia's eyes, he was a fan and Rick was the star.

# ART OR ARTIFACT?

I AM NOT A DEADHEAD, and this book is not about the Grateful Dead—it is about the artists and their art. I have chosen the Grateful Dead, the famous band headed by the late Jerry Garcia, as a window into this vibrant and charismatic American folk-art. The variety and volume of this art is daunting; focusing on a single band as a medium into this world simplifies the task.

*Art of the Dead* contains a diversity of posters ranging from the most rare to the most iconic. These works have been chosen for reasons of historical importance, aesthetic merit, cultural significance, and so on. There are also a great many examples of process materials, which were used during the creation and production of the final printed pieces. Years ago, I scoured many dumpsters and trash bins behind print shops looking for these process materials (blue-lines, color keys, printing plates, et cetera), which were routinely discarded as they had no financial value. This book is rich with examples of these "found" items. To me, the value of these materials is not currently and has never been monetary; the value is in what they can tell us about the production process.

What makes art *art* is one of the most contested questions of all. The art in this book does not have an established name, nor does it have the status that comes from inclusion in a genre. Instead, these pieces are most commonly referred to as either "rock posters" or "psychedelic art." I find both these terms limiting and inaccurate. The term "rock poster" is too generic. "Psychedelic art" also misses the mark, as it conjures up associations with mind-altering substances and vibrant, clashing colors; while this does fit some of the art, it certainly does not apply to the whole.

This art movement is thus understandably difficult to define. It does not show clear lines of descent from another established school of art. It arose seemingly by parthenogenesis—from the vagaries of the artists' environment, their experiences with LSD, the treasure trove of images and styles they found in libraries, and so forth. What they came up with flew in the face of everything that came before. Established rules were discarded. A new path was being blazed.

There are, however, several characteristics common to their art. One of these is the seamless, aesthetic integration of art and message; these artists developed unique and distinctive ways of incorporating into their posters the information that advertisements are tasked with communicating. Another characteristic is that artists did not require that the central image be directly associated with the message: the bands or the event being promoted.

What is the appropriate designation for this genre of art? Over the years I've tried to imagine the possibilities: Renascense Art? Art Wilde? Dark Nouveau?

The art on the following pages, notwithstanding its final designation, spans nearly fifty years and continues to thrive today.

I have always considered these posters to be legitimate art. Though they are undeniably linked to the events they promote and the bands they feature, in my mind, the name of the artist has always eclipsed the name of the band. Whatever the name, and even without a name, I love this art. I have from the moment I flew out to San Francisco and bought my first pieces. I quickly fell in love with posters; I found them beautiful and tactile. From the beginning, I knew I would never be able to leave the world of poster art.

# GRATEFUL DEAD'S UNDYING POSTER LEGACY

BY STEVEN HELLER

ENGLAND HAD ARTS and Crafts, France had Art Nouveau, Germany had Jugendstil, Spain had the Modernismo, Austria had the Secession—each were fin de siècle floriated graphic styles that telegraphed something new, something youthful, something sensual and all things taboo to those who deciphered the code. Jugendstil means "youth style," and Secession was an aggressive split from establishment constraints. These manifestations took place in the 1890s when art and design were entering the early Modern era. Six decades later, long after these early counter-culture conceits had become out-worn and passé, the United States finally came to the fore with its own indigenous youth style. Known to one and all as the Psychedelic Style, it borrowed from, and co-mixed with these and other eccentric visual languages. The typically spikey gothic type routinely printed in vibrating colors, often illegible but decidedly comprehensible, defined a particular time and place (sixties Haight-Ashbury), which owing to persistent revivals, has never entirely disappeared.

Psychedelia continues to blow minds, if not in a drug-induced hallucinogenic way, then in an aesthetically comforting manner. The rock posters that introduced psychedelic colors and amorphous patterns as codes for an impressionable youth culture are now historical dye markers with renewed contemporary resonance. The Grateful Dead concert posters in this volume, which have in-fluenced other mass media, did not just breathe perpetual (or undead) life into the style, the band's recurring association with psychedelia helped distinguish it from a temporary cultish veneer to a bone fide visual brand.

So what do you see—or viscerally experience—when looking at a Grateful Dead poster? The answer either depends on what substance you have taken (and when), or more likely, what memories and emotions the typefaces, lettering and imagery conjure. It is virtually impossible—even for the non-Dead Head—of a certain age not to have brushed against the iconic power of Mouse & Kelley's "Skeleton and Roses," the sine qua non of living Dead graphics. This 1966 poster for an Avalon Ballroom concert, reprised in 1977 as the cover of the Dead's eponymous 1971 live double-LP (referred to as "Skull and Roses"), became an emblem of the times. And ironically, given the reference to the "Danse Macabre," a lifeline for many alienated kids. Funny, how music and art can ground the ungrounded.

When I see—and experience—Grateful Dead posters—particularly the multitude of interpretations collected here—the history of art and design runs joyfully through my mind. While many approaches (and levels of craft) abound, the common thread is gothic with a touch of Aubrey Beardsley transported into a postwar twentieth century aesthetic. The Grateful Dead may meant many things to acid rock and roll fans, but to the artists and designers who were breaking the strictures of "good design" at the time, the band's image was a means of testing legibility, intelligibility, and more nuanced cognitive sensibilities.

The posters became wildly fascinating given the application of how different posterists applied their personal graphic idioms. From Victor Moscoso's undulating vibrations to Mouse and Kelley's post nouveau lyricism to Wes Wilson's heated erotic gyrations to David Singer's surreal dislocations, the Dead have been represented by some of the most brilliant artists of a generation.

The veritable "inventor" of the illustrated record album cover, the late Alec Steinweiss, said he made his art so that he might "see the music." The posters representing the Dead take that notion to another level. They do more than tune in the visual bandwidth, they add alternative layer of information—indeed what we should call "allure." Even the anonymous gig posters—the ones that mimic the heroic and famous ones—say more than just "come see and hear" on any given night. They are tasty bait on the end of a hook. They are also mnemonics, the paper memory of a Dead event.

Grateful Dead posters are as integral to the Dead's mythology as any record, any song, and any concert. They are endemic to Dead culture, which has had a hypnotic effect on so many for so long. And curiously, regardless of the imagery, lettering or color palette, these posters exhibit a distinct power. Like membership rites for a secret society, these posters are an incredibly large part of why the Dead have lived as long as they have.

# IT'S ALL IN THE LINE

BY PETER COYOTE

I T'S ALL IN THE LINE. There's inline and outline, but the first line you crossed to crack the codes of psychedelic culture was ingesting LSD. That changed everything, dissolved the boundaries of self, and placed you at some unlocatable point in the midst of a new world, vast beyond imagining, stripped of language, where new skills of communication were required. The first thing you learned was that everything communicated in its own way.

On acid, space was no longer empty. It had palpable textures. Space rolled off the bodies of people as they passed through it. Everything was "just as it was," unmanipulatable by language and ideas, and this meant millions of new categories of perception and feeling—previously unnoticed and unexplored nuances of perception that left you gasping.

The perceptions stayed with you when you came down. They expressed themselves as clothes, as language: "far out!" (from "normal," dude!). And they expressed themselves via the skillful hands of the psychedelic artists.

There was a great coming together of newly kindred souls who had crossed the line. There were dances with light shows, bare-breasted girls, and strobes.

Images from the entire human collective unconscious projected on the walls. They all made sense now.

"Something is happening and you don't know what it is, do you, Mr. Jones?" The artists got it immediately—the interpretation of inline and outline,

lysergic
acid
diethylamide

the fluid sharing of space within the borders of the posters announcing the events. There they were—plastered on store windows, on walls, on telephone poles—functional announcements made beautiful by perception. They were glorious and announced more

than who-where-and-when. They trumpeted the new awareness that had catapulted this generation into gravity-free, boundary-free space. The world was literally new.

Watching the befuddled elders stop and stare at these incomprehensible puzzles so immediately accessible to psychedelic pioneers made the line visible . . . and risible. We were free, we were fabulous, we were special, and before too long, many of us were dead.

It was not the line, but what we made of it. For the artists, they could meander and play on paper without consequence. We knew in an instant that their posters were iconic and collectible—reminiscent and evocative of a moment that was changing under our feet.

Many of us took the insight and tried to do something with it. I sought a high that would not end when the drugs wore off. So did many others. The painters and artists, the Mouses and Kelleys, the Rick Griffins, the masters of plasticity: perhaps they struggled in their bodies and psyches, but the footprints they left of their passing appear today, joyous and effortless. They carry the same inexpressible truth—outline is inline. It's always that way. You can see it, if you've ever crossed the line.

# ART AT THE EDGE OF MAGIC

## BY MICKEY HART

THERE WERE NO radio or newspaper ads. Only word of mouth and posters told the time, place, and location of events, slightly camouflaged.

Both musicians and audience considered the music to have spiritual connections, and the art that was its calling card directly reflected the phenomena. The art sounded like the music, and the music looked like the art in all its wondrous, sonic colors, leading to a state of mind that allowed for change. The music was different, new, and loud. The strange new art became a language linked to this strange new sound.

The bands' big, all-consuming sounds represented the sacred. The music rattled your bones and made you wonder and ponder the illusion and rituals driven by sound and lights. This music was high, as was the visual component.

In a mythic sense, the Fillmore, Winterland, and the Avalon were our "Temple Caves," churches for these new rituals. The sacred was explored through the use of hallucinogens and sound as loud and detailed as the art it inspired. This music was filled with many new perceptions, time changes, and audio and visual distortions. The noise of many newly discovered senses blazed on.

What was the look of the sound? As you study these creations, you will notice they ooze with the fluidity of the musical experience. The concerts were not ordinary. The festivities were laced with a little extra ingredient: psychoactive drugs. LSD, mescaline, and peyote drove the rhythms of the visual domain as well as those of the music. The designs were different, fantastic in many ways. They stood out. They shouted out, "Somethin's happenin' here!" Morphings in inks, oils, and watercolors made eye-play hallucinations—bright neon, twisting madly, curling inside out, descending rapidly into words, rising suddenly, then settling back to the names and places.

"Is it the body of the bird that has the word you think?"

"Or the head?" you wonder.

"Now let's see, this looks kinda like a letter, or is it in the bird's tail feathers, perhaps?"

"Perhaps, but you must hunt for it a bit."

"Let's keep going and look further into the illusions. This will take some time. Space out and follow the map. It must lead somewhere . . . "

"You never forget a great poster."

This was an age of experimenting with illusion, with the edge of magic, be it visual art, sound, clothes, lifestyles, or dreams and beliefs. These creations were not, nor did they stand for, the obvious. They represented in many cases what Mircea Eliade would call a "heirophany," something "wholly other" created to honor, explain, amplify, and represent. The posters were camouflage, cover, a secret language between the knowing, the straights, the artists, and the musicians. The artists were tripping, the bands were tripping, and everybody danced.

The posters were sound symbols that connected to a sacred dimension— a full-blown trance experience, powerful in spiritual information and transformative in nature. We were now "all turned on," "like a switch." The posters were trippy enough to make you imagine you had taken LSD.

The designs stretched the imagination. That's what all this was about. Stretching. Changing it all up. Probing the now. Revealing a more powerful groove. The visual art and the music in total synesthesia. A uniting of senses. Entrained. In sync. The rhythm and the dance of the vibratory universe, pumped up to a gazillion decibels and just headin' your way.

This new electric art was used for everything from rolling papers, blotter acid, album covers, shirts, and eventually ties. It was everywhere! Some posters were so well done you could hear the symbolism morph into snaky swirls and distorted letters. These posters provided a vehicle to a new, exciting realm of consciousness, of musical magic and visual magic.

Now, the art, the posters, are the objects of awe. The poster art has become sacred, iconic imagery.

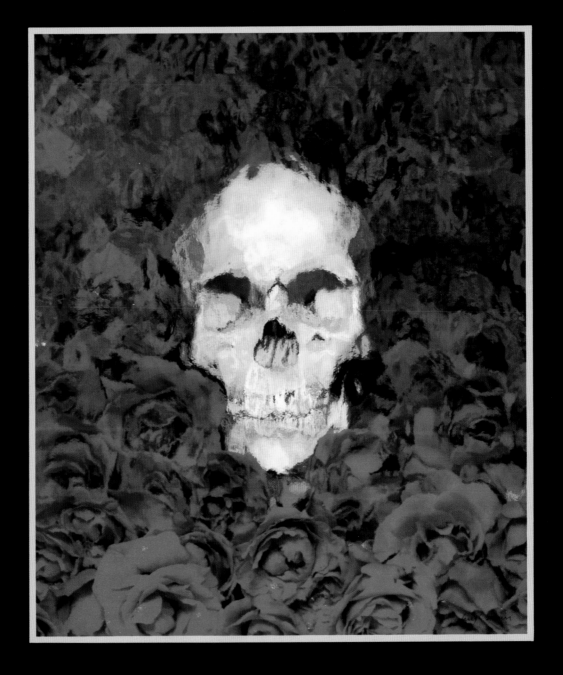

# GRATEFUL DEAD

## NEW YEAR'S EVE 1987

### OAKLAND COLISEUM

Philip Cushway Lithos #78 ◆ Original Artwork by Hugh Brown ◆ © 1987 Art Rock/Grateful Dead Productions ◆ Printed by Tea Lautrec Lithography, San Francisco, CA USA ◆ All Rights Reserved.

FIGURE 3. HUGH BROWN "NEW YEAR'S EVE, 1987"
OFFSET LITHOGRAPH, 69.8 X 48.2 CM.

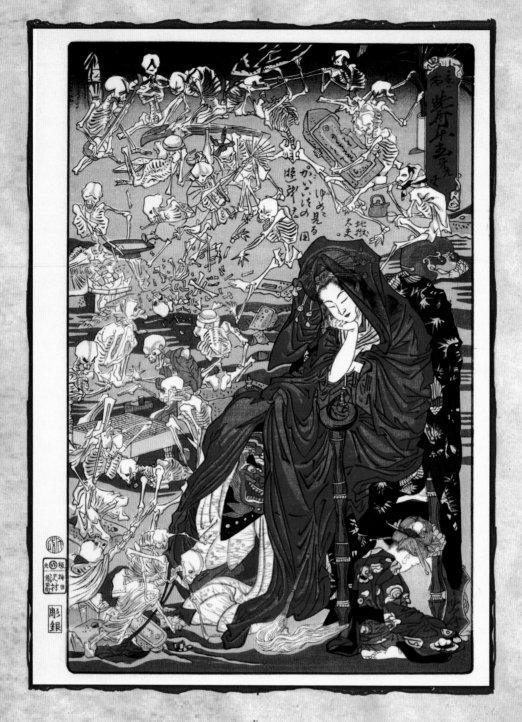

*"What happened with the psychedelic poster is what happened with the
Art Nouveau poster, is what happened with the Japanese woodcut.
Throwaway art was not thrown away; ephemera did not 'ephemerate.'
It crossed the line on its own into the so-called world of fine art.
Now, you tell me: What's so fine about 'fine art?'"*

*—Victor Moscoso*

# JAPANESE WOODBLOCKS

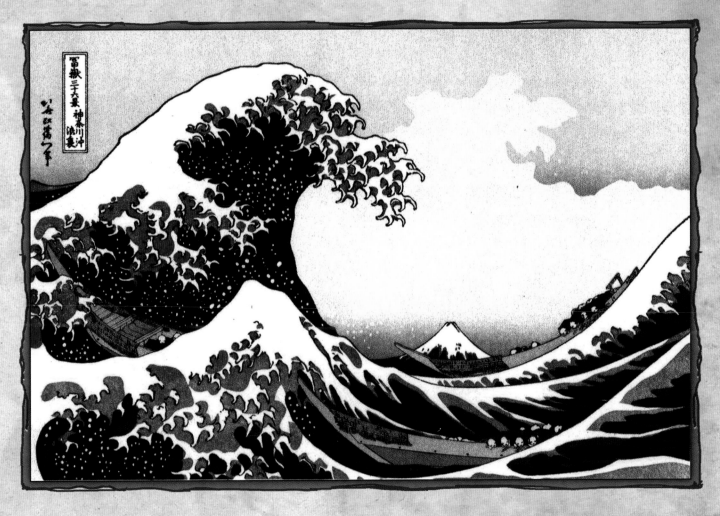

Fig. 5
Katsushika Hokusai "The Great Wave off Kanagawa"
woodblock print (25.7 cm x 37.8 cm)

POSTER ARTIST VICTOR MOSCOSO draws a connection between three great periods of affordable popular printed art. The earliest of these were the Japanese Woodblocks of the 1800s. Profoundly influential to the impressionists and modern artists, these prints, in stark contrast with conventional Western geometric perspective, were characterized by flat, or nearly flat, spatial planes as well as the use of a strong color palette. In 1878, a store featuring these Japanese woodblock prints opened in Paris; it immediately influenced the local artists. These artists experimented with bold calligraphic lines and composition that verged, to a certain extent, on caricature. They further broke from contemporary Western art etiquette, thereby opening the door to more conceptual ideas in terms of imagery. Fast-forward to San Francisco in the mid-1960s where untrained (and untamed) artists created yet another era of popular and affordable art. Concomitantly, they borrowed heavily from Art Nouveau—the sinuous lines, Victoriana patterns, and so on. In this book, however, you will notice that this is only one of many influences that developed and shaped this art. As Moscoso points out, the prints derived from these three popular art movements share a great deal in common: They are aesthetically appealing and affordable, and people regarded them as art long before the art critics did.

# BELLE EPOQUE

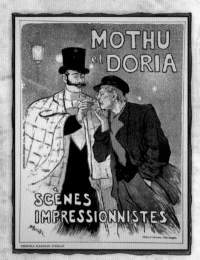

Théophile Alexandre Steinlen
"Mothu Et Doria"
(46.3 cm x 39 cm)

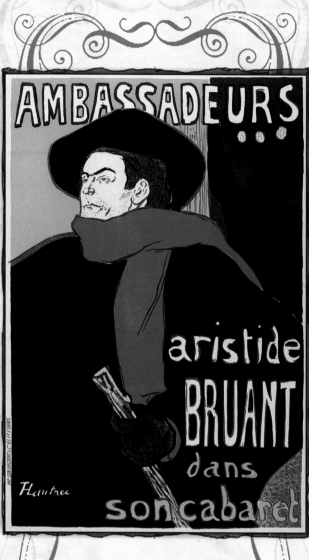

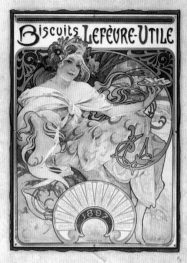

Alphons Maria Mucha
"Biscuits Lefèvre-Utile"
(61 cm x 44.5 cm)

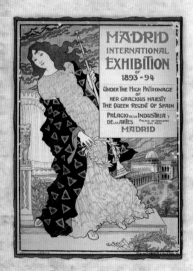

Eugène Samuel Grasset
"Madrid International
Exhibition"
(145.4 cm x 109.2 cm)

Henri De Toulouse-Lautrec
"Ambassadeurs: Aristide Bruant"
(150 cm x 100 cm)

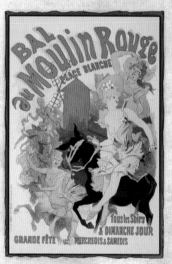

Jules Chéret
"Bal Du Moulin Rouge"
(125 cm x 88 cm)

*"The whole point of the poster was the advertisement. It was the only advertisement for the event; no radio,*
*no newsprint, nothing but posters and either flyers or handbills. They were first and foremost advertising art,*
*just like Toulouse-Lautrec's posters for the Moulin Rouge were advertising art. For Aristide Bruant at his*
*theater—advertising art. And I felt a special kinship for Toulouse-Lautrec, because he was highly trained*
*as well. And how does he make it? As a commercial artist, doing advertisements for dance halls. Wow!"*

—*Victor Moscoso*

# SAN FRANCISCO

STANLEY MOUSE & ALTON KELLEY
"FAMILY DOG NO. 29"
(50.7 CM X 36.1 CM)

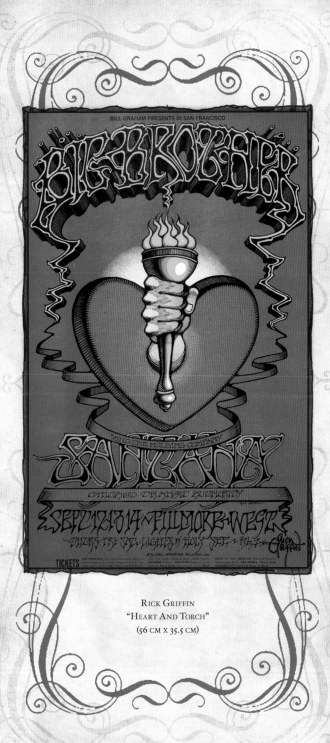

RICK GRIFFIN
"HEART AND TORCH"
(56 CM X 35.5 CM)

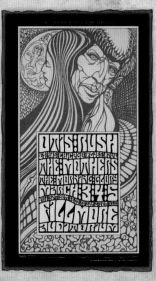

STANLEY MOUSE & ALTON KELLEY
"EDWARDIAN BALL"
(50.8 CM X 33 CM)

WES WILSON
"BILL GRAHAM NO. 48"
(59 CM X 34.5 CM)

WES WILSON
"BILL GRAHAM NO. 53"
(57.2 CM X 34.2 CM)

*"I saw the same thing occurring in San Francisco as happened in Paris. In fact, I even timed the years.*
*Approximately eighty years had passed since Toulouse-Lautrec, Chéret and Mucha had done their thing.*
*And here was Wes Wilson, Mouse, Kelley, Moscoso, Rick Griffin doing their thing for dance halls—*
*Moulin Rouge was a dance hall; the Avalon was a dance hall; The Matrix was a club."*

—Victor Moscoso

# FROM THE STREETS
# OF SAN FRANCISCO

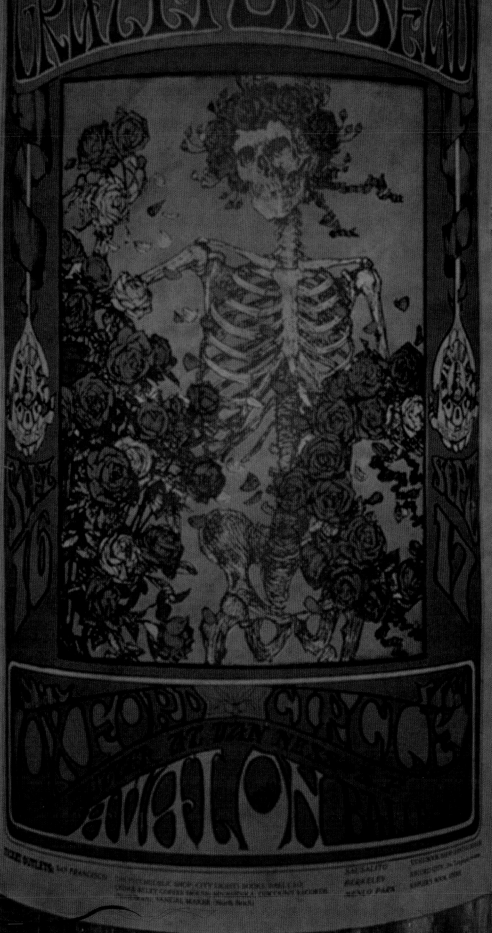

# TO THE MUSEUMS
# OF THE WORLD

**ART GALLERY OF ONTARIO**
TORONTO, ONTARIO

**THE BOSTON MUSEUM**
BOSTON, MASSACHUSETTS

**BROOKLYN MUSEUM**
BROOKLYN, NEW YORK

**THE CALIFORNIA MUSEUM**
SACRAMENTO, CALIFORNIA

**CITY OF FULLERTON MUSEUM**
FULLERTON, CALIFORNIA

**DENVER ART MUSEUM**
DENVER, COLORADO

**DE YOUNG MUSEUM**
SAN FRANCISCO, CALIFORNIA

**LAGUNA ART MUSEUM**
LAGUNA BEACH, CALIFORNIA

**THE LOURVE**
PARIS, FRANCE

**NATIONAL GALLERY OF SCOTLAND**
MIDLOTHIAN, UK

**NATIONAL MUSEUM OF MODERN ART**
KYOTO, JAPAN

**NATIONAL MUSEUM OF MODERN ART**
TOKYO, JAPAN

**MUSEUM OF FINE ARTS**
BOSTON, MASSACHUSETTS

**MUSEUM OF MODERN ART**
NEW YORK, NEW YORK

**SAN FRANCISCO MUSEUM OF MODERN ART**
SAN FRANCISCO, CALIFORNIA

**OAKLAND MUSEUM OF CALIFORNIA**
OAKLAND, CALIFORNIA

**THE SAN DIEGO MUSEUM OF ART**
SAN DIEGO, CALIFORNIA

**ROCK AND ROLL HALL OF FAME**
CLEVELAND, OHIO

**SMITHSONIAN AMERICAN
ART MUSEUM**
WASHINGTON, DC

**SOUTHERN ALLEGHENIES
MUSEUM OF ART**
ALTOONA, PENNSYLVANIA

**SPENCER MUSEUM OF ART**
LAWRENCE, KANSAS

**TATE BRITAIN**
MILLBANK, LONDON

**TOLEDO MUSUEM**
TOLEDO, OHIO

**TWEED MUSEUM**
DULUTH, MINNESOTA

**UNIVERSITY ART MUSEUM**
SANTA BARBARA, CALIFORNIA

**THE VICTORIA AND ALBERT MUSEUM**
SOUTH KENSINGTON, LONDON, UK

**FORM/DESIGN CENTER**
MALMÖ, SWEDEN

*"While there seemed to be general agreement on how to make posters effective, a revolution was heralded in the designs by a small group of young, untutored California poster makers in the 1960s. Some of the most brilliant American posters have challenged the often-cited rule of poster graphics—that the text be legible. Wes Wilson, who gave form to the psychedelic-rock poster movement, reconfigured type to conform with abstract shapes and blocks of color. He developed what he called an easy-to-see but also mysterious form of lettering that immediately attracted attention. These word-forms became a new visual language that served as metaphor for a new freedom among youth who flocked to the San Francisco Bay Area in search of a developing music and the accompanying lifestyle.*

*Perhaps the most fascinating aspect of American posters is their genius for mirroring and enlarging American cultural issues. They mix art and commerce; they picture many forms of advocacy. Although we recognize that our response to many early American posters involves nostalgia for the times and events of our history, the most significant thread in our reaction to posters in all periods is a willingness to accept the disappearance of the distinction between high and low art. This is an American Style."*

*—Therese Heyman, Curator, Smithsonian*

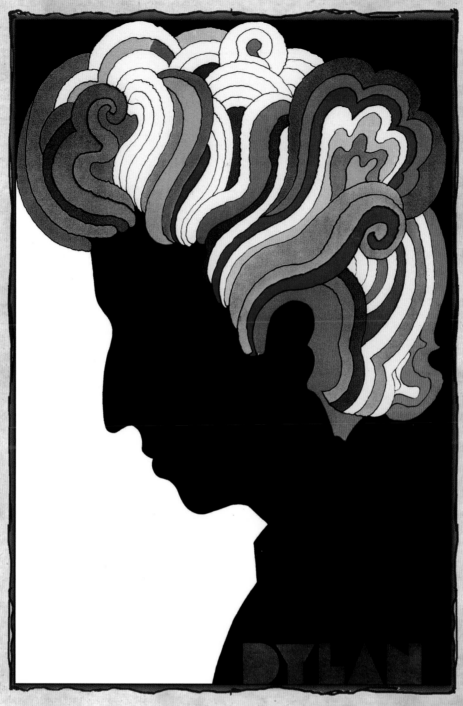

"In the late '60s, there began in America an artistic movement that might have lasted a hundred years in fourteenth-century Florence . . . It was a movement that was formed out of many co-existing influences—most noticeably Art Nouveau and the Decadent movement. It incorporated some of the visual adventurousness and color play of the Op-art activity that just preceded it. It integrated into its vocabulary Duchamp and Pop Art; it became the most identifiable visual style of America in the '60s."

—Milton Glaser

# 1965

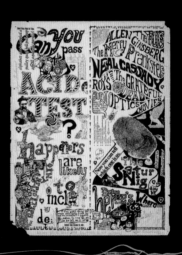

WHAT A DIFFERENCE a year makes. In 1965 "The Seed" had been planted but it had not yet bloomed. The posters shown above, from June through December of 1965, illustrate the genre's first initial steps. As artist Randy Tuten put it, "those early posters, while crude, they do convey a sense of excitement." The posters shown on the opposite page are from June through December of 1966. What a contrast!

*"When I'd first come out [to San Francisco], two years earlier [in 1964], there was not much of a new art scene happening. But in 1966, it was much, much different. Posters for the early rock concerts were just beginning to appear, and there was an early feeling of excitement."*

*—Stanley Mouse*

20

# 1966

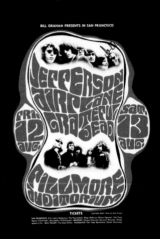  

 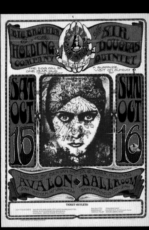 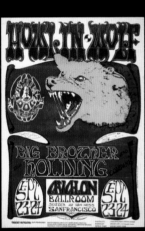

**T**HESE POSTERS ARE sophisticated; they have a well-defined sense of style and an immediacy, which the posters from 1965 clearly lack. It all happened so fast. In a little over a year, this new art form rose from the streets of San Francisco. These artists were not a splinter group of an already established school of art. They came from varied backgrounds and defined their art as they went along—creating, by happenstance, a genre of art that defies easy categorization but demonstrates obvious passion.

*"I had these dreams that something was gonna happen seeing the number 1966 in my sleep, so I was just passing time 'til then. I wanted my own scene, making my music, not playing the same riffs."*

—*Jimi Hendrix*

# THE BIG FIVE

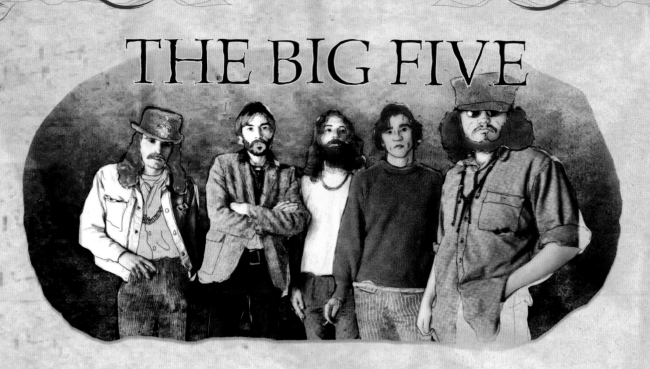

*"There was just a few of us doing it. Everyone had his own style. Victor was heavy on the color. Wes had that zig-zaggy lettering. Rick had the weird imagery, and Stanley and I had these bold images. There were all these distinct styles that were all connected ..."*

—*Alton Kelley*

## STANLEY MOUSE
### (OCTOBER 10, 1940–)

*"I pulled into San Francisco [in a hearse] the first night of the Trip's Festival."* Stanley 'Mouse' Miller was the son of a Disney animator and grew up doing hot-rod art in Detroit. Upon moving to San Francisco, he teamed up with Kelley to form the renowned "Mouse and Kelley." Mouse had a natural feel for the organic lines of Art Nouveau as well as a hand that drew the art seemingly of its own volition.

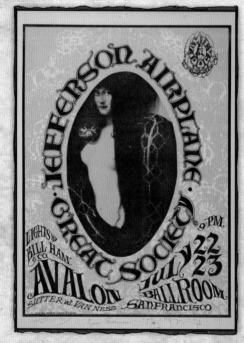

"FAMILY DOG NO. 17"
(50.6 CM X 36 CM)

## ALTON KELLEY
### (JUNE 17, 1940–JUNE 1, 2007)

*"When I used an image I didn't steal it ... I made it my own ..."* Always known by his last name ("even my mom calls me Kelley"), Kelley was smart young man (finishing high school at sixteen with straight As) with a clever turn of mind and an affinity for pop culture. Over time, he developed a preference for bold imagery in his art, and working with Mouse, his artistic partner for many years, he greatly enriched the visual language of a generation through art.

# VICTOR MOSCOSO
### (JULY 25, 1936–)

*"It's happening now. Just like it happened in Toulouse-Lautrec's day."* Victor Moscoso was the only one of the Big Five to have had formal art school training. He attended both Cooper Union and Yale; while at Yale he studied under Josef Albers, one of the world's foremost educators in the field of color. Moscoso was an excellent student, and yet he would have to unlearn everything—break all the rules he had learned—in order to make the art we know him for. His daring use of color greatly influenced this new emerging aesthetic.

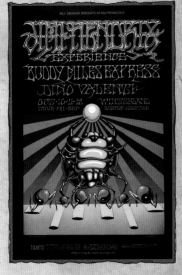

BILL GRAHAM NO. 140
(54.7 CM X 36 CM)

# RICK GRIFFIN
### (JUNE 18, 1944–AUGUST 17, 1991)

*"There was a really soulful graphics movement that appealed to me . . ."* Rick Griffin was already called "the legendary Rick Griffin" even before he died tragically in a 1991 motorcycle accident. Widely regarded as the best in the field, he could very well be America's Toulouse-Lautrec. He impacted this movement with his artistic excellence and his affinity for mythology and mysticism—these were his contributions.

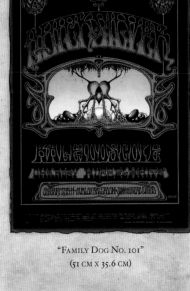

"FAMILY DOG NO. 101"
(51 CM X 35.6 CM)

# WES WILSON
### (JULY 15, 1937–)

*"I selected my colors from my visual experience with LSD."* Wes Wilson is widely regarded as the godfather of the modern American rock poster. Between late 1965 and early 1966, he began experimenting with lettering and color in new ways. Letters became shapes, and shapes became art. Haltingly, as if by parthenogenesis, a new art form took its first tentative steps.

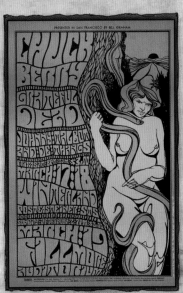

"BILL GRAHAM NO. 55"
(52.1 CM X 34.6 CM)

# EVOLUTION
# 1965 – 1995

*"Very soon the posters became their own form of entertainment . . . And we, the artists, became famous before the bands did . . . because the posters were being done before the bands had any record contracts."*

*–Victor Moscoso*

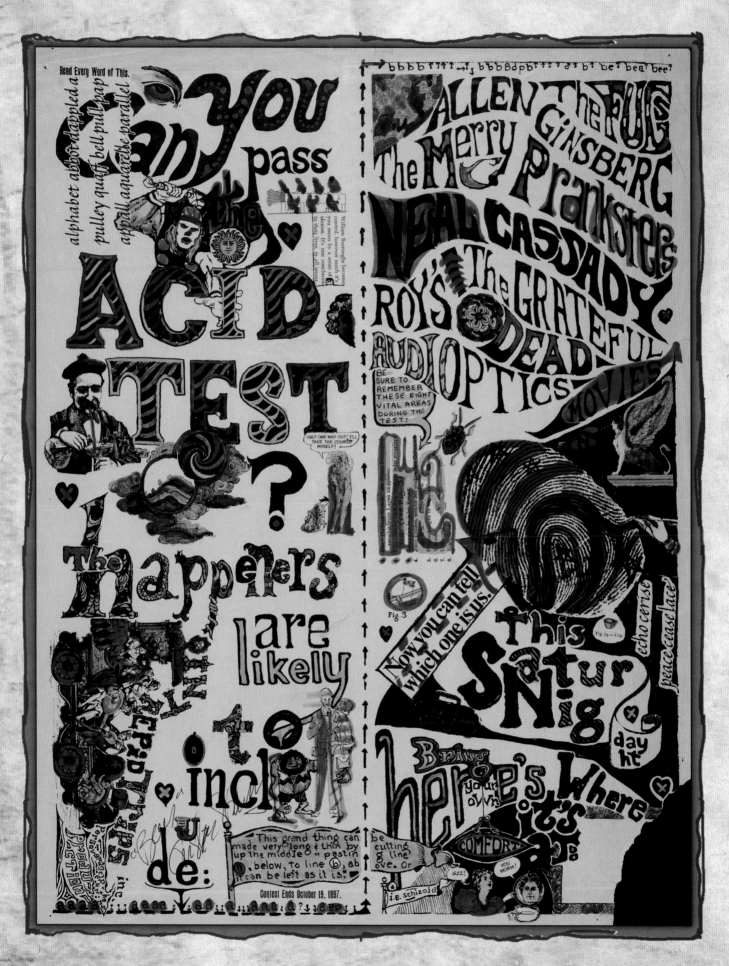

FIG. 7
ARTIST UNKNOWN "CAN YOU PASS THE ACID TEST?"
OFFSET LITHOGRAPH (55.9 CM X 43.5 CM)

"*In the fall 1965, The Warlocks, a local San Francisco band, changed their name to the 'Grateful Dead.' Jerry Garcia chose the name by opening a dictionary and randomly placing his finger on that particular entry. The name stuck. The two pieces presented on this page constitute the only times the band's former name appeared in print. The handbill below incorporates a reproduction of Ralph J. Gleason's widely read and respected San Francisco Chronicle column.*"

*—Phil Cushway*

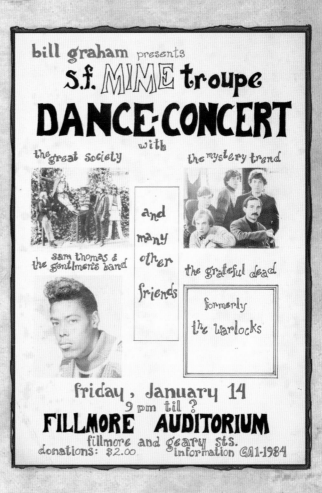

Fig. 9
Artist Unknown "Appeals III"
offset lithograph (60.7 cm x 35.5 cm)

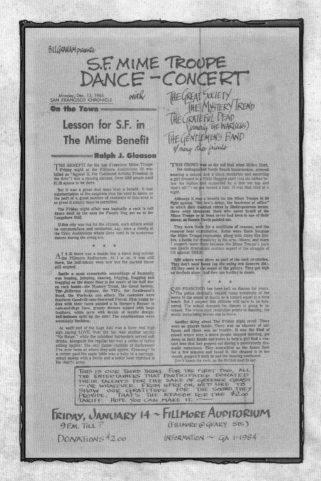

Fig. 8
Artist Unknown "Appeals III" (Handbill)
offset lithograph (21.6 cm x 14 cm)

"*In the opening months of 1966, the scene was thriving. Artists had no idea that the posters they were designing were creating a new art form as yet undefined and unnamed. At this moment, there was still no identifiable look or style. The first time the words 'Grateful Dead' appeared in print was on the Acid Test poster shown opposite. The infamous and legendary LSD chemist Owsley Stanley III once owned this particular piece.*"

*—Phil Cushway*

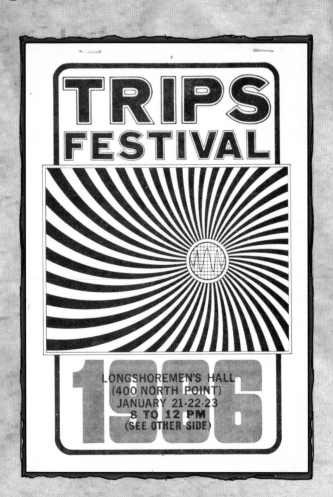

FIG. 10
WES WILSON "TRIPS FESTIVAL" (HANDBILL)
OFFSET LITHOGRAPH (24.1 CM X 16.5 CM)

"*Most chronicles of rock posters, a heavily trafficked narrative, generally ignore the political component of the music scene. Yet from the viewpoint of movements that were trying to change the world, the hot new bands were often the fuse that lit the firecracker. The deep chill of 1950s anticommunism had killed off posters that criticized the dominant paradigm. The whole genre, hugely vital through the 1930s, just vanished. But in 1965, after concert promoters first started handing out great flyers, and then great posters, young people—the dominant demographic back then—gobbled them up.*"

—Lincoln Cushing

"*Political organizers took note, and the counterculture and the New Left found their groove. Getting people to attend a rally was greatly enhanced by a hip advertisement and musical performers. A benefit concert was one of the best ways to raise funds for a campaign or project. Some bands made the distinction between "political" benefits (opposing the Vietnam War) and more "community" gigs, such as free clinics, but in the heat of the moment those were often distinctions without a difference. The music, and the art, was sticking it to The Man and helping build a new society. It was heady stuff.*"

—Lincoln Cushing

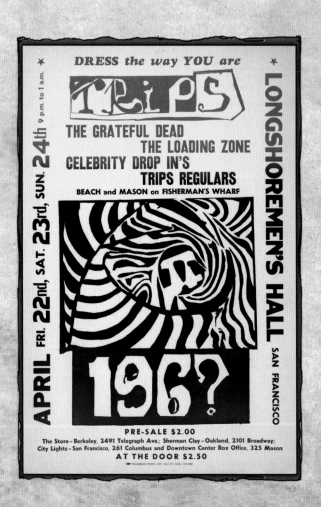

FIG. 11
ARTIST UNKNOWN "196?"
LETTERPRESS (62.1 CM X 40.7 CM)

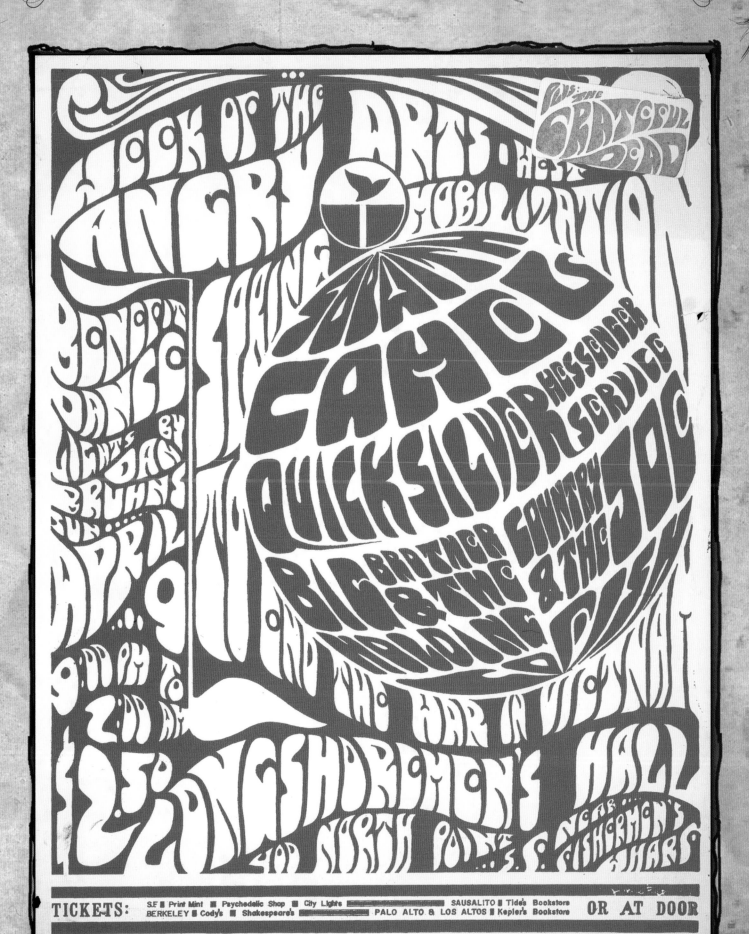

Fig. 12
Artist Unknown "Angry Arts"
Serigraph (57.1 cm x 44.3 cm)

# WES WILSON

**B**ORN ROBERT WESLEY WILSON on July 15, 1937, Wes is considered by many to be the godfather of the modern rock poster. Like many of his fellow artists, Wilson did not have formal art training, yet, oddly enough, this might have been his biggest asset. He was not held back by the conventions of advertising commonly taught in school: a central image and easy-to-read lettering that spells out what the poster is promoting. He designed nearly all of the early posters for the Avalon Ballroom and Fillmore Auditorium. Especially well known for his lettering, Wilson's artwork earned him a place as one of the famed "Big Five."

His artistic influences were rooted in Victorian and Edwardian display lettering as well as the Art Nouveau movement, particularly the great French poster designers of the late 1800s. Wilson coupled this inclination towards Art Nouveau with his love of the Viennese Secessionist lettering style developed by Alfred Roller. Wilson is best known for reviving what would later be called the "psychedelic" font, which made the letters look like they were moving or melting. He was also the first to use a skeleton in an image for the Grateful Dead.

In May 1967, Wilson abruptly stopped producing posters for Graham, claiming the promoter had failed to honor their royalty agreement. He moved his family to a farm in Missouri, where he still lives and works today.

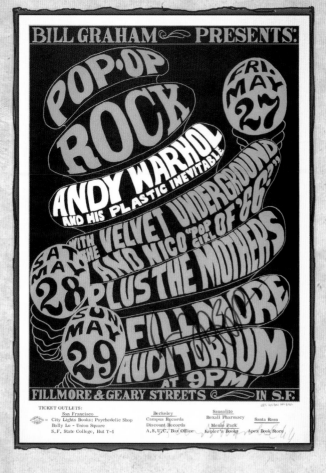

FIG. 13
WES WILSON "BILL GRAHAM NO. 8"
OFFSET LITHOGRAPH (50.8 CM X 35.5 CM)

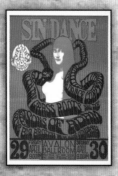

"FAMILY DOG NO. 6"
OFFSET LITHOGRAPH
(50.9 CM X 35.6 CM)

"BILL GRAHAM NO. 7"
OFFSET LITHOGRAPH
(50.7 CM X 35.4 CM)

"BILL GRAHAM NO. 17"
OFFSET LITHOGRAPH
(50.9 CM X 35.2 CM)

"BILL GRAHAM NO. 10"
OFFSET LITHOGRAPH
(50.9 CM X 35.5 CM)

"BILL GRAHAM NO. 26"
OFFSET LITHOGRAPH
(53.1 CM X 34 CM)

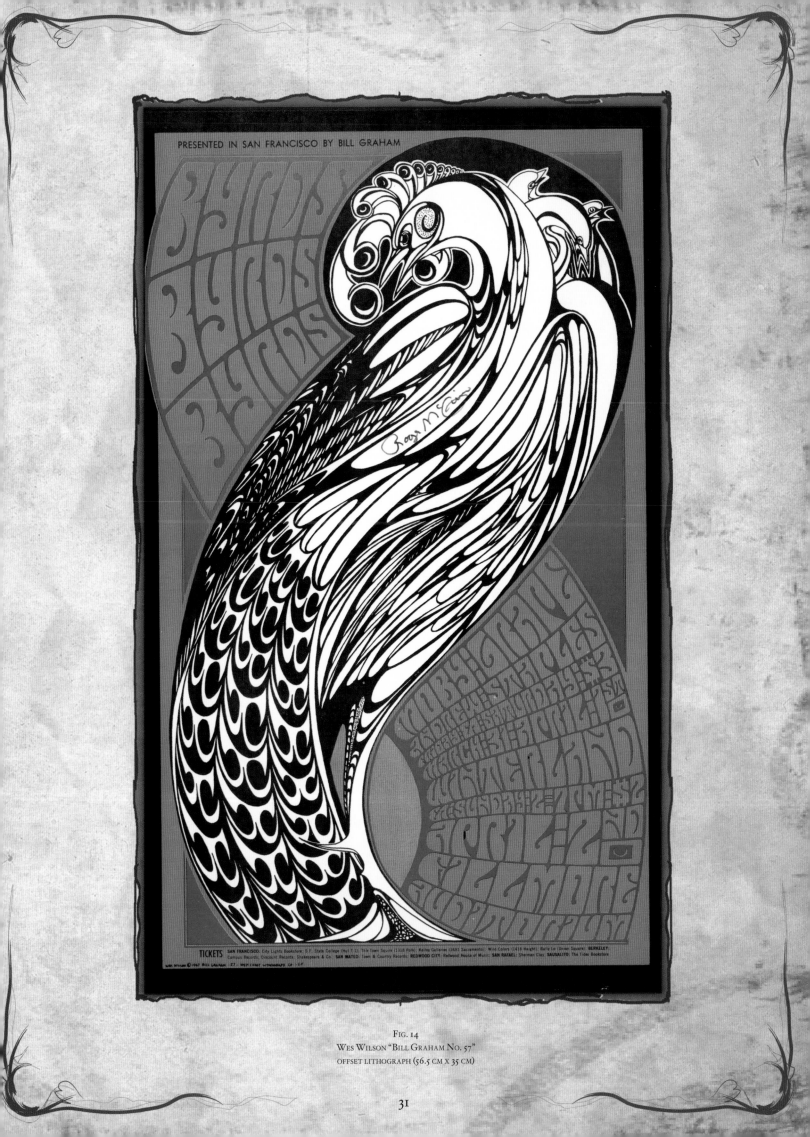

"Normally I had to design and deliver printed posters in a matter of a week, or even days. Within three or four days of getting the billing, I had to have the poster at the shop getting printed. For producers like Chet Helms and Bill Graham, that was usually as quick as they could get these bands scheduled. It was just tough to schedule two or three bands way in advance for some reason. I don't know why, but that was just the way it was. Once in a while, I remember Bill would be real happy if he had over a week in advance and would perhaps have photos for a poster. That was a big deal. It was a pretty fast-moving business in those early days. As a result, I had to find somebody who could print these posters quickly. And the printing also had to be cheap."

—Wes Wilson

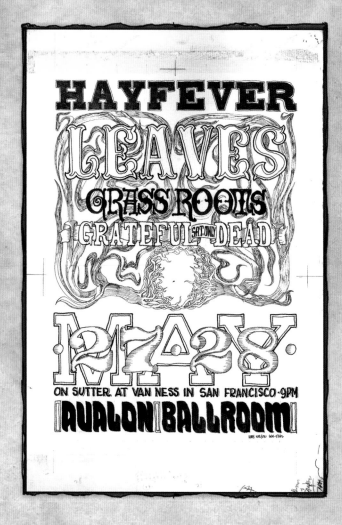

FIG. 16
WES WILSON "HAYFEVER" (ORIGINAL ART)
INK ON ILLUSTRATION BOARD

"Bill would charge $2.50 at the door—Chet, too—and there'd be three bands that had to get their share. Everybody had to get paid. So there wasn't a lot of money. A lot of people like me, some musicians, and the light show guys were just happy to get enough money to get by and have a good time. That was actually an important part of the whole early scene—nobody was super demanding about money, so events seemed to move right along without too many money hitches. After a while, I got more money from Bill for printing expenses, and we were able to expand into color bleeds and printing multiple posters, with handbills and tickets even, all on one press sheet. By that time, I had pretty much perfected the whole printing process, and it could be done fairly quickly, but the lead-time was still most often only a matter of days."

—Wes Wilson

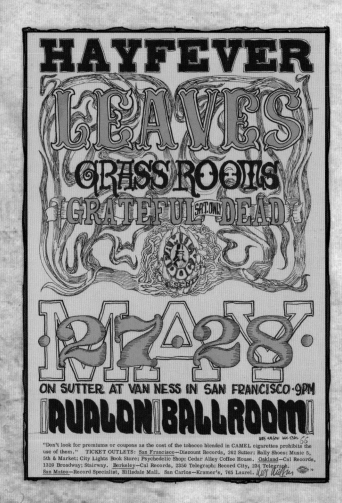

FIG. 15
WES WILSON "HAYFEVER"
OFFSET LITHOGRAPH (50.8 CM X 35.5 CM)

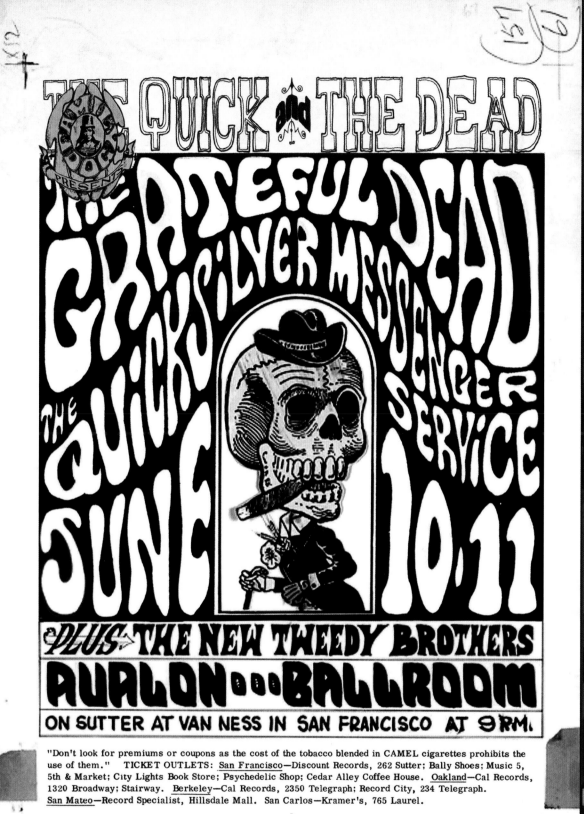

"Don't look for premiums or coupons as the cost of the tobacco blended in CAMEL cigarettes prohibits the use of them." TICKET OUTLETS: San Francisco—Discount Records, 262 Sutter; Bally Shoes; Music 5, 5th & Market; City Lights Book Store; Psychedelic Shop; Cedar Alley Coffee House. Oakland—Cal Records, 1320 Broadway; Stairway. Berkeley—Cal Records, 2350 Telegraph; Record City, 234 Telegraph. San Mateo—Record Specialist, Hillsdale Mall. San Carlos—Kramer's, 765 Laurel.

FIG. 17
WES WILSON "QUICK AND THE DEAD" (ORIGINAL ART)
STAT ON ILLUSTRATION BOARD

# STANLEY MOUSE

**S**TANLEY "MOUSE" MILLER was born on October 10, 1940, in Fresno, California. His father, a Disney animator, moved the family to Detroit, Michigan, in the 1950s. Mouse became interested in painting, and by the seventh grade, he was known for his monster hot rod pictures. Through his fascination with American muscle cars, he discovered his unique talent for fine detailing and airbrushing.

Mouse was expelled from high school after he applied his artistic talents to the newly painted walls of a local teen hangout. His parents encouraged him to attend Detroit's School for the Society of Arts and Crafts, where he found himself disillusioned by the rigid confines of art school.

In January 1966, Mouse moved back to San Francisco on the first night of the Trips Festival. With the help of Alton Kelley, Mouse began creating images for local bands like the Grateful Dead, including, of course, the iconic "Skeleton and Roses" image for the band, which remains an enduring symbol of sixties counterculture. Together, Mouse and Kelley became masterminds behind a new media—that of the psychedelic poster—which came to exemplify the Haight-Ashbury of the late 1960s.

"PHILIP CUSHWAY LITHOS NO. 2"
OFFSET LITHOGRAPH
(75.3 CM X 54.5 CM)

"BILL GRAHAM NO. 110"
OFFSET LITHOGRAPH
(50.8 CM X 36.2 CM)

"WILDERNESS CONFERENCE"
OFFSET LITHOGRAPH
(53.5 CM X 35.5 CM)

FIG. 18
STANLEY MOUSE & ALTON KELLEY "ANGEL"
OFFSET LITHOGRAPH (50.8 CM X 35.6 CM)

# ALTON KELLEY

**A**LTON KELLEY was born in 1940 in Houlton, Maine. He studied industrial design in college. Then in 1964, Kelley hitchhiked to Los Angeles, where he worked for a time as a motorcycle repairman. He moved to San Francisco, where he would find his life's work in psychedelic rock art. He met Stanley Mouse, and an artistic collaboration was born. In 1965, Kelley co-founded the Family Dog, a collective who held the dances that helped ignite the whole scene.

Their success crystallized in 1968 when Kelley and Mouse were invited to exhibit their work in the Joint Show alongside that of Wes Wilson, Rick Griffin, and Victor Moscoso. From then on, these artists would be known as the "the Big Five." Many of Kelley's most memorable pieces were produced for the Grateful Dead. Together, he and Mouse created the "Skeleton and Roses" emblem, which was used by the group for many years to follow. They also designed a number of album covers and other images for the band, which were reprinted on countless T-shirts and posters. Alton Kelley died in 2008 at the age of sixty-seven after a long illness.

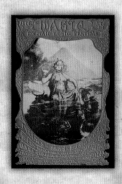

"MAGIC MOUNTAIN"
OFFSET LITHOGRAPH
(71.2 CM X 48.3 CM)

"FAMILY DOG No. 85"
OFFSET LITHOGRAPH
(50.7 CM X 35.5 CM)

"FREE"
OFFSET LITHOGRAPH
(40.75 CM X 25.5 CM)

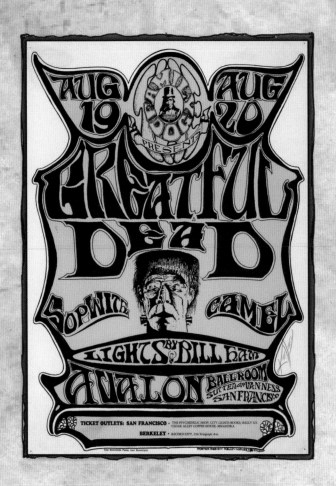

"Stanley and I had no idea what we were doing. But we went ahead and looked at American Indian stuff, Chinese stuff, Art Nouveau, Art Deco, Modern, Bauhaus, whatever. We were stunned by what we found and what we were able to do. We had free rein to just go graphically crazy. We were looking through thousands of books. We were blown away by the stuff we found. When I used an image, I didn't steal it. I made it my own. I did something with it. It was a tool. It was art. I felt I had a right to use it."

—Alton Kelley

FIG. 19
STANLEY MOUSE & ALTON KELLEY "FRANKENSTEIN"
OFFSET LITHOGRAPH (50.6 CM X 35.2 CM)

"There was so much happening, every day was like a year. I quickly became more and more sophisticated, and then Kelley and I would go to the library and go through all the art books—they had these stacks in the back. You couldn't take books out, but they had all the old books—art books—and we would just scour through them all. And by just doing that, our art education expanded amazingly. I looked at the Art Nouveau and the Art Deco . . . Nobody knew that stuff then. Nor was anyone doing it."

—Stanley Mouse

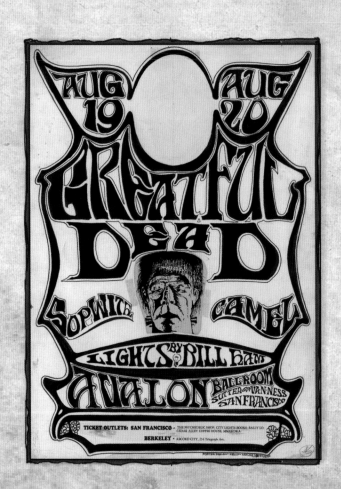

FIG. 20
STANLEY MOUSE & ALTON KELLEY "FRANKENSTEIN" (ORIGINAL ART)
STAT AND INK ON ILLUSTRATION BOARD (50.8 CM X 35.6 CM)

FIG. 21
STANLEY MOUSE & ALTON KELLEY "WINNIE THE POOH"
OFFSET LITHOGRAPH (50.8 CM X 35.6 CM)

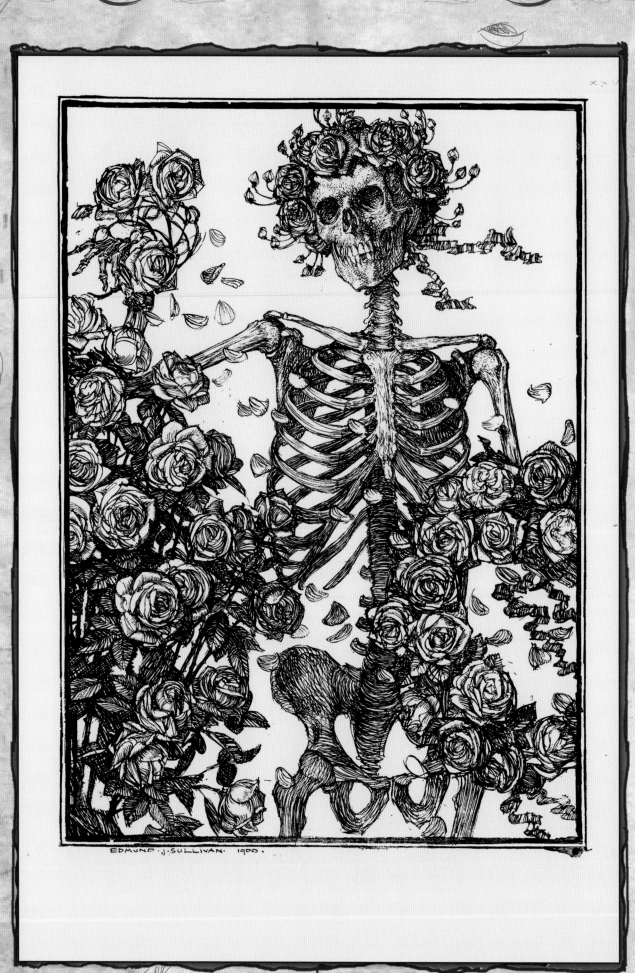

FIG. 22
EDMUND SULLIVAN "QUATRAIN NO. XXVI, *RUBÁIYÁT* OF OMAR KHAYYÁM"
INK ON ILLUSTRATION BOARD

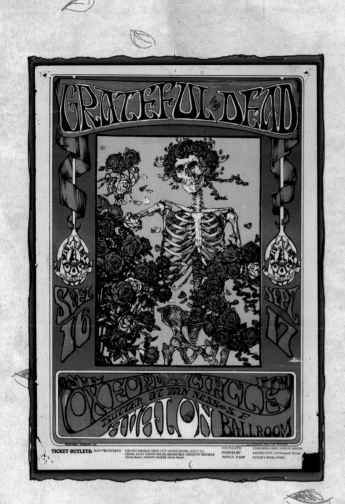

*"We didn't really know what it was going to look like, but when it came out it just floored us. I remember putting it on the side of our truck and driving around town and stopping at a gas station on Geary Boulevard and the guy who worked there looked at it and said, 'Wow! What's happening? Who's the Grateful Dead? Where's the Avalon?' It was like, 'I'll be there!'"*

—Alton Kelley

*"I was just thumbing through some books, and I had the Rubaiyat of Omar Khayyam with the illustrations by Edmund J. Sullivan, and I came to that picture. I said, 'Look at this, Stanley. Is that the Grateful Dead or is that the Grateful Dead?' So, we did a bigger drawing of it, worked up the lettering and the ribbon and made the overlays."*

—Alton Kelley

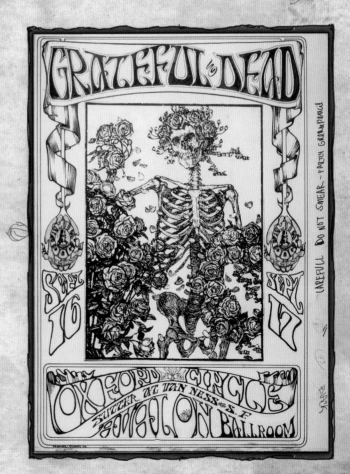

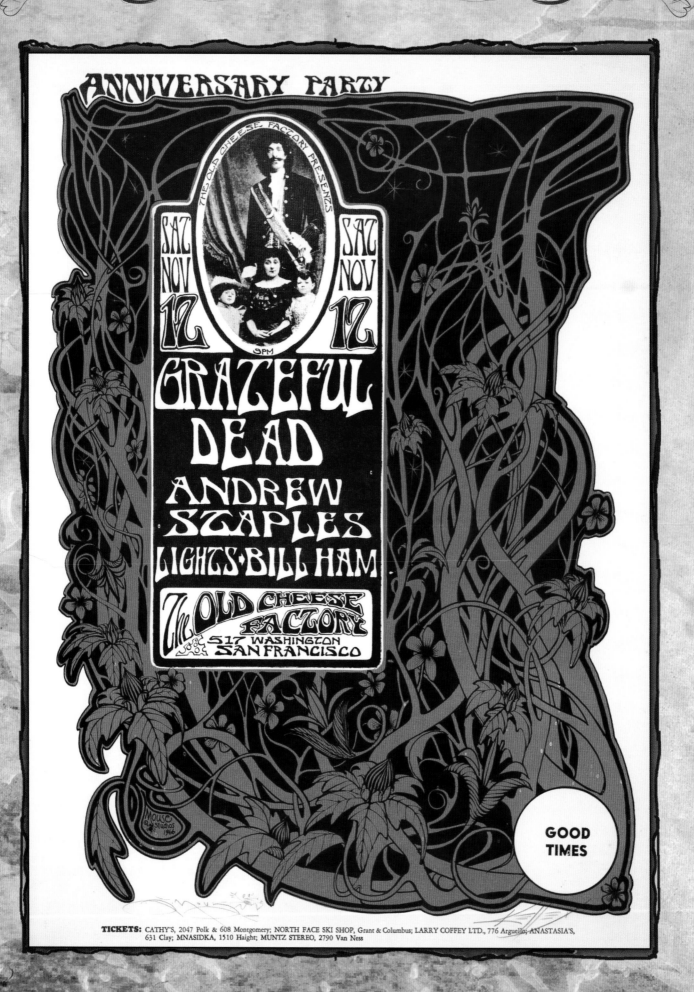

FIG. 25
STANLEY MOUSE & ALTON KELLEY "CHEESE FACTORY"
OFFSET LITHOGRAPH (50.6 CM X 35.9 CM)

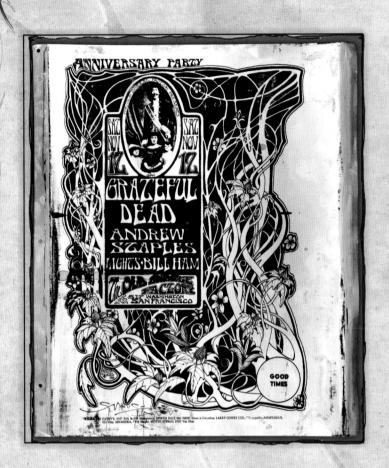

FIG. 26A
STANLEY MOUSE & ALTON KELLEY "CHEESE FACTORY" (PRINTING PLATE)
PHOTOCHEMICALLY ENGRAVED PLATE (52.2 CM X 45 CM)

"We were real surprised that the public accepted as much as they did . . . Nothing was preconceived. I don't think Lautrec did any serious thinking about what he was doing for the Moulin Rouge. He was there on this scene that was his world. And we were there on this scene. We went to all the dances, there was always a lot of stuff to do, and it all fell into one direction."

—Alton Kelley

"My history with the Grateful Dead goes far back. They were playing at the Avalon Ballroom, and nobody really knew about them. But they had a great name. I'd always loved painting skulls and stuff, because I came out of the hot rod art world. I liked their name, which propagated a lot of imagery in my head."

—Stanley Mouse

FIG. 26B
STANLEY MOUSE & ALTON KELLEY "CHEESE FACTORY" (PRINTING PLATE - RED)
PHOTOCHEMICALLY ENGRAVED PLATE (52.2 CM X 45 CM)

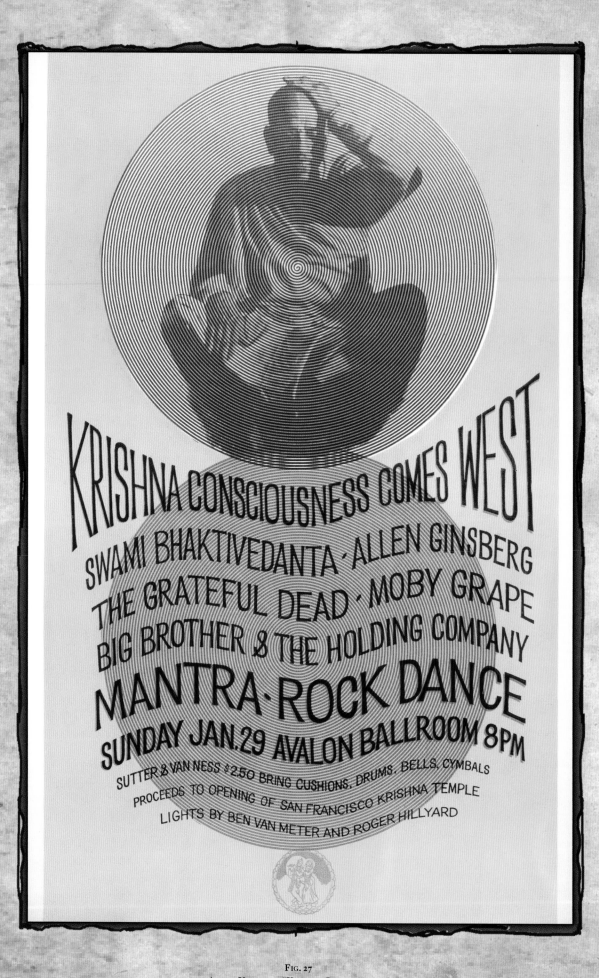

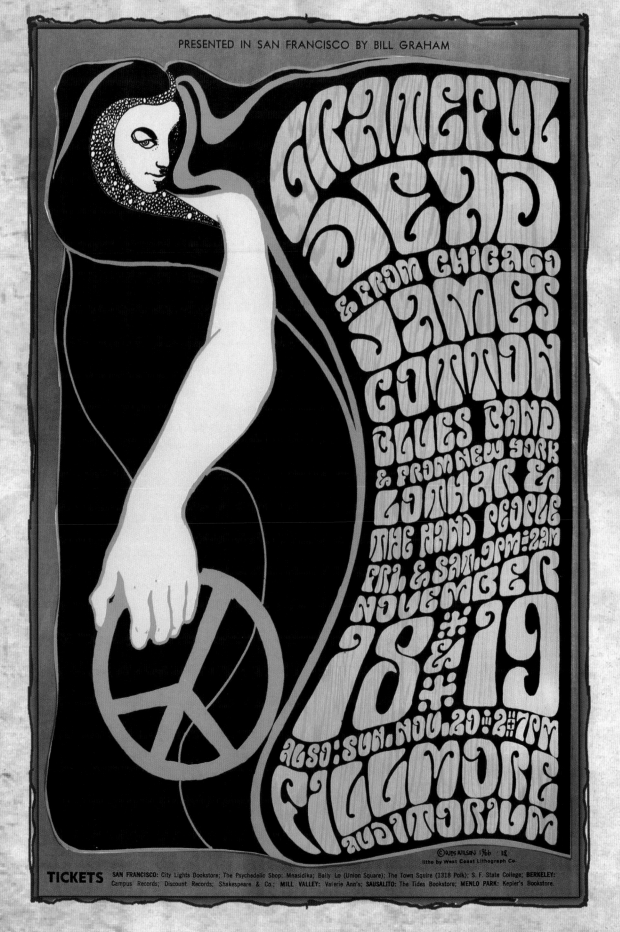

FIG. 29
WES WILSON "BILL GRAHAM NO. 38"
OFFSET LITHOGRAPH (53.9 CM X 34.2 CM)

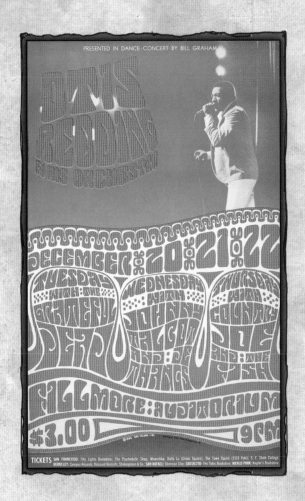

FIG. 30
WES WILSON "BILL GRAHAM NO. 43"
OFFSET LITHOGRAPH (57.5 CM X 35.4 CM)

"I liked to use lettering for backgrounds or for shapes. I really like the idea of using the whole piece of paper. I didn't like the existing letterings, they looked boring . . . The dance halls had elaborate light shows [and] I adapted it around that. The light shows were very important because they created the inner visual environment for these events. The bands were dance bands. The dancers were dancing . . . It was more of a participatory event than an observational event."

—Wes Wilson

"I remember that one. That one had kind of a pinkish red lettering . . . That was a really nice one . . . I was just always trying to do the job of illustrating and working on the posters for the printer or event . . . And with that one there was seven days . . . I really enjoyed the lettering on that one, [it] just kind of rhythmically went across the picture . . . that was a really . . . good contrast . . . the background with the sound going across in the form of lettering, like sound."

—Wes Wilson

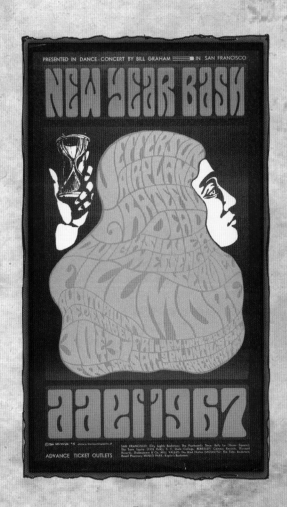

FIG. 31
WES WILSON "BILL GRAHAM NO. 37"
OFFSET LITHOGRAPH (62.4 CM X 35.8 CM)

# VICTOR MOSCOSO

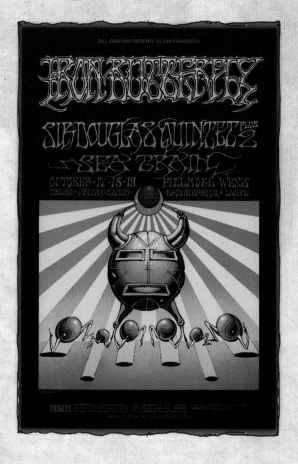

**V**ICTOR MOSCOSO was born in 1936 in Oleiros, Spain, at the dawn of the Spanish Civil War. Moscoso's father was a house painter who taught Moscoso about pride in craft and the power of color. At the height of the war, Victor's father fled Franco's fascists and left a young Moscoso alone with his mother. Reflecting on his feelings about his father's abandonment, Moscoso told an interviewer, "He left my mother and me. You don't take the kids with you. You leave them and hope that nothing happens to them. It's hard to hide a kid."

After the war, his father moved the family to Brooklyn. Growing up in New York also shaped his artistic eye. In his own words: "When you're in a city like New York, it's the tyranny of the straight line; everything is a straight line, trees are captive on the sidewalk in little metal cages or in large concentration camps like Central Park or Prospect Park in Brooklyn."

As a young man, Moscoso studied art first at Cooper Union and then at Yale University with the prominent color theorist Joseph Albers, whose teachings were an important influence on Victor and the development of the psychedelic poster. Through his unconventional use of the color wheel, Moscoso found a new way to make color come alive and his posters burst with a "pulsing" visual effect that became his trademark.

Motivated by Kerouac's *On the Road*, Moscoso moved to the West Coast and settled in Berkeley. He enrolled at the San Francisco Art Institute for more intense study of visual art. He further honed his visual talents when he began studying design and drawing posters for the music venues of San Francisco, advertising such bands as Big Brother & the Holding Company and the Grateful Dead. He met Stanley Mouse, Wes Wilson and Alton Kelley and a new collaboration was born that resulted in the most successful poster art of the time. The only academically trained artist among the leading poster designers, Victor Moscoso became one of the most compelling artists of the psychedelic era.

FIG. 32
RICK GRIFFIN & VICTOR MOSCOSO "BILL GRAHAM NO. 141"
OFFSET LITHOGRAPH (54.7 X 36 CM)

*"With all of my schooling, I wasn't getting it. I was trying to make it traditional. I was trying to make the illegible lettering legible. I was trying to make it fit my preconception of what the poster was that I had learned in school, rather than examine what Wes, Mouse and Kelley were doing. But I managed to hop on in time, and I did it by reversing all the rules."*

—*Victor Moscoso*

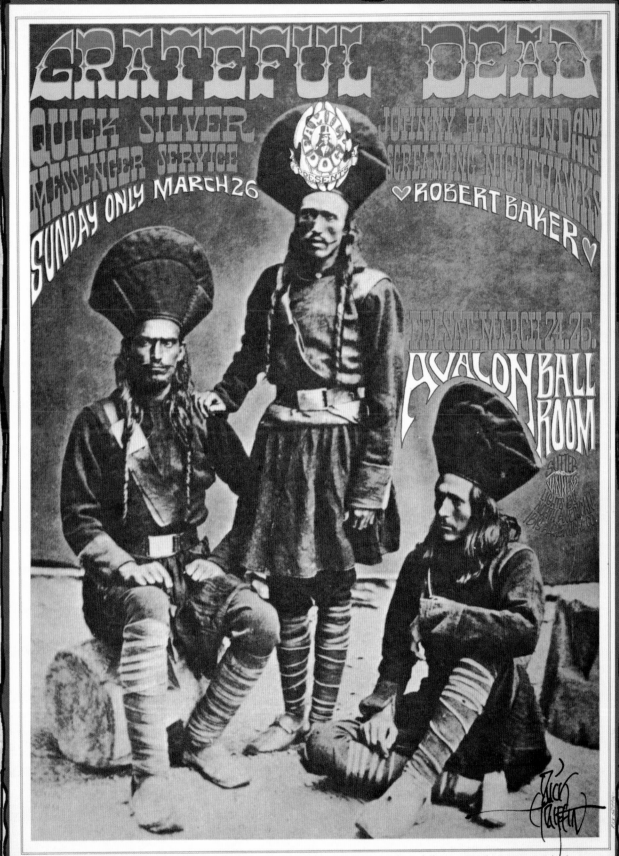

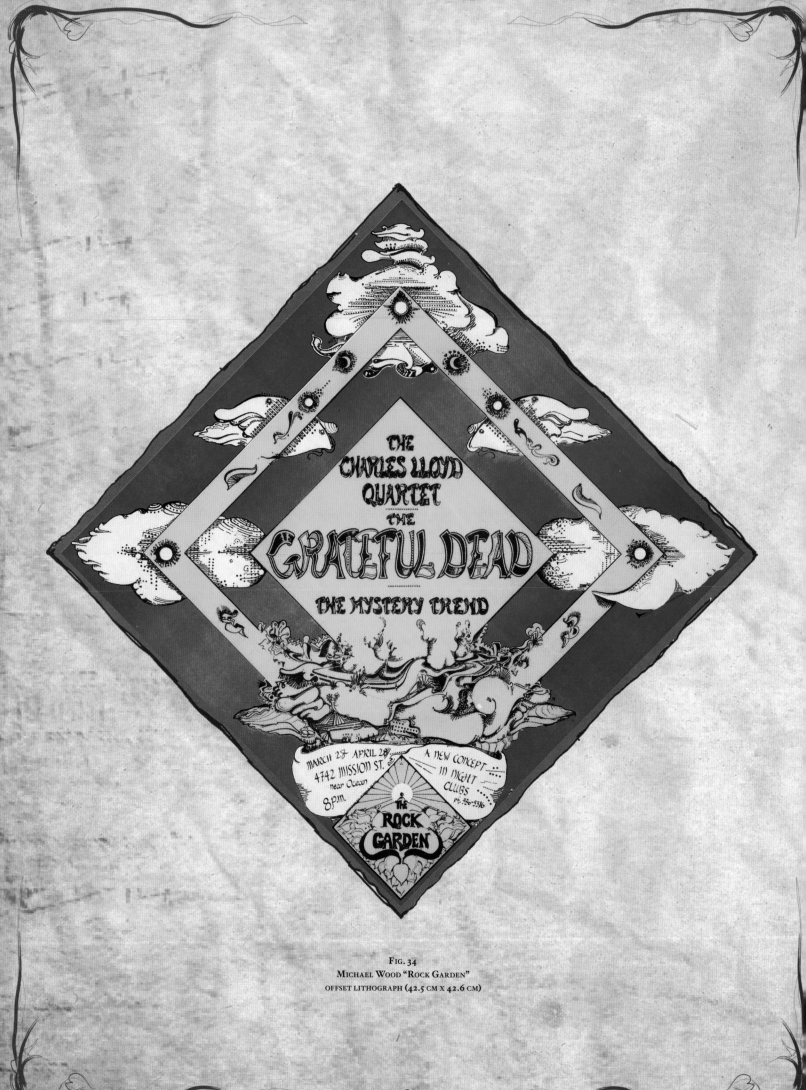

FIG. 34
MICHAEL WOOD "ROCK GARDEN"
OFFSET LITHOGRAPH (42.5 CM X 42.6 CM)

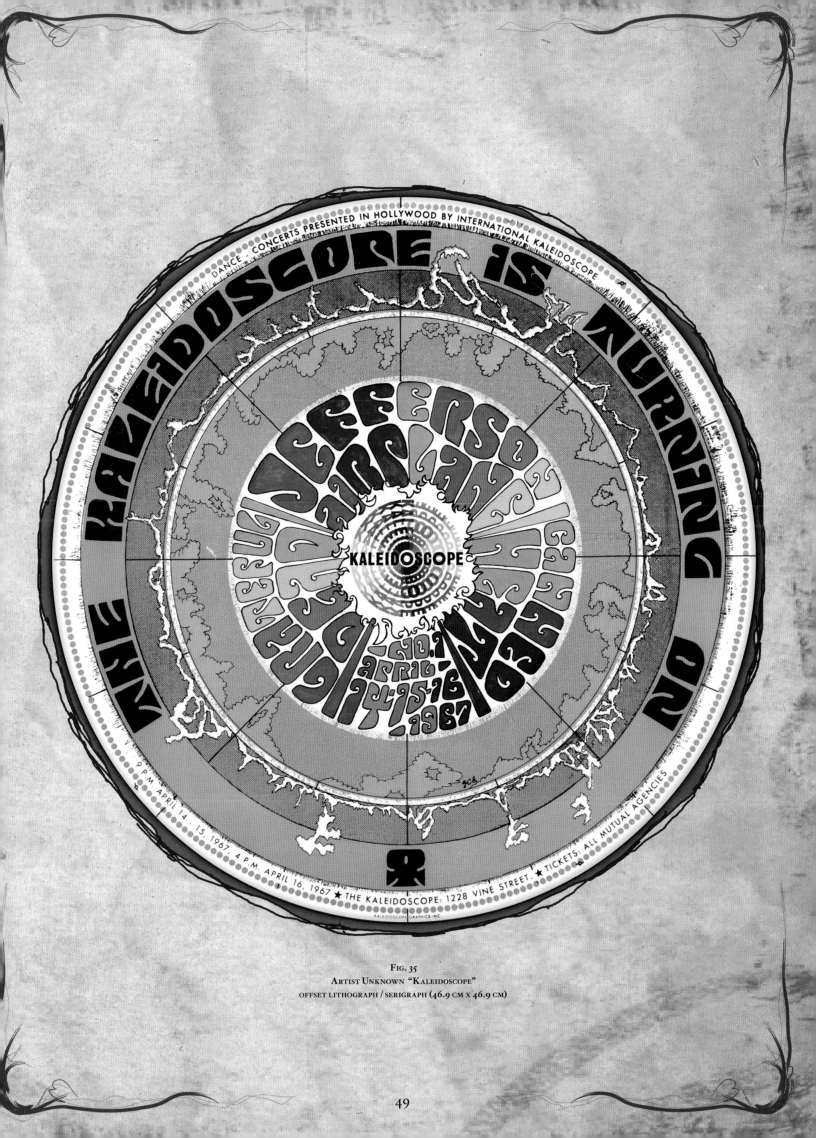

Fig. 35
Artist Unknown "Kaleidoscope"
offset lithograph / serigraph (46.9 cm x 46.9 cm)

# RICK GRIFFIN

ORN RICHARD ALDEN Griffin on June 18, 1944, Rick grew up in Palos Verdes, California. He was an avid surfer and often brought this passion to his art. In the fall of 1966, after catching sight of the rock posters designed by Stanley Mouse and Alton Kelley, he moved to San Francisco.

Griffin designed posters for the Family Dog, which led to his next job at The Berkeley Bonaparte poster distribution agency. As his name recognition soared, Jan Wenner, a high school friend and one of the co-founders of *Rolling Stone* magazine, commissioned Rick to design the iconic masthead for the magazine. Griffin thus took his place as one of the "Big Five," joining leading poster artists Victor Moscoso, Wes Wilson, and Mouse and Kelley.

Rick's life changed directions in 1969 when he sold everything and left for Mazatlan with only a surfboard and a bag of marijuana. While in Mexico, having discovered he was a new father, Griffin created his most famous poster, "Aoxomoxoa." Bursting with images of sexuality and fertility, this poster reflects the birth of his child.

Griffin had grown up in an atmosphere of Christian conservatism that had always contributed to his sense of artistic perfectionism. Then, in 1970, he became a born-again Christian, which led to a profound change in the direction and style of his art. Rick Griffin was killed in 1991 in a motorcycle accident in Petaluma, California.

FIG. 36
RICK GRIFFIN & RANDY TUTEN "SIOUXSIE" (ORIGINAL ART)
COLORED PENCIL ON ILLUSTRATION BOARD (37 CM X 28 CM)

"CAL STATE, FULLERTON '68"
OFFSET LITHOGRAPH
(50.8 CM X 35.5 CM)

"FAMILY DOG NO. 89"
OFFSET LITHOGRAPH
(50.8 CM X 36.2 CM)

"GRIFFIN SHIELD"
OFFSET LITHOGRAPH
(50.3 CM X 42.7 CM)

"SURFER MAGAZINE COVER"
OFFSET LITHOGRAPH
(27.9 CM X 21.6 CM)

"MAN FROM UTOPIA"
OFFSET LITHOGRAPH
(30.3 CM X 22.7 CM)

FIG. 37
RICK GRIFFIN "THE EYEBALL"
OFFSET LITHOGRAPH (54.8 CM X 35.6 CM)

# HUMAN BE-IN

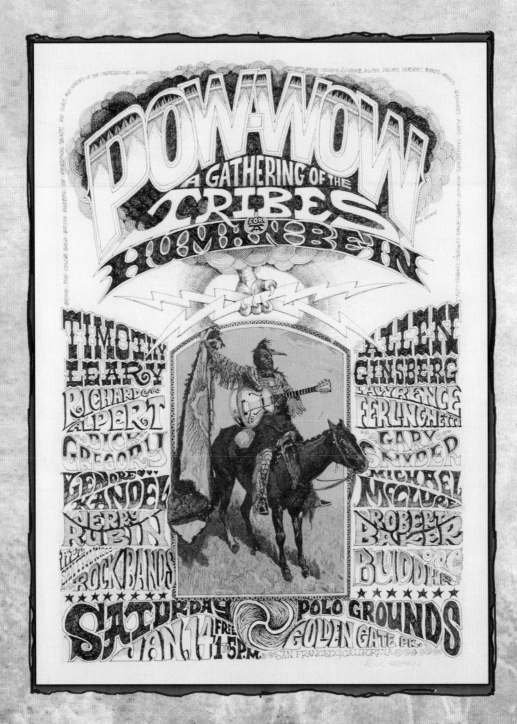

Fig. 38
Rick Griffin "Pow-Wow"
Offset Lithograph (57.2 cm x 36.3 cm)

THE HUMAN BE-IN was a seminal event in the development and expression of the countercultural community. Tens of thousands of people showed up; these were the people who this art reflected and resonated with, who tore the posters off telephone poles to put up as art in their homes. This was their art.

# JANUARY 1967

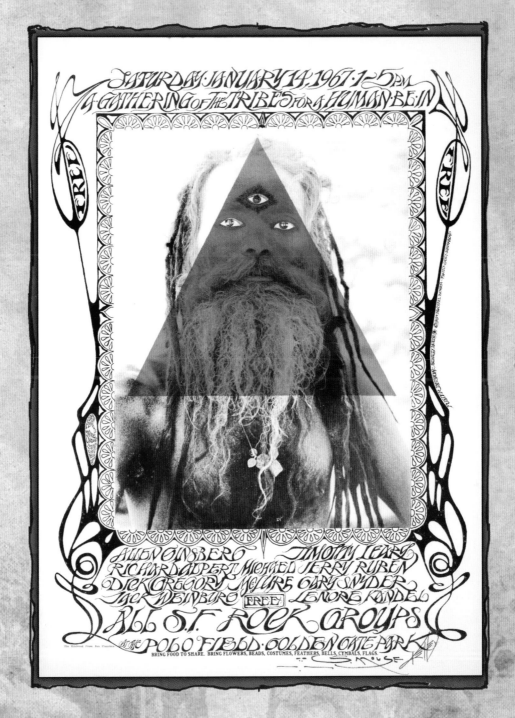

Fig. 39
Stanley Mouse & Alton Kelley "Human Be-In"
Offset Lithograph (50.5 cm x 36.1 cm)

CHARLES PERRY, in his book *The Haight-Ashbury: A History*, describes the event: "The winter had been one of the rainiest of the decade, but miraculously the morning had dawned bright and clear . . . people started showing up at 9:00 a.m. . . . Wherever you looked, hundreds of people were wending toward it."

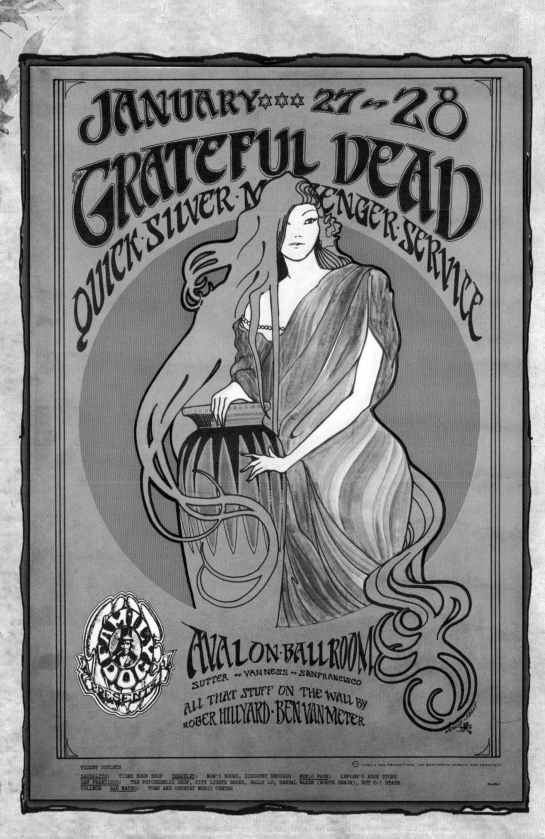

FIG. 40
STANLEY MOUSE & ALTON KELLEY "FAMILY DOG NO. 45"
OFFSET LITHOGRAPH (50.8 CM X 35.5 CM)

"*The posters were real things in a real time, and a really far-out time. The posters were for dances, and the dances were special. It was like Toulouse-Lautrec doing posters for the Moulin Rouge—each of these things was for a dance that really turned him on. I got . . . involved in a totally new art scene . . . I can look back at the very first ones and remember how it all started, and what it felt like.*"

*—Alton Kelley*

**Ralph & Al Pepe** Present . . 9:00 p.m. to 1:00 a.m.

- SEE AND HEAR THE -

# GRATEFUL DEAD

## Moby ✶ The Morning
## Grape ✶ Glory

# L·I·G·H·T·S
By: ZAP

# THUR. DEC. 29th
# Santa Venetia ARMORY

### ADMISSION $2.50

## R & A ATTRACTIONS — 454-6165

TILGHMAN PRESS, 1217-32nd ST., OAK.— 653-4388

FIG. 41
ARTIST UNKNOWN "SANTA VENETIA ARMORY"
LETTERPRESS (38.9 CM X 58.6 CM)

FIG. 42
ARTIST UNKNOWN "BIG MAMA THORNTON"
OFFSET LITHOGRAPH (35 CM X 27.9 CM)

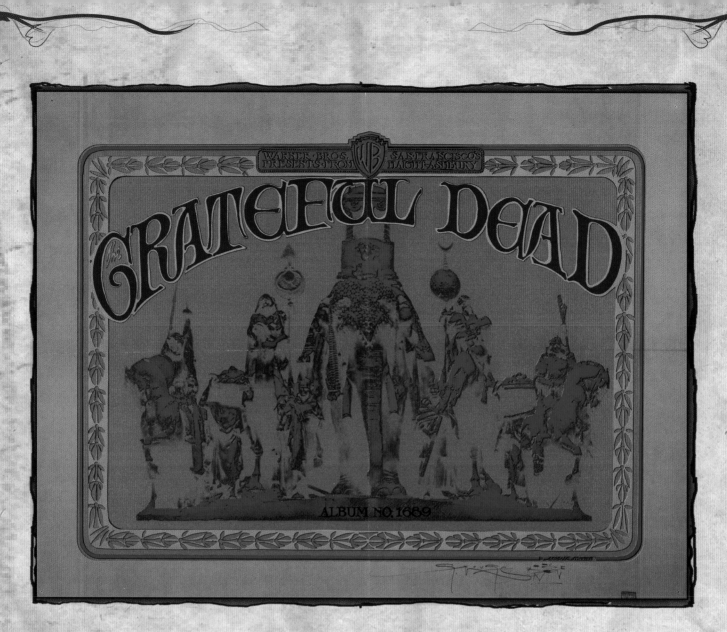

FIG. 43
STANLEY MOUSE & ALTON KELLEY "ELEPHANT"
OFFSET LITHOGRAPH (56.5 CM X 42.2 CM)

"The posters were vehicles for both incorporating new graphic techniques and juxtaposing colors that traditionally were never printed side by side. The eye is not equipped to perceive red and blue simultaneously, so vibrant red-green, red-blue combinations served to simulate the shimmering world of the psychedelic experience."

—Chet Helms

"I would say that the inspiration was the trips I made down to San Francisco. I was getting inspired by the San Francisco scene and just getting involved in Art Nouveau in general—the lettering that looks like Stanley Mouse's—so I was trying to bring a little bit of San Francisco up to Vancouver."

—Bob Masse

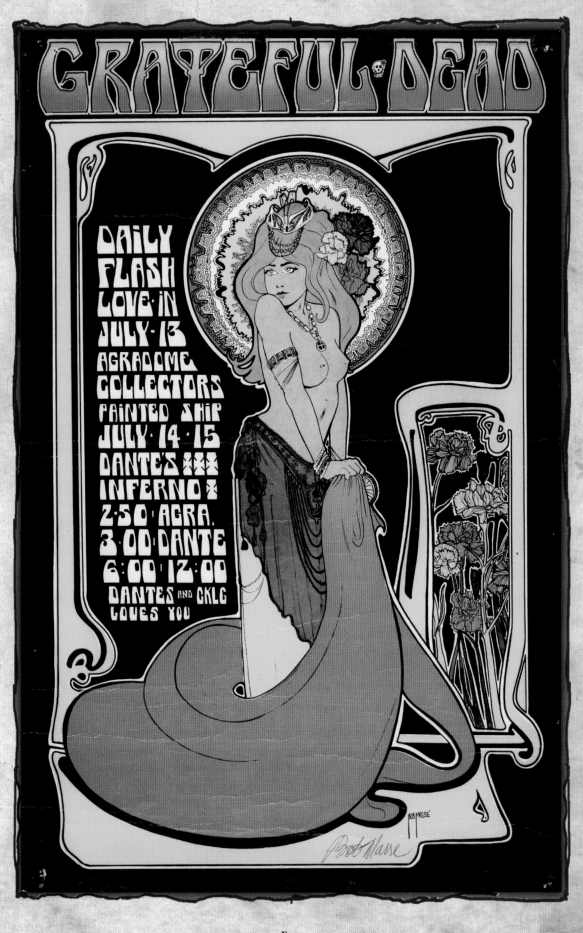

GRATEFUL · DEAD

DAILY
FLASH
LOVE · IN
JULY · 13
AGRADOME
COLLECTORS
PAINTED SHIP
JULY · 14 · 15
DANTE'S
INFERNO
2 · 50 · AGRA.
3 · 00 · DANTE
6 · 00 · 12 · 00
DANTES AND CKLG
LOVES YOU

FIG. 44
BOB MASSE "DEAD VANCOUVER"
OFFSET LITHOGRAPH (53.2 CM X 34.4 CM)

# SNAPSHOT IN TIME

BY GREIL MARCUS

I'VE GAZED AT these Wes Wilson curlicues for years upon years, long since forgetting, if I ever really noticed, who was featured. Does it matter that it was the great Chicago blues guitarist Otis Rush (a thunderbolt crashing down on dead-end streets in "Double Trouble" in 1958, nine years before this show took place), followed by the Grateful Dead and the Canned Heat Blues Band? It doesn't matter that Canned Heat, the purist band of record collectors, got to shorten their name after they had bigger pop hits than Rush or the Grateful Dead ever would—hits that you can still hear on the radio, as you don't hear, say, the Dead's "New New Minglewood Blues" or Rush's "All Your Love." What matters is the vortex Wilson made here—a swirling pool of '50s pink-and-black cool in aqua water sucking every word or letter straight into a picture that told you that you had to go to this show, even if, in the Möbius-strip movement of the picture, it barely told you where or why.

I know someone who came home with this poster and was so seduced by the way it wouldn't hold still, wouldn't stop moving, wouldn't let the Mona Lisa smile in the eyes of the face of which all the words and letters are Medusa's hair and answer a single question—someone so caught up in the way the art sends the bands elsewhere, so that it became its own subject—that he spent weeks pasting other words, pictures cut from magazines, tiny headlines, bits of news stories into Wilson's design until the poster, not the commercial message it was supposedly sending

OTIS RUSH AND HIS CHICAGO BLUES BAND • GRATEFUL DEAD •
THE CANNED HEAT BLUES BAND • FRI • SAT • SUN • FEBRUARY 24 • 25 • 26 •
AT THE FILLMORE

was the language. Anyone can speak it. All you have to do is let the poster translate your desires, and that was easy to do at the time and easy to do now.

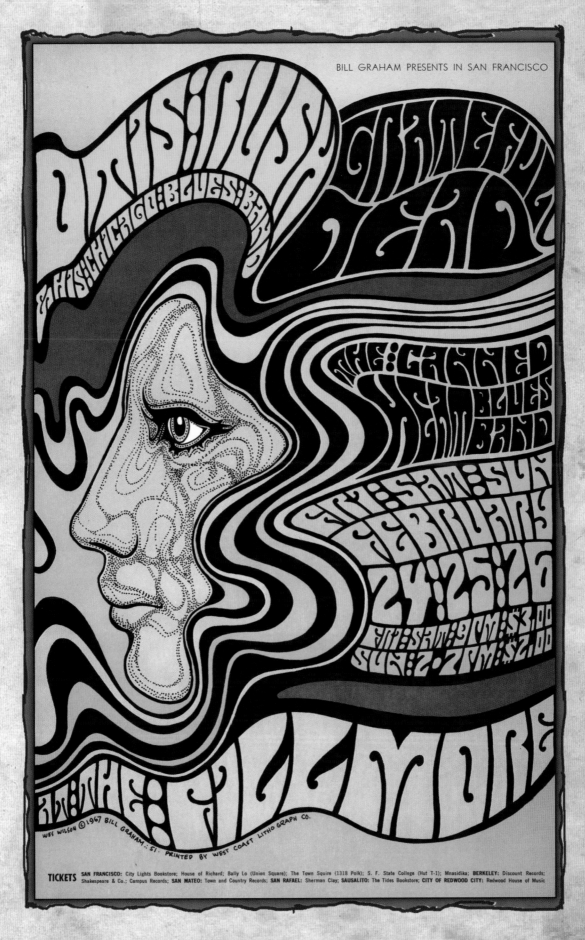

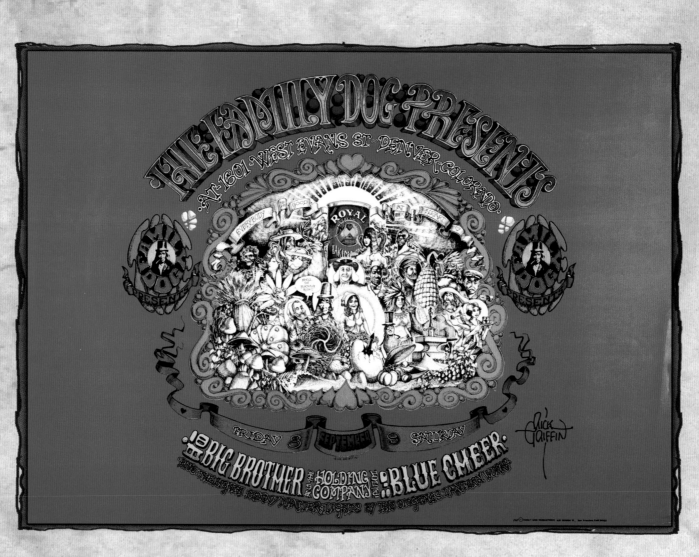

FIG. 46
RICK GRIFFIN "FAMILY DOG NO. 79"
OFFSET LITHOGRAPH (50.7 CM X 35.3 CM)

THIS POSTER WAS originally created for the opening of The Family Dog in Denver, Colorado—an extension of their dance hall operation in San Francisco. The art is by the legendary Rick Griffin and illustrates two of the main aesthetic tenets of this new genre of art: breaking the rules, and poster art as the artists' domain, independent of the band or bands being promoted. The image is a hand-drawn cornucopia of American consumer products from Mr. Peanut to Quaker Oats.

Ida Griffin describes it: "We'd go shopping at the grocery store—we would look for the artwork on the old cans and labels. He drew all these without their permission. It was like breaking on through to the other side with graphics and commercial art. All the artists were trying to break away from standard corporate rules and regulations about what an artist could and couldn't draw. It was a revolution. Artists should have the freedom to draw what they want."

Fig. 47
Rick Griffin "Family Dog No. 79" (Original Art)
stat and ink on illustration board (37.6 cm x 50.6 cm)

GRIFFIN HAD FIRST drawn the original central image. He then had a photostat taken, after which he hand drew the lettering around it. This mockup was then put on illustration board with non-reproductive blue ink. Rick would have then individually inked each of the blue-lines with the appropriate color.

Note: I owned this black-line for a number of years and had noticed that the lettering along the bottom was a photostat instead of original hand-inked lettering like the rest of the piece. One day, Tom Hill, a friend of mine, lifted up the stat just a little bit to see what was underneath it and found that there was hand-inked lettering. He simply peeled it off. Underneath we discovered that the original lineup for this concert was different than what was printed on the final poster. "Grateful Dead" had been covered with the photostat patch reading "Big Brother." Apparently the band lineup had changed at the last minute. I found this fascinating. To me, it clearly illustrates that these posters should be regarded as art; the bands are interchangeable.

FIG. 48
DANIEL FENNELL "CAFÉ AU GO GO"
OFFSET LITHOGRAPH (50.8 CM X 35.5 CM)

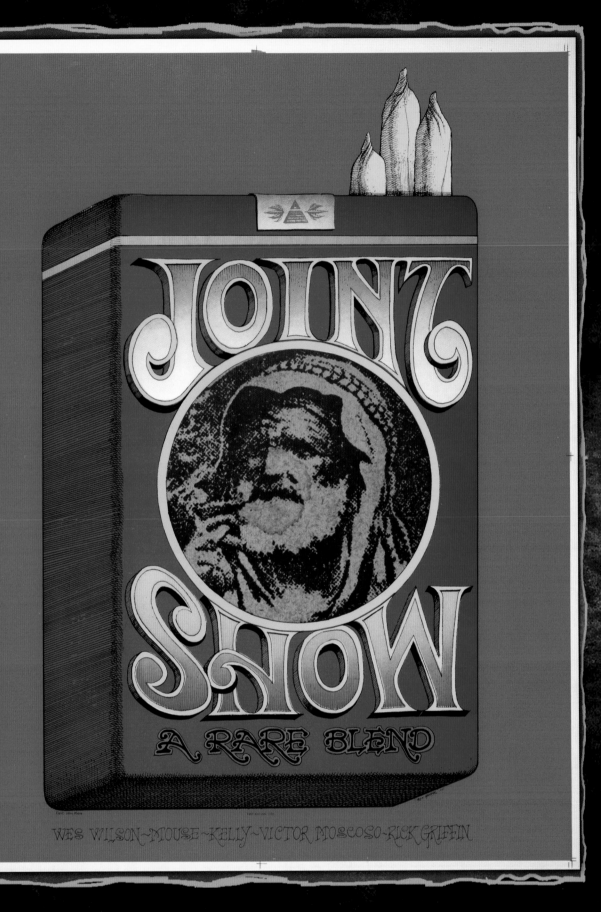

FIG. 49
RICK GRIFFIN "JOINT SHOW"
OFFSET LITHOGRAPH (73.9 CM X 58.7 CM)

# THE JOINT SHOW

**T**HE JOINT SHOW opened at the Moore Gallery in San Francisco on July 15, 1967. It was at this exhibition that the term "the Big Five" was coined. With this, Griffin, Moscoso, Wilson, Kelly, and Mouse were finally getting the recognition they deserved.

*"When we had our show, The Joint Show, one of the questions reporters asked us—the art critics—they said, 'Are you gonna' go on to serious art from here?' And we went, 'Gee, I don't know, should we just stay with the comedy stuff?'"* —Alton Kelley

*"Art is whatever you want it to be. There is no one interpretation of art; your interpretation of a piece is as valuable or as right or as true as anybody else's. A critic's job is supposedly a guide for the uninitiated. My feeling is this: Fuck the critic. All right? I can figure it out for myself."* —Victor Moscoso

*"At that time, we knew history was being made with that whole Haight-Ashbury scene, and we were the visual part of that. We were just riding the wave of what was happening. I was doing a poster every week. There was so much going on. Every day back then was like a whole year. There was no time to think about: "Is this going to be in museums some day?"* —Stanley Mouse

"*I once wrote that psychedelic poster art might be the first revolutionary movement to sneak into art history by way of the society and entertainment pages of the newspaper; the art establishment still had trouble recognizing real Pop Art in its natural context. The other side of it is that the poster movement itself has served as a backdoor which has gained for art a new audience approaching art in a new way. To a generation that grew up on finger-painting and largely dropped-out of school before art appreciation courses had instilled their deadly, monumentalizing religious awe toward art, the posters were a non-intimidating art form full of familiar ingredients—pop advertising art, culture hero photographs and reminders of Victorian relics in grandma's attic; they poked fun at the plastic slickness of adult commercial art, the reverential attitude toward fine art, and flaunted the taboos. They were an art, which everyone could identify and live with, simply by sticking four thumbtacks in the wall. The result is a come-off it, it-ain't-got-a-thing-if-it-ain't-got-a-swing attitude which is carrying over as a healthy new standard in approaching more serious art.*"

—*Thomas Albright*

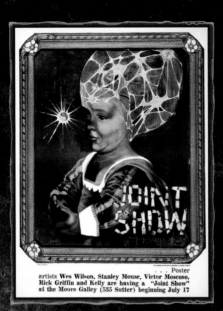

. . . Poster
artists Wes Wilson, Stanley Mouse, Victor Moscoso,
Rick Griffin and Kelly are having a "Joint Show"
at the Moore Galley (535 Sutter) beginning July 17

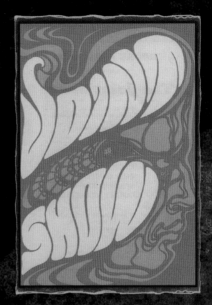

FIG. 50
STANLEY MOUSE
"JOINT SHOW"
(68.1 CM X 50 CM)

FIG. 51
ARTIST UNKNOWN
"JOINT SHOW"
(11.7 X 8.1 CM)

FIG. 52
ALTON KELLEY
"JOINT SHOW"
(73.2 CM X 55.9 CM)

FIG. 53
WES WILSON
"JOINT SHOW"
(63.4 CM X 95 CM)

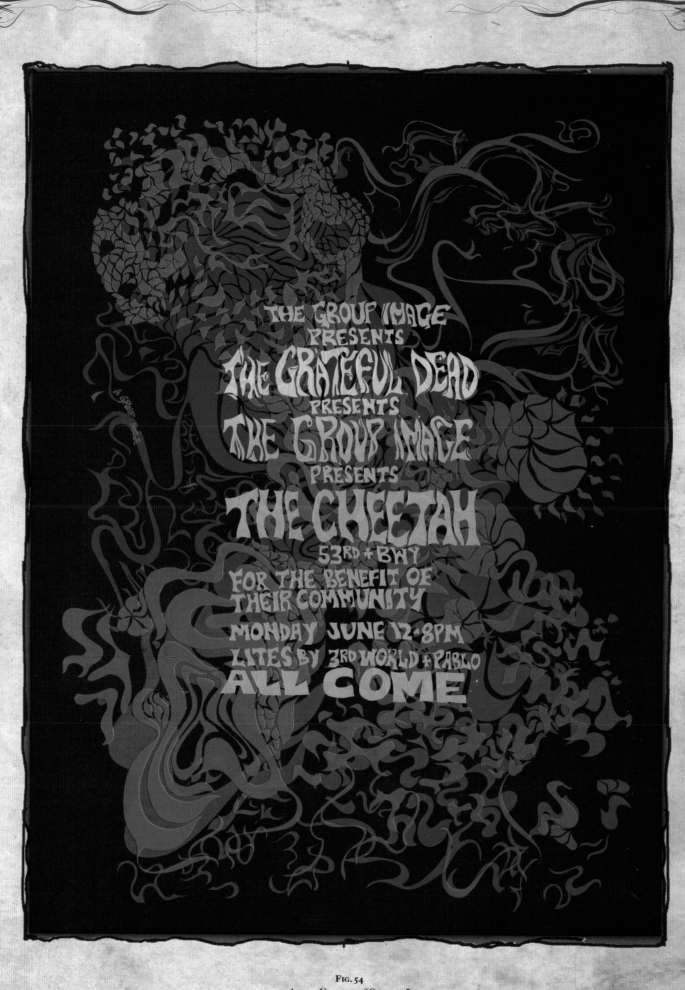

THE GROUP IMAGE
PRESENTS
THE GRATEFUL DEAD
PRESENTS
THE GROUP IMAGE
PRESENTS
THE CHEETAH
53RD & BWY
FOR THE BENEFIT OF
THEIR COMMUNITY
MONDAY JUNE 12 • 8PM
LITES BY 3RD WORLD & PABLO
ALL COME

FIG. 54
ARTIST UNKNOWN "CHEETAH"
SERIGRAPH (66.3 CM X 51.1 CM)

# MARI TEPPER

NY ANALYSIS OF Mari Tepper's work would be incomplete if one were to omit the details of her life. She found herself homeless at the age of seventeen after an argument with her tempestuous mother, which led to a life of transience and depression. Her professional career began early, and her painting was often a means of survival. This was the only way she could make enough money to support herself and her young son, who was eventually taken from her. "I was devastated, so I did art, because art is survival," Tepper told an interviewer. A painting she did for the Winterland Ballroom in 1966 reveals a cacophony of human body parts—arms, breasts, and feet all dangling loosely from some unidentifiable core—interspersed with faces displaying bewildered expressions, each a study in feminine desolation.

Fig. 55
Mari Tepper "Bill Graham No. 117"
Offset lithograph (53.5 cm x 34.1 cm)

MARI TEPPER

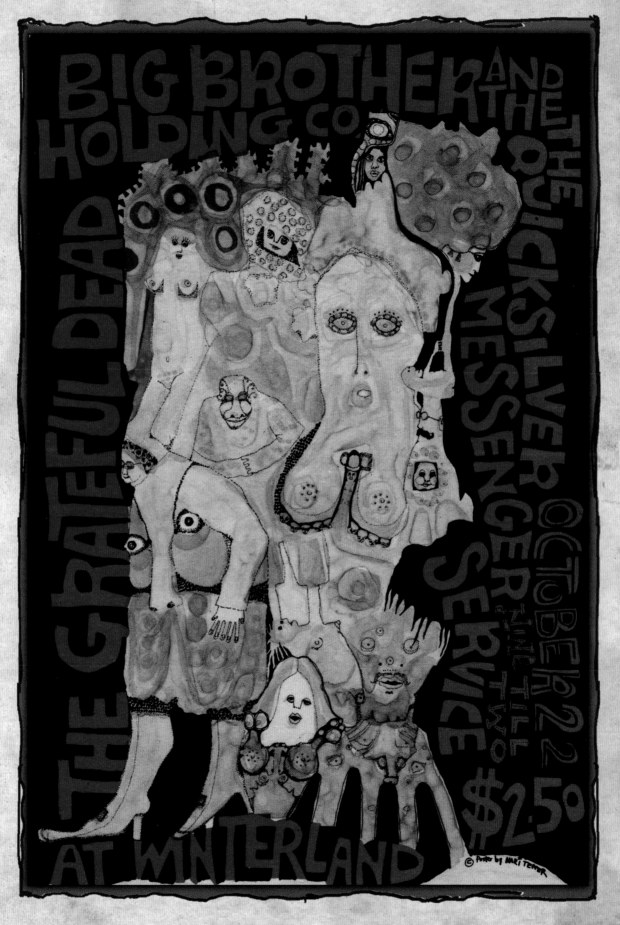

FIG. 56
MARI TEPPER "WINTERLAND, OCTOBER 22ND, 1967" (POSTCARD)
OFFSET LITHOGRAPH (16.6 CM X 11.4 CM)

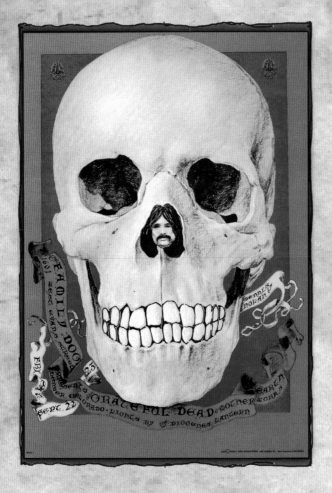

FIG. 57
DENNIS NOLAN "FAMILY DOG NO. 82"
OFFSET LITHOGRAPH (50.8 CM X 35.5 CM)

"*The Skull poster was made for a Family Dog concert at the Denver Ballroom. I wanted to use a big, simple image to make as bold a statement as possible through a strong visual. San Francisco posters in the sixties were blending imagery, lettering, and color in new ways, with a disregard for easy legibility in favor of an interesting and arresting design. I thought it would be fun to work the lettering into the design so it was fairly hidden and not at all obvious, but still able to be discovered. I remember wanting to use the skull to fill the poster; and then Pigpen's image in the nose and the Grateful Dead lettering in the teeth were instantaneous inspirations that fit perfectly.*"

—*Dennis Nolan*

"*I drew the skull on gray paper with white chalk and a Pentel pen and worked with the printer on the color separations. I can't remember if I cut Rubylith, or worked with ink on blue-line, or if the printer prepared everything with my instructions. I had worked in all of those ways on various posters. I do remember being paid $100 for the poster, but I was an art student and having a big poster printed was more thrilling than the money. The posters of the time were like little events that had their own separate lives beyond the concerts they advertised and it was fun to be part of that.*"

—*Dennis Nolan*

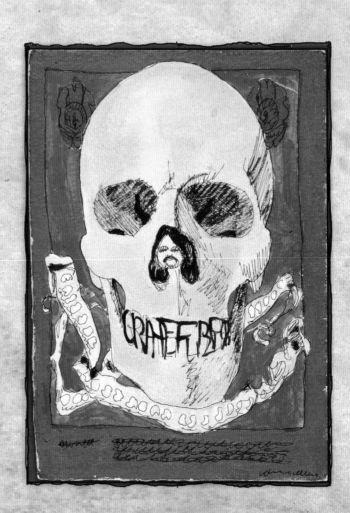

FIG. 58
DENNIS NOLAN "FAMILY DOG NO. 82" (ORIGINAL SKETCH)
PAINT ON ILLUSTRATION BOARD (17.9 CM X 12.8 CM)

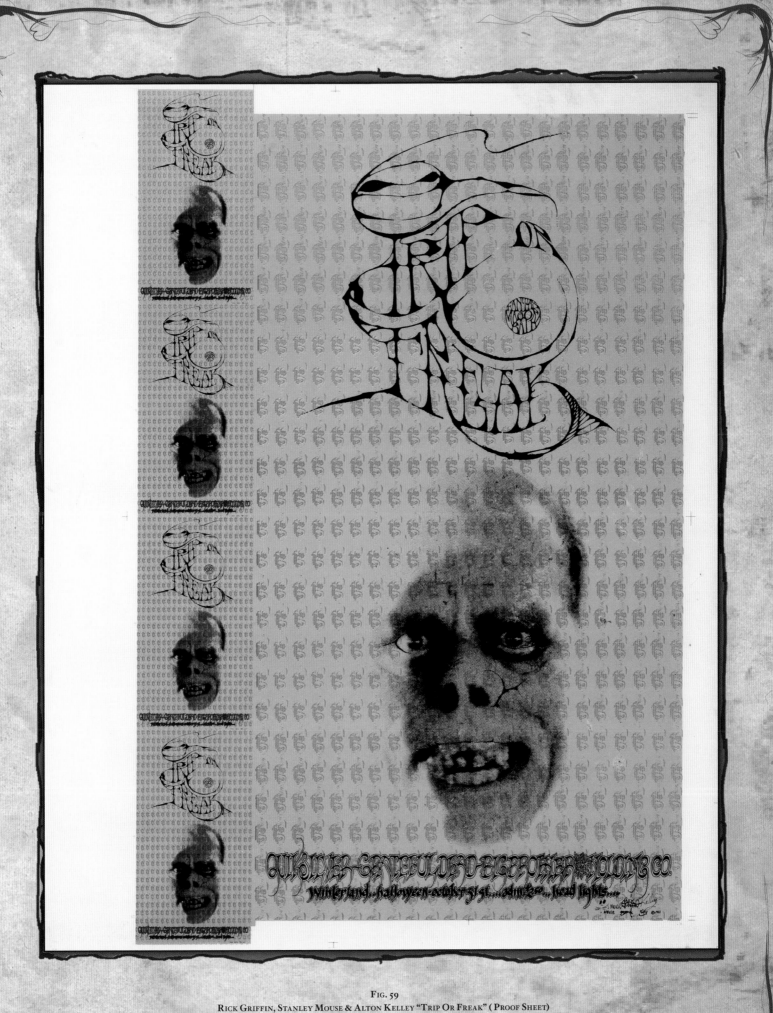

FIG. 59
RICK GRIFFIN, STANLEY MOUSE & ALTON KELLEY "TRIP OR FREAK" (PROOF SHEET)
OFFSET LITHOGRAPH (72 CM X 58.1 CM)

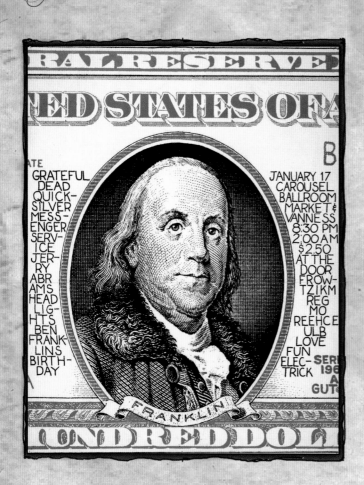

"Allen 'Gut' Terk is a man with a peripatetic and varied life: a former Hell's Angel, Merry Prankster, manager of Blue Cheer and a self-taught artist. To create this piece (for a show that took place on Ben Franklin's Birthday), Gut used a photostat from a one hundred dollar bill. Note how Blue Cheer is spelled backwards."

—Phil Cushway

"The posters featured on this page spread are from The Carousel Ballroom, once a swing-era dance hall that was re-opened by the Grateful Dead and the Jefferson Airplane. In July, 1968 Bill Graham took over the operation and reconfigured it into what would be known as The Fillmore West."

—Phil Cushway

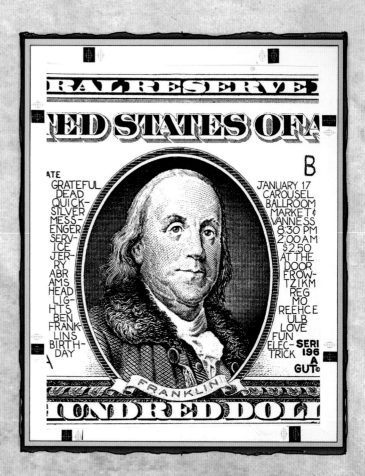

FIG. 62
PATRICK LOFTHOUSE "MEDALS"
OFFSET LITHOGRAPH (56.2 CM X 33.1 CM)

73

# NOTICE!

## TOUR OF THE GREAT PACIFIC NORTHWEST

## THE GRATEFUL

# DEAD

## AND THE

## QUICKSILVER

## MESSENGER SERVICE

### Sun., Feb. 4
So. Oregon College Gym

Ashland   8 - 12   2.50 adv.   3.00 door

## HEADLIGHTS BY JERRY ABRAMS

THE BINDWEED PRESS, SAN FRANCISCO

FIG. 63
GEORGE HUNTER "NOTICE"
OFFSET LITHOGRAPH (50.6 CM X 32.2 CM)

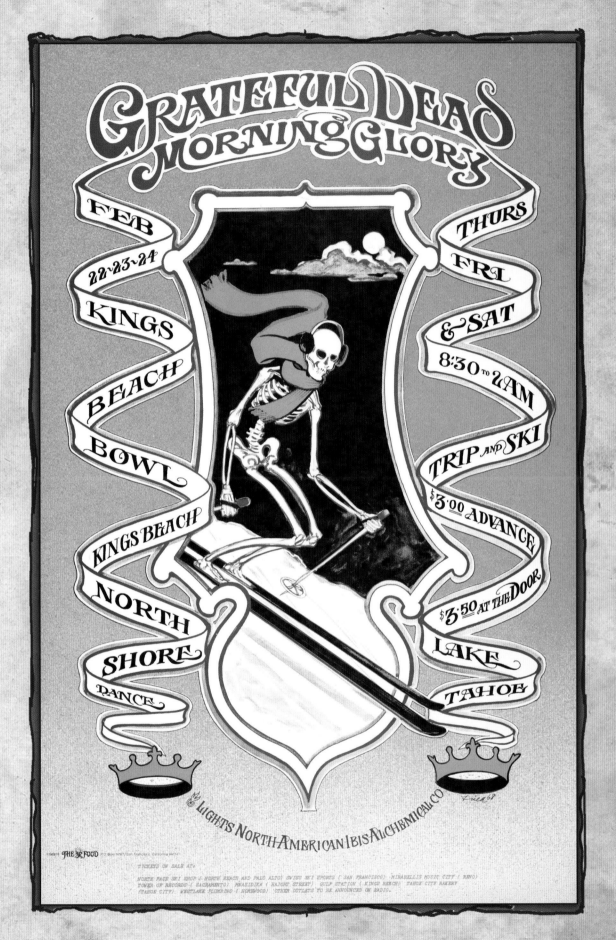

FIG. 64
BOB FRIED "TRIP OR SKI"
OFFSET LITHOGRAPH (55.8 CM x 36 CM)

FIG. 65
ALTON KELLEY "SORE THUMB"
OFFSET LITHOGRAPH (72.8 CM X 57.9 CM)

*"The posters had to work. There were no posters for anything else. There was a vacuum there. The whole period was a vacuum, a breakaway from naiveté. They worked because the radio wasn't happening yet. The posters were the only form of communication."*

*—Alton Kelley*

*"We had free rein to just go graphically crazy. Where before that, advertising was pretty much just typeset with a photograph of something. It was a furious time, but I think most great art is created in a furious moment."*

*—Alton Kelley*

FIG. 66
ALTON KELLEY "SORE THUMB" (BLUE LINE)
BLUE LINE ON BOARD (50.7 CM X 38.2 CM

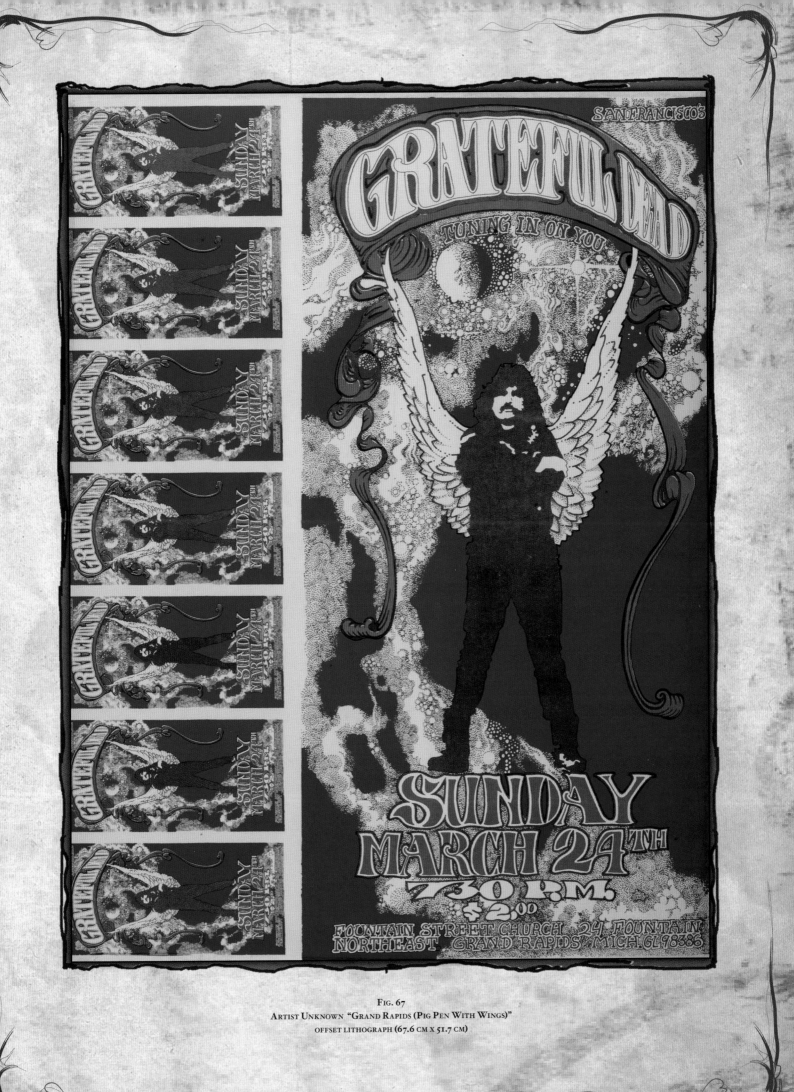

FIG. 67
ARTIST UNKNOWN "GRAND RAPIDS (PIG PEN WITH WINGS)"
OFFSET LITHOGRAPH (67.6 CM X 51.7 CM)

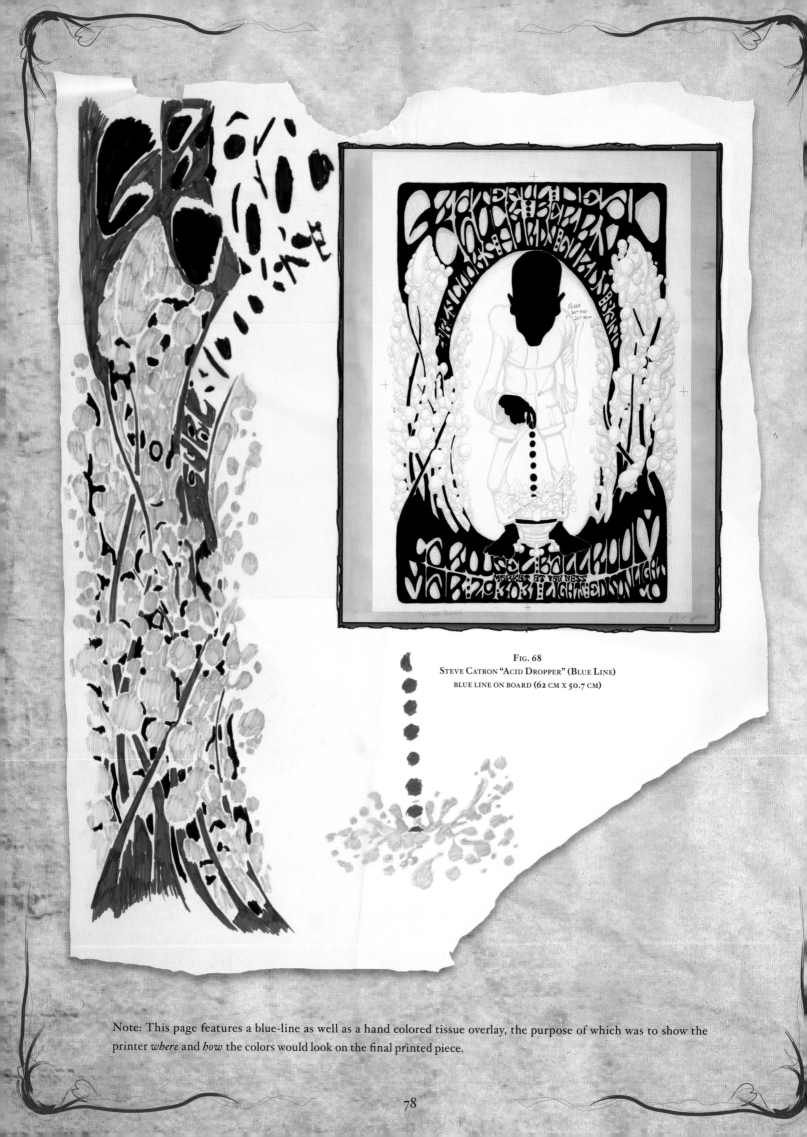

**Fig. 68**
**Steve Catron "Acid Dropper" (Blue Line)**
Blue Line on Board (62 cm x 50.7 cm)

Note: This page features a blue-line as well as a hand colored tissue overlay, the purpose of which was to show the printer *where* and *how* the colors would look on the final printed piece.

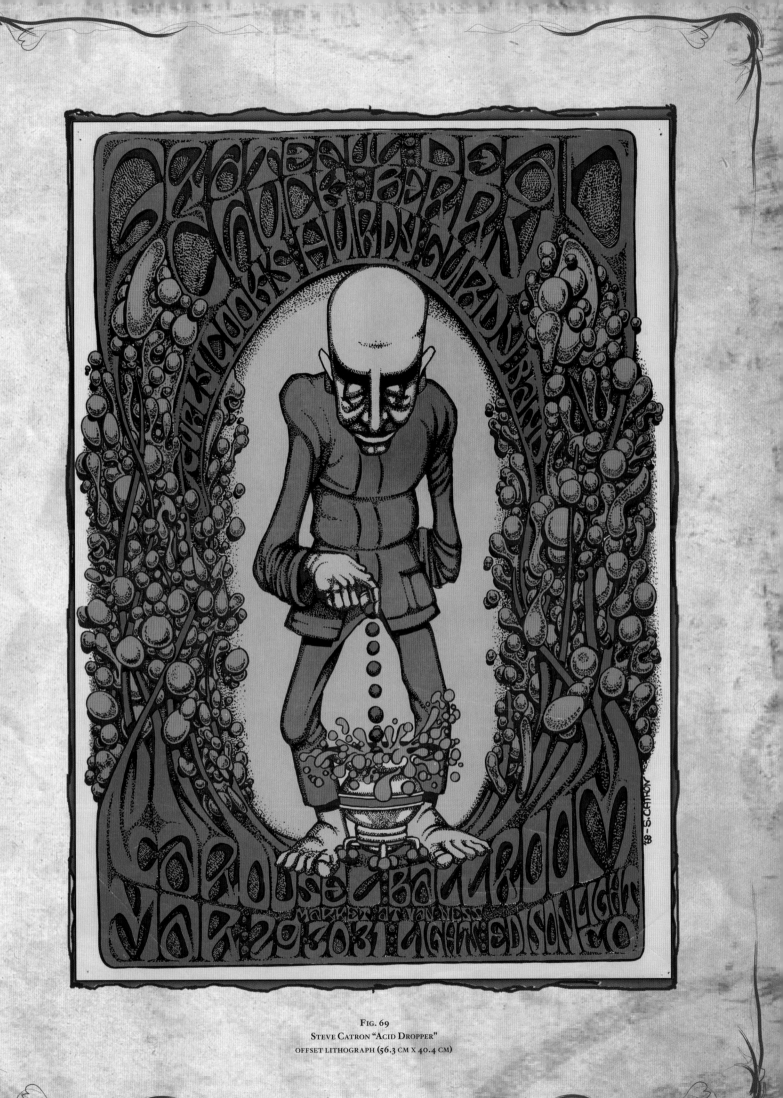

FIG. 69
STEVE CATRON "ACID DROPPER"
OFFSET LITHOGRAPH (56.3 CM X 40.4 CM)

# LEE CONKLIN

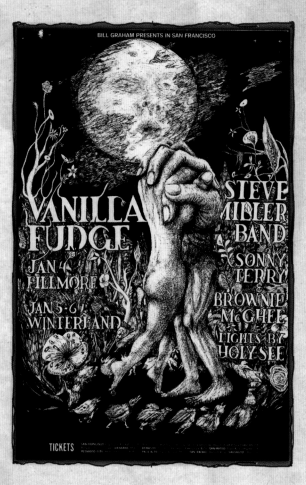

LEE CONKLIN WAS born July 24, 1941, in Englewood Cliffs, New Jersey. Lee first moved to Los Angeles in 1996 after returning from military service as a cook in the Korean War. There he found work as a security guard in an airplane factory and spent long hours sketching everything from cartoon animals to erotic scribbles of nude women. In 1968, determined to become an artist, he moved to San Francisco.

Conklin, who had never received formal art training, developed a disciplined eye, paying attention to the smallest details in his posters while developing a preoccupation with the human form. His signature graphic style is an explosion of tiny embedded images, skillful lettering, and a reverence for the understated power of black and white. "It was a Friday night in February," Lee Conklin remembered. "I went into the Fillmore with my drawings, and Bill Graham just liked what he saw. He needed a poster done that weekend for the following week's show, so I went to work adding lettering to a drawing I had already done." The encounter was the beginning of a working relationship that produced more than thirty posters.

Asked to describe his technique for creating art, Conklin said, "What I look for the most is that feeling of being really involved in what you're doing . . . you get a groove on sometimes and that's nice to have so it's like exercising and getting those endorphins. I guess there's an art endorphin too."

FIG. 70
LEE CONKLIN "CLASPING HANDS" (POSTCARD)
OFFSET LITHOGRAPH (17.8 CM X 11.7 CM)

"BILL GRAHAM NO. 139"
(CARD) OFFSET LITHOGRAPH
(17.8 CM X 11.2 CM)

"BILL GRAHAM NO. 142"
OFFSET LITHOGRAPH
(54 CM X 35.8 CM)

"BILL GRAHAM NO. 109"
(CARD) OFFSET LITHOGRAPH
(17.5 CM X 11.8 CM)

"BILL GRAHAM NO. 125"
OFFSET LITHOGRAPH
(55.7 CM X 35.6 CM)

"BILL GRAHAM NO. 153"
OFFSET LITHOGRAPH
(72 CM X 53.4 CM)

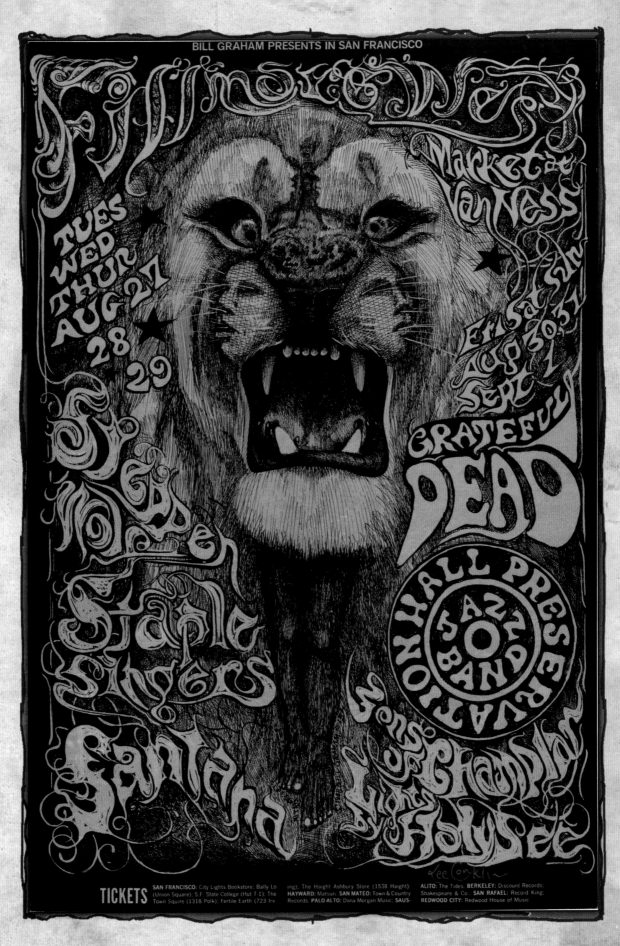

FIG. 71
LEE CONKLIN "THE LION"
OFFSET LITHOGRAPH (53.3 CM X 35.7 CM)

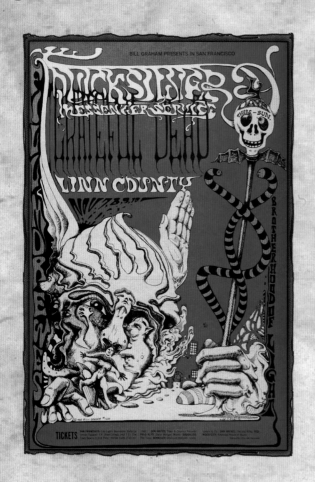

"It says 'Quicksilver' at the top and then 'The Grateful Dead' in black, hanging off of the Quicksilver lettering. That was another Bill Graham change. I was proud of my Quicksilver lettering and wasn't sure who was going to be second billing. The drawing was done and there was Mercury down below there and now I had to figure out how to give Grateful Dead equal billing, so I draped them on top of the drawing I already had of Quicksilver and then put a skull on top of it for the Dead."

—Lee Conklin

"Lee Conklin's 'New Year's Eve' piece for Dec. 31, 1968, shows countless bodies oozing through an hourglass, evoking Dante's "Inferno" and the Vietnam War's My Lai massacre, which had happened that year. Are America's youths, once so convinced that they could build a new world, now watching time run out like the imperiled Dorothy sitting in the witch's castle in The Wizard of Oz? 'No question, that poster reflected a kind of dissolution with the political image of America the beautiful,' Conklin recalls. 'All of these things had been shattered.'"

—Joel Drucker

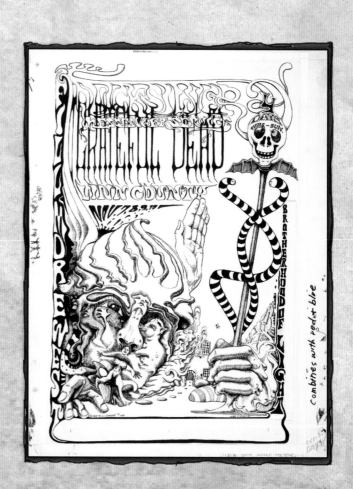

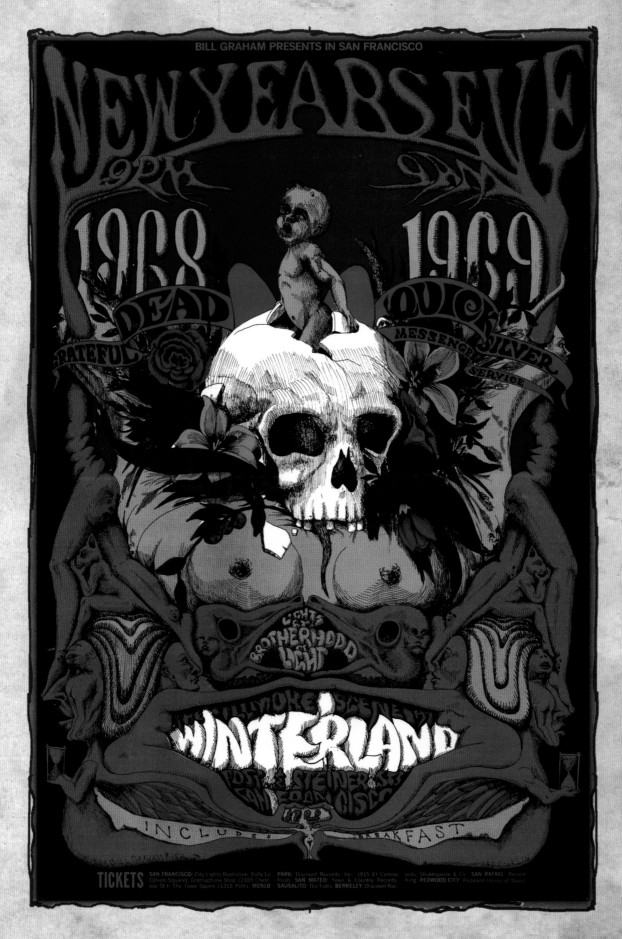

FIG. 74
LEE CONKLIN "BILL GRAHAM NO. 152"
OFFSET LITHOGRAPH (53.7 CM X 35.6 CM)

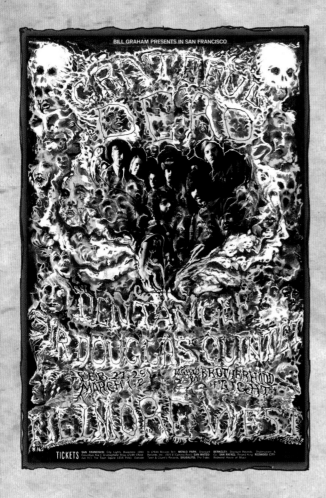

FIG. 75
LEE CONKLIN "BILL GRAHAM NO. 162" (ORIGINAL ART)
STAT AND INK ON ILLUSTRATION BOARD

*"Illegibility was a goal that I did not invent but remained
faithful to. I had always loved lettering but was alienated
from the world of advertising, and still am. I don't want to
sell anything, music being the exception, although
art was why I worked so hard."*

—*Lee Conklin*

*"If 'the Big Five' had been 'the Big Six,' Lee Conklin
would have surely been amongst them. With Conklin, I
find the original art is much more impressive than the final
printed piece. This page allows for the comparison of the
original art and the published poster. Look at the exquisite
detail on the original art—the myriad faces, delicate and
detailed, each cramped face with its own emotion."*

—*Phil Cushway*

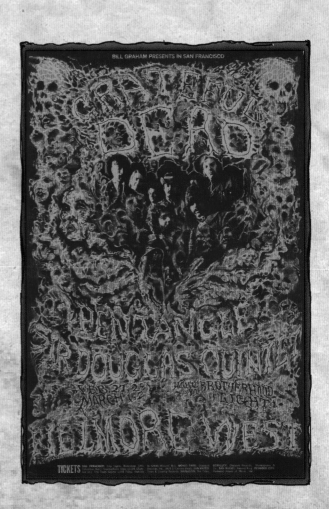

FIG. 76
LEE CONKLIN "BILL GRAHAM NO. 162"
OFFSET LITHOGRAPH (53.4 CM X 35.6 CM)

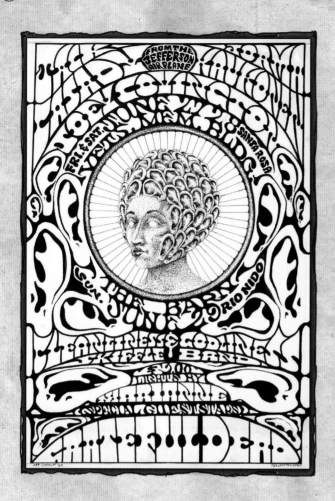

*"If you look closely at Fig. 78, you may notice there is a crease along the middle of the poster; this is because this particular poster was once housed inside a printing docket—a large envelope, which lists the specifics of a print job (quantity printed, specific paper used, date printed, run-time, cleanup time, etc cetera) and usually contains a folded sample of the final printed piece for reference."*

—Phil Cushway

*"The posters were ripped off the walls as soon as they were posted. I was so happy to be sharing my art with my contemporaries without first earning the approval of the art world snob set, but I was also hoping my art would outlive my body."*

—Lee Conklin

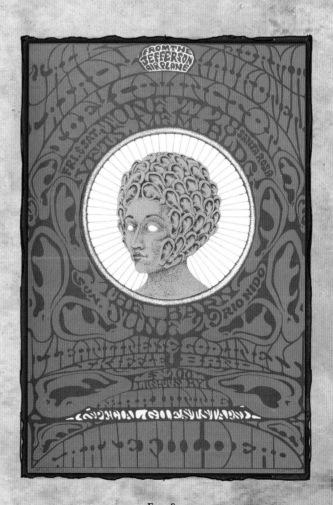

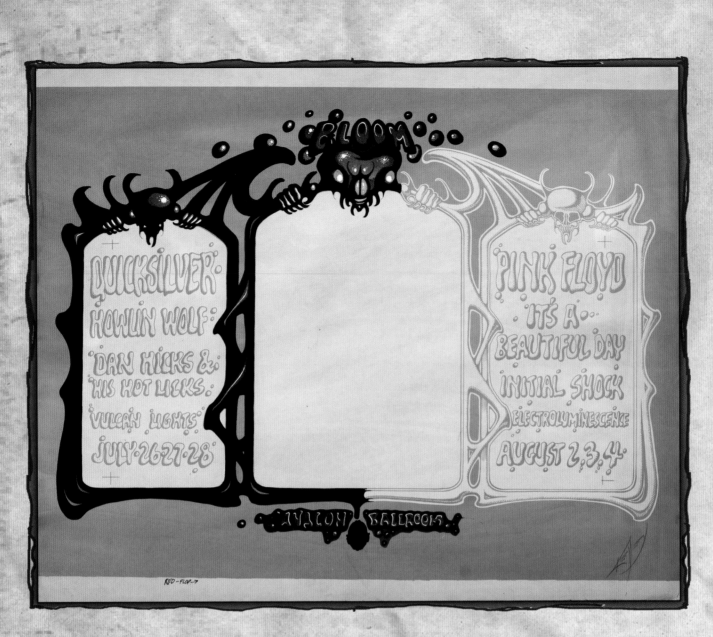

FIG. 79
RICK GRIFFIN "AVALON BALLROOM, JULY 26TH, 1968"
BLUE-LINE ON BOARD (76.4 CM X 61 CM)

A BLUE-LINE is the illustration board where the original art is usually first shot, which is done using non-reproductive blue ink. It is then hand-inked by the artist—in this case Rick Griffin. (Griffin did the lettering and the border while Kelley did the collage that appears in the center of the final printed piece.)

I was startled when I first looked at this piece—the blue-line was obviously for Bill Graham No. 133, but the bands featured on it do not match the actual poster. The Family Dog was running low on funds by this time, and they were now producing their posters as inexpensively as possible by using a single ink color on white paper. The bands listed on this blue-line are the same line-ups as on Family Dog posters No. 130 and No. 131. The financial problems at The Family Dog prompted Griffin and Kelley to take this image to Bill Graham, who then used it to publish the poster shown on the opposite page.

Some artists paint, some artists draw, and still others do sculpture. Kelley did collages—beautiful, intricate collages composed of disparate elements that pull together in an aesthetic embrace.

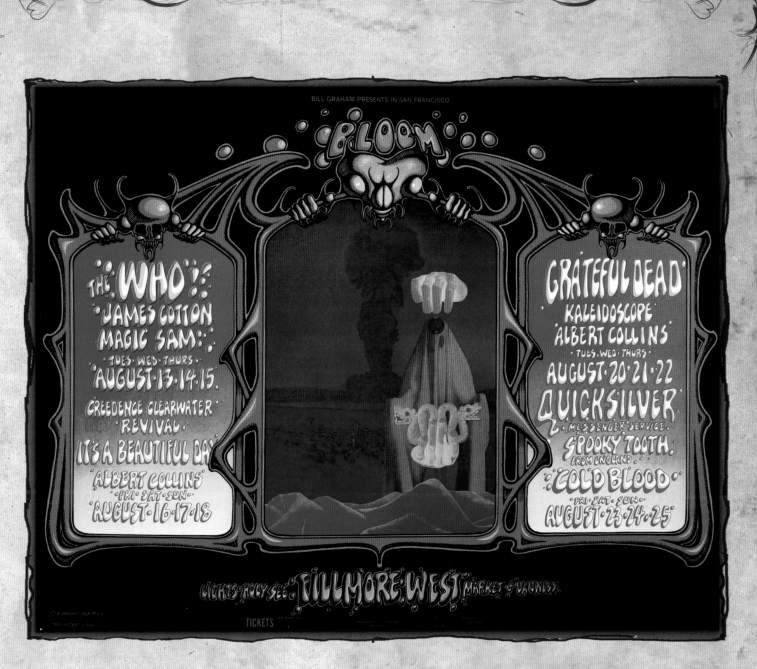

FIG. 80
RICK GRIFFIN & ALTON KELLEY "BILL GRAHAM NO. 133"
OFFSET LITHOGRAPH (72.2 CM X 55.8 CM)

"Kelley's collage posters are McLuhanesque montages of images
whose Surrealism is closer to Maxfield Parrish than Magritte."

—Thomas Albright

# AOXOMOXOA

**R**ICK WAS FOND of words and mystical associations. Here he uses a palindrome, but not just any type of palindrome. This one can also be read in a mirror. Ida, Rick's wife, was an artist herself and was often present, or involved, while Rick worked on his art. Here she talks about "Aoxomoxoa," its creation and symbolism:

*"When Rick used to work here he started at the top and just drew. It wasn't planned out—he didn't make sketches. With "Aoxomoxoa" he started at the top doing the Egyptian winged serpent, first the picture and then the lettering. When it was time to work on the lettering, he just sat down and concentrated on each letter, the outline first, and then the drop shadow, using his Rapidograph pen."*

—*Ida Griffin*

At my gallery, ArtRock, different people come in wanting to see different things. Fans ask to see pieces featuring their favorite bands. Collectors want to see the valuable and rare pieces. And then there are the artists; they don't care about the bands or about the commercial value of the art. What the artists want to see are process materials—things like sketches, plates, film, and original art—condition does not matter.

For example, one day Malleus (a trio of talented Italian artists) came by my gallery. They were interested in Rick Griffin's work, so I decided to show them a piece of film from "Aoxomoxoa," which Rick had deliberately hand scratched in a way so as to create the textured effect he wanted for the sun. I was worried I had bored them. As it turned out, they were not bored at all. *That* was what interested them.

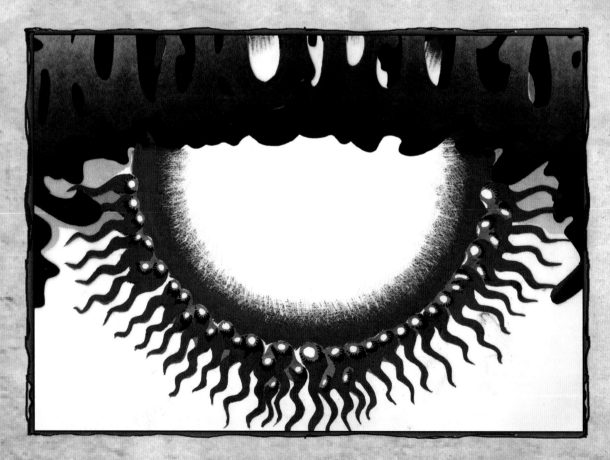

FIG. 81
RICK GRIFFIN "AOXOMOXOA"
FILM (76.1 CM X 65.7 CM)

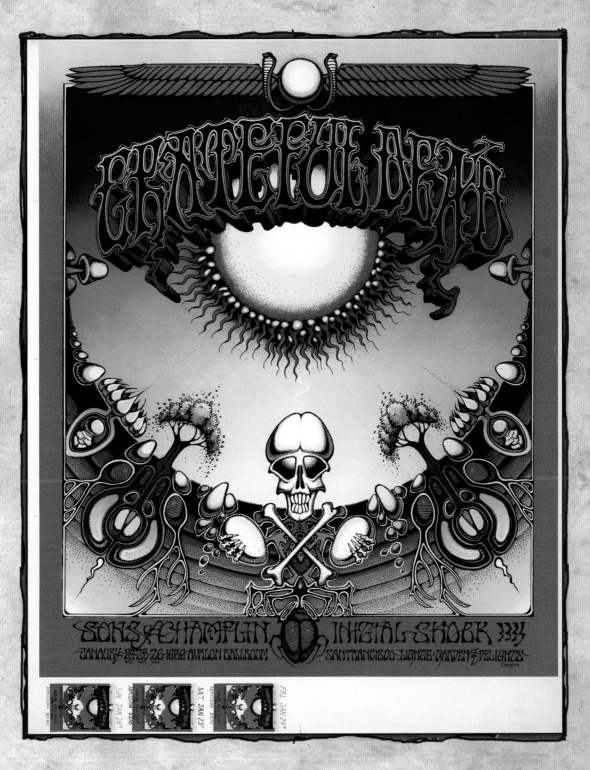

FIG. 82
RICK GRIFFIN "AOXOMOXOA" (UNCUT SHEET)
OFFSET LITHOGRAPH (73.6 CM X 58.6 CM)

*"Rick was a surfer so he loved the sun and we were having our first child so we were studying natural childbirth.
In a way, the whole thing is about reproduction and birth, life and death. It's very symbolic. We were also
studying tantric art—Tibetan art—so that kind of has a mandala look to it. The mandala (the circle) was
coming into everybody's visual through Eastern art. To me it's just nature. Loving nature."*

—*Ida Griffin*

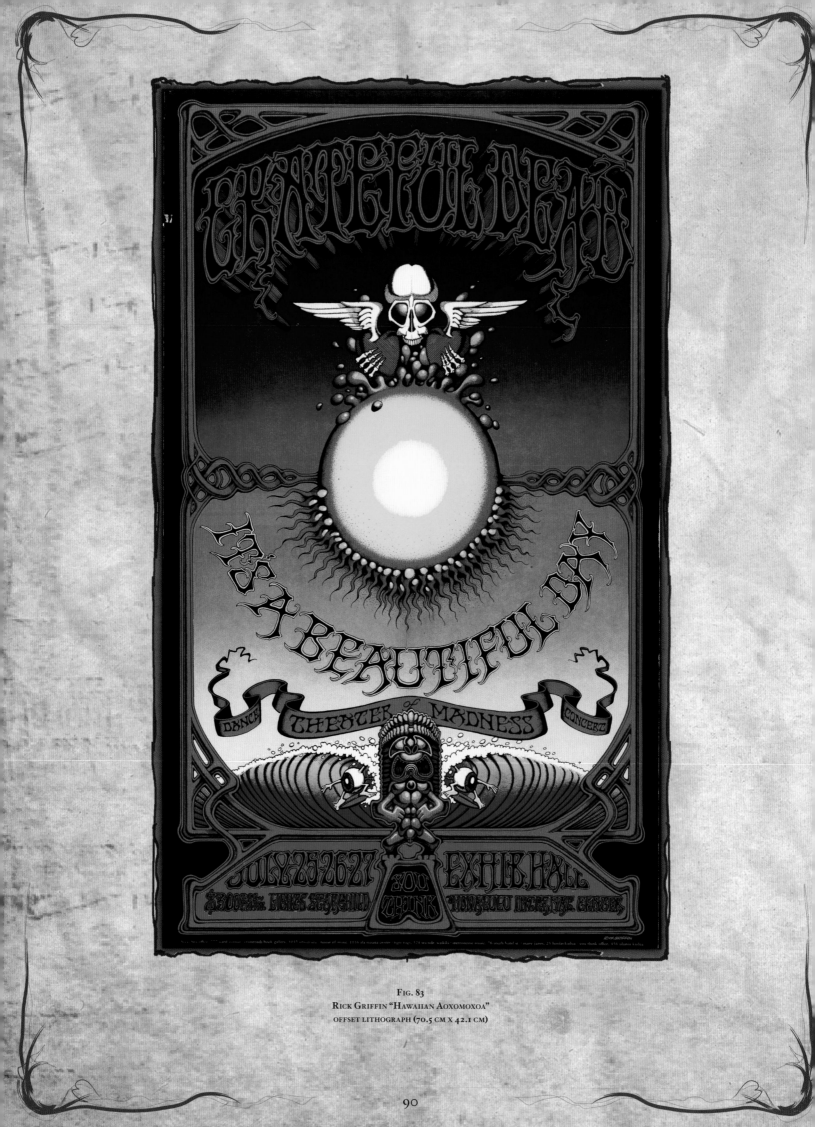

Fig. 83
Rick Griffin "Hawaiian Aoxomoxoa"
offset lithograph (70.5 cm x 42.1 cm)

FIG. 84
ARNOLD SKOLNICK "WOODSTOCK"
OFFSET LITHOGRAPH (62.1 CM X 45.6 CM)

# DAVID SINGER

D AVID SINGER CAME to San Francisco in 1964 as a sailor with the United States Navy and stumbled into the city's counterculture with its rebellious appeal and raucous music and art scene. Though Singer yearned to be an artist, he rejected the idea of art school. Instead, he prepared a portfolio of his collages and walked into Bill Graham's office; Graham hired him that same day to create a poster for the weekend show.

It is unclear whether Singer chose collage as his medium or if it chose him. What is clear is that, as a collagist, he found an unexpected freedom of form. Singer's reverence for sacred geometry goes some way towards explaining his mastery of this art style. The individual images in his work appear to divide and multiply like new cells, each image aesthetically dependent upon the last to survive.

When asked about his predilection for geometrical shapes as the underlying and invisible templates that form the foundation of all his creations, Singer explains the magical qualities of triangles and numbers, circles and symmetry as keys to visual stimulation. A typical Singer collage often emerged from a collection of his observances and remembrances. A work could have been inspired, for instance, from a stroll in a San Francisco park or an early memory of his childhood in the Pennsylvania Dutch countryside, with its abundant Amish and Mennonite folk art. Underneath each vivid image, the celestial and the earthbound collide in what Singer calls "the natural order."

FIG. 85
DAVID SINGER "MOSES" (POSTCARD)
OFFSET LITHOGRAPH (18.1 CM X 11.3 CM)

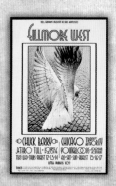

"BILL GRAHAM NO. 244"
(CARD) OFFSET LITHOGRAPH
(17.8 CM X 11.7 CM)

"BILL GRAHAM NO. 235"
(CARD) OFFSET LITHOGRAPH
(17.9 CM X 11.7 CM)

"BILL GRAHAM NO. 221"
(CARD) OFFSET LITHOGRAPH
(17.7 CM X 11.3 CM)

"BILL GRAHAM NO. 214"
(CARD) OFFSET LITHOGRAPH
(18.1 CM X 11.7 CM)

"BILL GRAHAM NO. 187"
OFFSET LITHOGRAPH
(55.8 CM X 35.4 CM)

FIG. 86
DAVID SINGER "TULIPS (TWO LIPS)"
OFFSET LITHOGRAPH (56 CM X 35.6 CM)

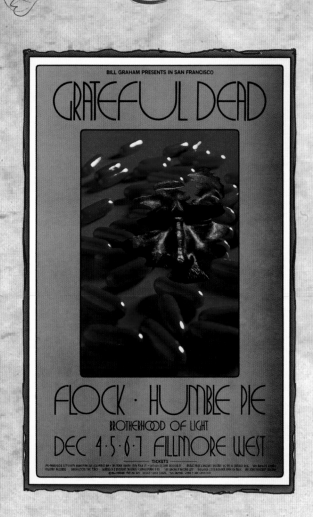

"This little man with no skin is running towards the gateway into the cosmos. The collage does have a certain LSD mystique. It's one of the most psychedelic posters I did. I had gone to a lot of Fillmore shows, and I had seen Griffin's, Mouse's and Moscoso's art and thought it was great. But I didn't really see myself doing rock poster art. My collages were kind of intellectual. I saw them as visual poems. If you're really into your art, it becomes a vehicle for discovery."

—David Singer

"The interesting thing about the Grateful Dead is the name itself. It's in the name. Some names just evoke imagery and I can't think of any other band that had the imagery of death in their name that was kind of unique. The name Grateful Dad was about life and death at the same time. A meeting of aligned and opposing forces, that's what Grateful Dead is about."

—David Singer

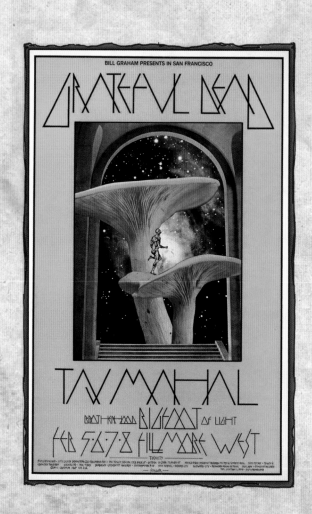

GRATEFVL DEAD

FILLMORE WEST

JVNE 4.5.6.7

LIGHTS BY • DR. ZARKOV

NEW RIDERS OF THE PVRPLE SAGE

SOVTHERN COMFORT

FIG. 89
DAVID SINGER "BILL GRAHAM NO. 237" (ORIGINAL ART)
MIXED MEDIA

# BONNIE MACLEAN

T TOOK A lot of courage to become a recognized artist in the male-dominated world of rock poster art in the 1960s, but Bonnie MacLean endured. Born in Philadelphia in 1939, she moved to New York City in 1960 at the age of twenty-one, landing a job at the Pratt Institute, where she also attended a figurative drawing class. MacLean moved to San Francisco in 1964, and it was there that she met and married Bill Graham, who became the most famous rock promoter in America.

When Graham parted ways with Wes Wilson, the artist responsible for creating the first posters for the Fillmore, Bonnie took over the production of all promotional artwork. MacLean's early style evolved into variations of Medieval Gothic themes, accentuated with pointed arches and rose windows. But it was her faces that captured the most attention—young women with dazed looks, suggesting the disconnect between traditional religion and the spirituality of the sixties. In a creative arc spanning from 1967 to 1969, she produced customized works featuring Native American subjects as well as other culturally diverse themes. "What's significant," explained MacLean, "is that these posters were created with an intensity that was lived."

MacLean's tenure as a Fillmore artist ended in 1968 as new artists like Lee Conklin and Rick Griffin appeared on the rock poster scene. In 1972, MacLean returned to the East Coast and settled in Bucks County; she and Graham divorced in 1975.

FIG. 91
BONNIE MACLEAN "BILL GRAHAM NO. 99"
OFFSET LITHOGRAPH (53.5 CM X 35.5 CM)

*B. MACLEAN*

"BILL GRAHAM NO. 90"
OFFSET LITHOGRAPH
(53.4 CM X 35.6 CM)

"BILL GRAHAM NO. 66"
OFFSET LITHOGRAPH
(58.3 CM X 35.6 CM)

"BILL GRAHAM NO. 72"
OFFSET LITHOGRAPH
(53.4 CM X 35.6 CM)

"BILL GRAHAM NO. 75"
OFFSET LITHOGRAPH
(53.4 CM X 35.6 CM)

"BILL GRAHAM NO. 89"
OFFSET LITHOGRAPH
(53.3 CM X 35.5 CM)

Fig. 92
Bonnie MacLean "Bill Graham No. 100"
offset lithograph (53.6 cm x 35.6 cm)

BILL GRAHAM PRESENTS IN SAN FRANCISCO

JEFFERSON AIRPLANE
GRATEFUL DEAD
SONS of CHAMPLIN
LIGHTS: GLENN McKAY'S HEADLIGHTS

2 DAYS ONLY-FRI.+SAT.
2 OCT. 24+25 2
WINTERLAND
POST and STEINER STREETS

—Tea Lautrec Litho—

**TICKETS** SAN FRANCISCO: City Lights Bookstore (261 Columbus Ave.); The Town Squire 1318 Polk); Outside In (2544 Mission St.); **MENLO PARK:** Discount Records, Inc., (915 El Camino Real); **SAN MATEO:** Town & Country Records; **SAUSALITO:** The Tides; **BERKELEY:** Discount Records; Shakespeare & Co.; **SAN RAFAEL:** Record King; **REDWOOD CITY:** Redwood House of Music; **SAN JOSE:** Discount Records

FIG. 93
BONNIE MACLEAN "BILL GRAHAM NO. 197"
OFFSET LITHOGRAPH (53.5 CM X 35.6 CM)

I did this poster specifically for the Grateful Dead—with the skeleton hand coming out and the shell. I was trying to make it more of a spiritual thing. The image was cosmic. The shell represents the "inner" or microcosm and the galaxy represents the "outer," macrocosm, a long-standing mystical idea about man: that man stood at the center, between the macrocosm and microcosm. We looked out into infinity and then into the atoms and we were in the middle.

The thing that makes that poster really unusual is that red triangle in the middle that just pops out. The whole poster is really cool, blue black and white and then this red triangle goes "bang" right at the center. I eyeballed it at the very last minute and pasted it on. I dashed to the printer when he was stripping up the poster and I knew it needed something, so I helped Levon with the poster and I said, "I'm going to make a change." He freaked out, but I said, "it's ok." So, I went and made him leave me alone for an hour and I started cutting up triangles, with an X-Acto blade, out of the Rubylith—that orange paper they used to lay over and strip up the poster, and which becomes black when it is photographed; so, I took this paper and made a bunch of triangles, and the one that looked best I taped right at the center. Levon came back and rolled his eyes. And I said, "this is the red plate, this one triangle." He was reluctant, but I was very insistent and I had a good relationship with him, I don't think he would have let me do that had he not liked me. I think it came out great; it is very valuable now.

Death is the big mystery, and the triangle is one of the symbols that represent the mystery. They always talk about the triangle in the Christian holy trinity. Everything inactive has two: up and down, left and right, fat and thin.

When it comes to the mind, there are always opposites; we don't think in oneness, we think in polarity; but in movement one has to have three. There is a stone and an artist; but it is inspiration that turns that stone into a statue. You can have a man and a woman, that's two, but they're just a man and a woman. If you throw in a third thing— love, hate, passion . . . that's what makes it work. The triangle is one of the most powerful geometric symbols; it is the symbol of the beginning of creativity. I used to teach geometry—the symbolism in geometry—so this came out of that.

—David Singer

"It was through Bill that I met the Grateful Dead. *Jerry Garcia, their guitar player, and I hit it off great, talking about music—what they liked and what I liked—and I think we all learned something. Jerry Garcia loved jazz, and I found out that he loved my music and had been listening to it for a long time. He loved other jazz musicians, like Ornette Coleman and Bill Evans."*

—Miles Davis

**B**ill Graham put together his own line-ups for his shows, which were sometimes daring, adventurous, and unexpected. For this Fillmore show he paired the warm and welcoming Grateful Dead with the cool and aloof Miles Davis Quartet to spectacular results. Here, Miles Davis talks about the experience:

"After *Bitches Brew*, Clive Davis put me in touch with Bill Graham, who owned the Fillmore in San Francisco and the Fillmore East in downtown New York. Bill wanted me to play San Francisco first, with the Grateful Dead, and so we did. That was an eye-opening concert for me, because there were about five thousand people there that night, mostly young, white hippies, and they hadn't hardly heard of me if they had heard of me at all. We opened for the Grateful Dead, but another group came on before us. The place was packed with these real spacey, high white people, and when we first started playing, people were walking around and talking. But after a while, they all got quiet and really got into the music. I played a little of something like *Sketches in Spain* and then we went into the *Bitches Brew* shit and that really blew them out. After that concert, every time I would play out there in San Francisco, a lot of young white people showed up at the gigs."

*". . . we played a four-night stand at the Fillmore West, where we were faced with the unenviable task of following the great Miles Davis and his most recent band, a hot young aggregation that had just recorded the seminal classic* Bitches Brew. *As I listened, leaning over the amps with my jaw hanging agape, trying to comprehend the forces that Miles was unleashing onstage, I was thinking, What's the use? How can we possibly play after this? We should just go home and try to digest this unbelievable shit. This was our first encounter with Miles's new direction.* Bitches Brew *had only just been released, but I know I hadn't yet heard any of it. With this band, Miles literally invented fusion music. In some ways it was similar to what we were trying to do in our free jamming, but ever so much more dense with ideas—and seemingly controlled with an iron fist."*

—*Phil Lesh*

Fig. 90
David Singer "Bill Graham No. 227"
offset lithograph (53.3 cm x 35.3 cm)

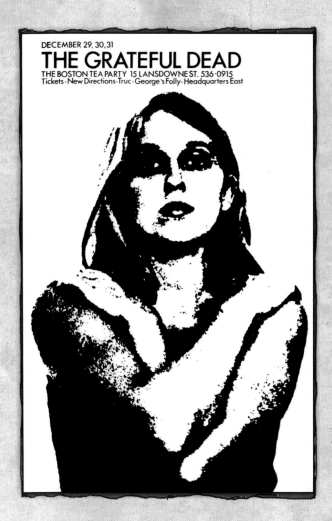

FIG. 94
BOB DRISCOLL "BOSTON TEA PARTY, DECEMBER 29TH 1969"
OFFSET LITHOGRAPH (43.2 CM X 27.9 CM)

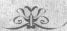

"Well, I'm a firm believer in the fact that you don't need to overkill something. You don't need a Mona Lisa every time. You don't need to do the Sistine Chapel on every job. You just got to get the best of what's it about. I believe that the simpler it is, the more people pick up on it. You have to keep in mind that no amount of planning can take the place of dumb luck. You have to do the right thing at the right time, the right symbol or image."

—Randy Tuten

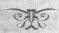

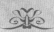

"The young lady on the poster was a fifth year museum school student who lived around the corner from me in Cambridge. I knew I would be doing a poster for the Dead, and after having made a short 8mm movie of her lying nude on a table, I told her I wanted to put her on the poster. She handed me that image of herself and I thought, 'Right on, how appropriate.' She was an unusual girl with a dramatic flair; I've never seen her since the sixties. I hope she's out there enjoying."

—Bob Driscoll

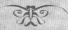

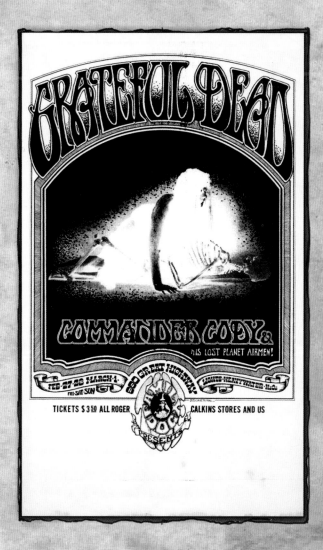

FIG. 95
RANDY TUTEN "GREAT HIGHWAY, FEBRUARY 27TH, 1970"
OFFSET LITHOGRAPH (35.6 CM X 21.7 CM)

# RANDY TUTEN

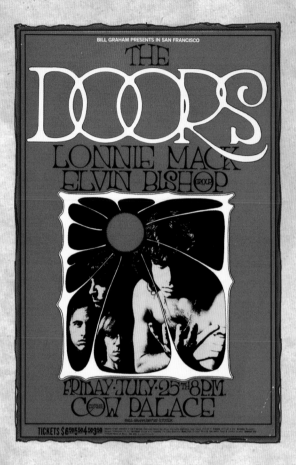

FIG. 96
RANDY TUTEN "BILL GRAHAM No. 186"
OFFSET LITHOGRAPH (55 CM X 35.4 CM)

**R**ANDY TUTEN WAS Born in San Francisco in 1946. As a young man in the sixties, he frequently hitchhiked between Los Angeles, where he grew up, and the Bay Area to see friends, hear local music or "road test" a new batch of LSD. When Tuten saw the posters Stanley Mouse and Victor Moscoso created hanging on telephone poles in San Francisco, he knew he wanted to create posters of his own.

Often the creative rebel, Tuten always followed his own instincts, and if great art emerged from his toils, all the better. But the purpose was never to create a masterpiece; for him, the goal was always to attract an audience to a show. The ironic result of this ethos, however, is an immense collection of great art.

Randy came to poster art as many of his peers did, through a chance meeting with Bill Graham. Tuten's talent for producing straightforward commercial advertising impressed Graham, so he was hired to do this kind of work.

Of his vast pool of work, one of the most eye-catching posters is the one he produced for a Grateful Dead benefit after the band was arrested for marijuana possession. According to Tuten, the poster reveals a subtle message about the dangers of the "devil weed." This poster, reminiscent of the Vietnam era, speaks to the moral confusion of a decade.

"LED ZEPPELIN"
OFFSET LITHOGRAPH
(71.1 CM X 48.3 CM)

"BILL GRAHAM No. 199"
OFFSET LITHOGRAPH
(54.5 CM X 34.7 CM)

"BILL GRAHAM No. 165"
(CARD) OFFSET LITHOGRAPH
(17.8 CM X 11.7 CM)

"BILL GRAHAM No. 203"
OFFSET LITHOGRAPH
(53.8 CM X 35.5 CM)

"BILL GRAHAM No. 155"
OFFSET LITHOGRAPH
(54.7 CM X 35.6 CM)

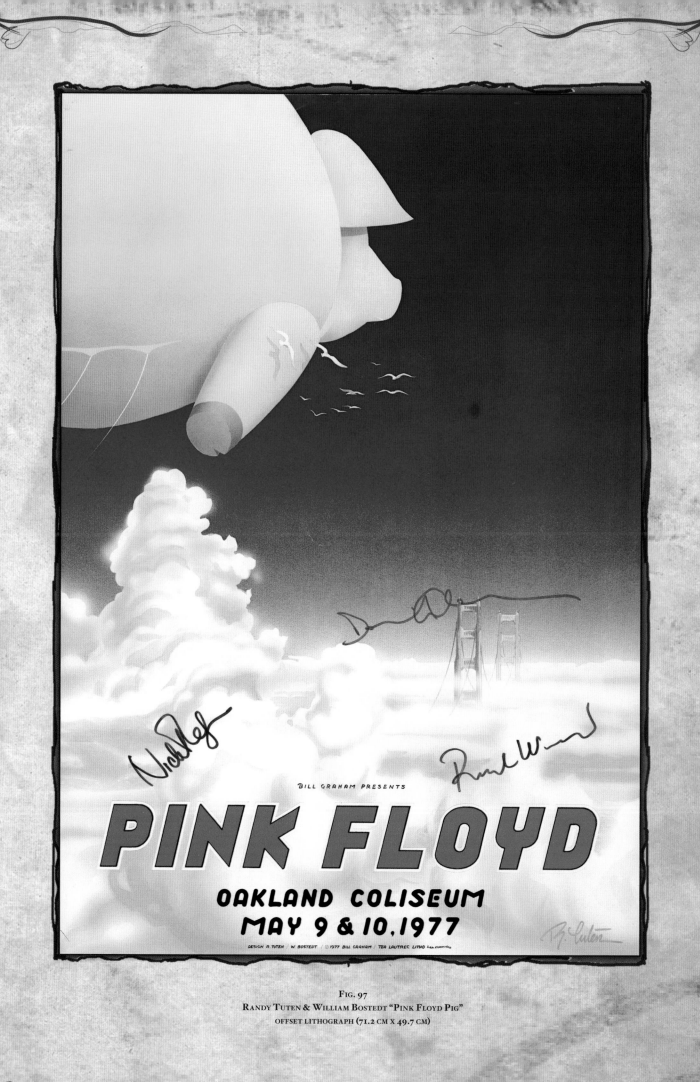

BILL GRAHAM PRESENTS

# PINK FLOYD

## OAKLAND COLISEUM
## MAY 9 & 10, 1977

DESIGN R. TUTEN / W. BOSTEDT / © 1977 BILL GRAHAM / TEA LAUTREC LITHO San Francisco

FIG. 97
RANDY TUTEN & WILLIAM BOSTEDT "PINK FLOYD PIG"
OFFSET LITHOGRAPH (71.2 CM X 49.7 CM)

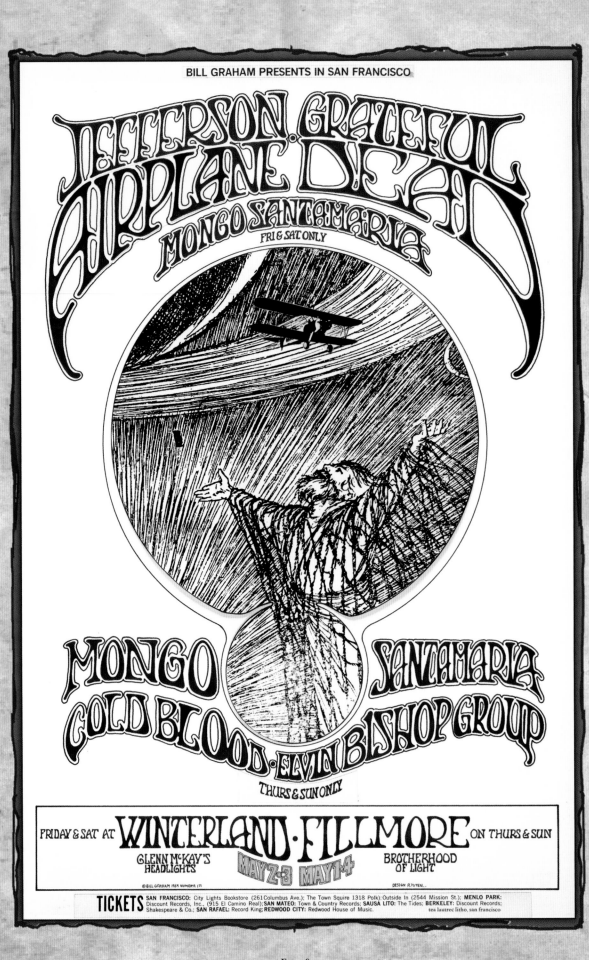

FIG. 98
RANDY TUTEN "BILL GRAHAM NO. 171" (ORIGINAL ART)

INK ON ILLUSTRATION BOARD

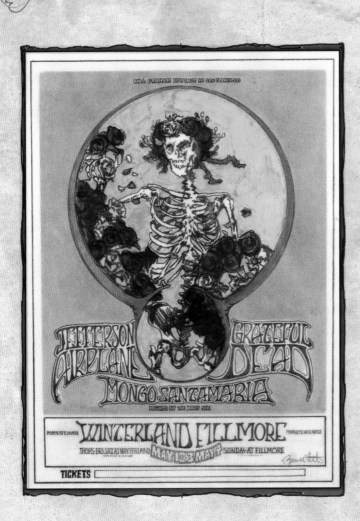

*"Now when I do lettering by hand, I'll draw it on a piece of vellum, and then again on another piece; finally, I'll turn the vellum over and make tracing paper, and then you repeat the steps. So, by the time you get ready to ink it, you've drawn it four or five times . . . it's all about making the range in motion that your hand is doing. It all flows better."*

*—Randy Tuten*

*"If you're a lettering artist, you can actually fit lettering in any shape you want. I used to contort letters and push and pull and redraw. In the old days, I actually liked doing that because by the time you finished redoing the lettering design three or four times in different shapes, your hand was working fluidly at that shape; so you had done your homework."*

*—Randy Tuten*

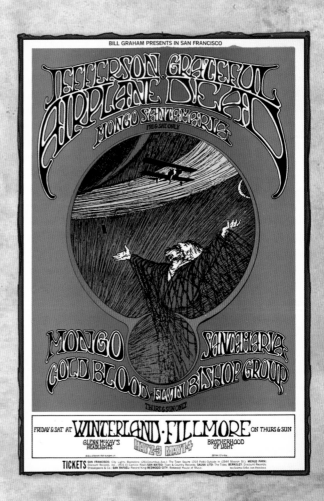

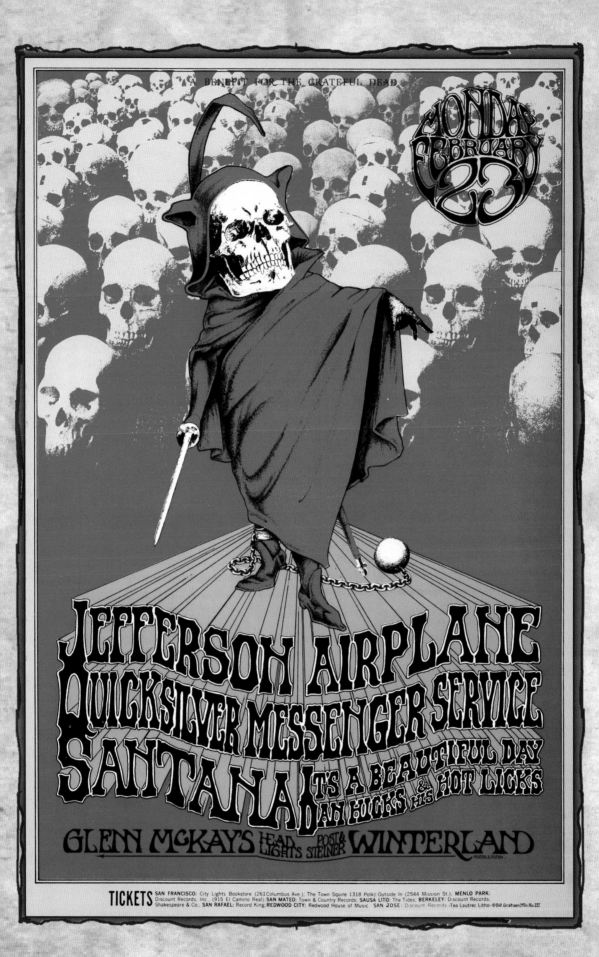

FIG. 101

RANDY TUTEN "BILL GRAHAM NO. 222"

OFFSET LITHOGRAPH (53.1 CM X 34.8 CM)

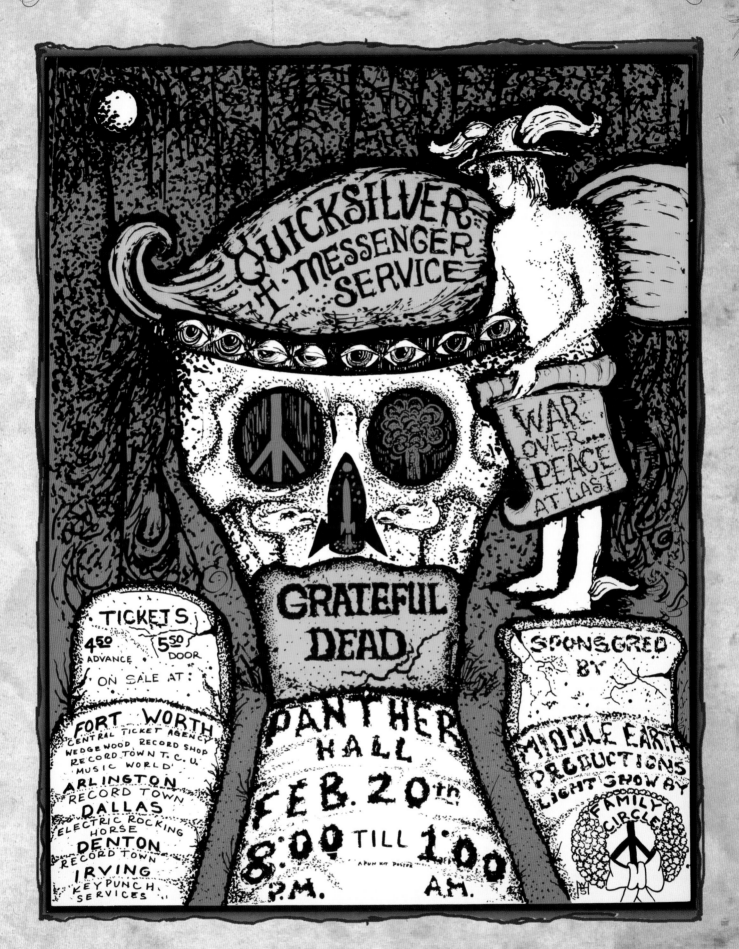

FIG. 102
BOB DRISCOLL "PANTHER HALL, FEBRUARY 20TH, 1970"
SERIGRAPH (71.6 CM X 57.2 CM)

# GUNTHER KIESER

**G**UNTHER KIESER'S ENTHUSIASM for the beautiful energy of American jazz in post-war Germany led him into the world of poster art. "The music of jazz during and after the war was the music of freedom; it was the elixir of life; it was the meaning of life," he told an interviewer. Kieser was born March 24, 1930, in Kronberg im Taunus, Germany; the early memories of his hometown were those of devastation—of stripped-down buildings and crumbling walls. And under such circumstances it was that he glimpsed his first poster. At the age of fifteen, a concert promoter asked him to create a poster for a jazz show, which he gladly agreed to do. Consequently, he began a brilliant career in graphic arts, designing many posters for the Lippmann+Rau concert agency.

In 1969, Kieser turned his gaze upon American rock when he created a poster for a Jimi Hendrix concert in Stuttgart, West Germany. He plugged directly into the heart of contemporary rock by using a photo of Jim Hendrix surrounded by dozens of multi-colored tubes encircling the singer's massive Afro.

When asked about the historical value of a 1960s rock poster, Kieser characterizes the art as being particularly representative of the time in which it was created. The psychedelic world of the sixties may have produced incoherent lettering and confusing juxtapositions of images and text. But that was exactly the point—confusing times bring forth chaotic art.

FIG. 103
GUNTHER KIESER "RETURN TO FOREVER"
OFFSET LITHOGRAPH (84 CM X 60 CM)

"GRAND FUNK RAILROAD"
OFFSET LITHOGRAPH
(84 CM X 60 CM)

"JACK BRUCE"
OFFSET LITHOGRAPH
(84 CM X 60 CM)

"MAGGIE BELL"
OFFSET LITHOGRAPH
(84 CM X 60 CM)

"THELONIOUS MONK OCTET"
OFFSET LITHOGRAPH
(84 CM X 60 CM)

"SLADE AND FANNY"
OFFSET LITHOGRAPH
(84 CM X 60 CM)

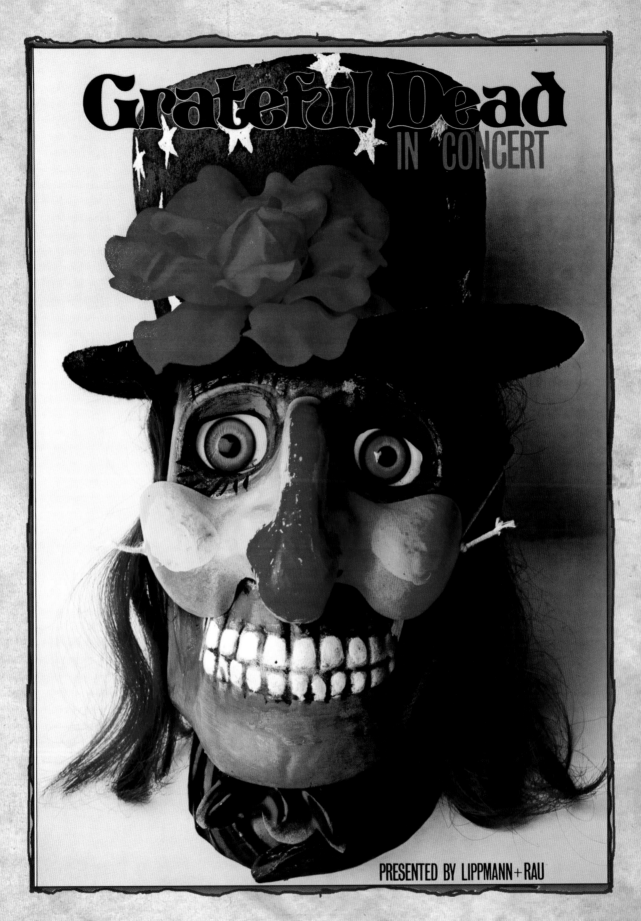

Fig. 104
Gunther Kieser "Grateful Dead"
offset lithograph (84.2 cm x 59.8 cm)

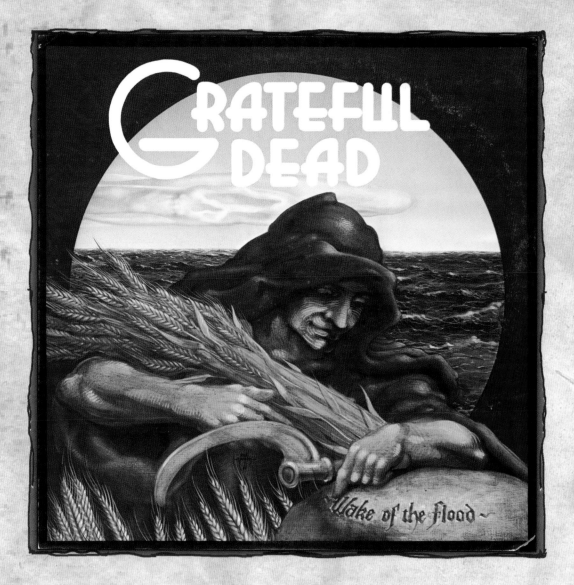

FIG. 105
RICK GRIFFIN "WAKE OF THE FLOOD" (ALBUM COVER)
OFFSET LITHOGRAPH (31.5 CM X 31.5 CM)

*"There's a lot to this one—Rick and I wanted to change the Grateful Dead image, which always had the skull and crossbones—I found a black pen and ink illustration of the grim reaper in a book—we were thinking of death, so we thought of the reaper—we didn't want some horrific looking person; we wanted to have a more gentle looking vision of the grim reaper. He had just started to oil paint and this was one of his first attempts to paint like the old masters. On top of it, we had been studying a lot of the old masters' paintings. In the back, there is a cloud with a skull in it, but you have to take the record and turn it sideways to see the skull. That idea came from an old master."*

*—Ida Griffin*

Note: The concept for this image was inspired by a line from the Book of Revelation:
*"And the sea gave up the dead which were in it; and death and hell delivered up the dead which were in them; and they were judged every man according to their works." Revelation 20:13*

"'Skeletons from the Closet' exemplifies symbolism and the psychological dreamscape of post-modernism. All the ideas of classical Italian painting—all these cultural symbols—are mixed together in a collage. It was amazing! Someone like Rick would just go, 'Oh my God, this is great! This is fantastic, how did you do this?' The arm looks like it's severed, you know? As if it was off of a mannequin. So it's very much what the recording business is, it's just an extension of something that's been broken off. And this needle is driven into this plastic surface and the vibration then is the music. The skeleton, inspired by Mouse and Kelley's 'Skeleton and Roses' is holding a record, which is a symbol of what they all want: the gold record. Then, the index finger is sort of a 'fuck you' to the industry. The image of Venus represents innocence—the beauty and the beast—a beautiful woman walking in the glistening trees."

—John Van Hamersveld

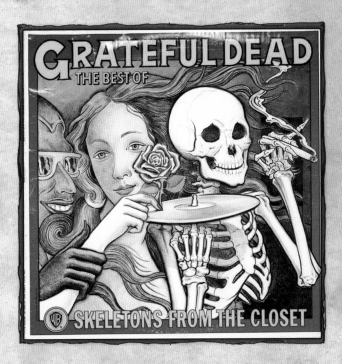

FIG. 106A
JOHN VAN HAMERSVELD & BOB SEIDEMANN "SKELETONS FROM THE CLOSET"
OFFSET LITHOGRAPH (31.5 CM X 31.5 CM)

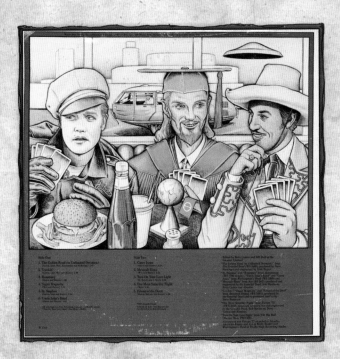

FIG. 106B
JOHN VAN HAMERSVELD & BOB SEIDEMANN "SKELETONS FROM THE CLOSET"
OFFSET LITHOGRAPH (31.5 CM X 31.5 CM)

"The Cisco Kid represents the Hispanic element, living in this fantasy of the incredible rancho-owner of the territory. Then, on the other hand, I took the white contingency and went down the pop realm of Warhol or something like that. Marlon Brando manifests, very much like James Dean, an alternate rebel. So he establishes an ideal of what we all want to be. So, the two of them are having this conversation and playing cards with Jesus Christ, who has just graduated from college again. The Café embodies the loins of this Americana thing, being this mix of American attitudes, you know, all different things that happen in cafés—like American Graffiti, the drive-in restaurant. It was the seventies. The world was a trophy."

—John Van Hamersveld

The Grateful Dead

one more saturday-
night: Dec. 8th, 7: pm
Cameron Indoor Stadium
tickets: $5, $6, same old places
Duke Union Major Attractions

FIG. 107
ARTIST UNKNOWN "DUKE UNIVERSITY, DECEMBER 8TH, 1973"
OFFSET LITHOGRAPH (55.2 CM X 35.5 CM)

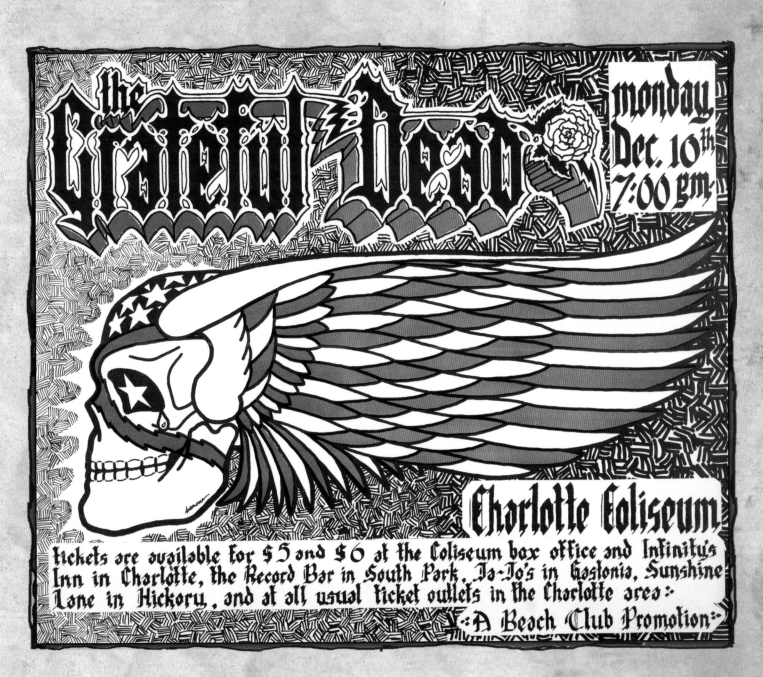

The Grateful Dead

monday
Dec. 10th
7:00 pm

Charlotte Coliseum

tickets are available for $5 and $6 at the Coliseum box office and Infinity's Inn in Charlotte, the Record Bar in South Park, Ja-Jo's in Gastonia, Sunshine Lane in Hickory, and at all usual ticket outlets in the Charlotte area.

A Beach Club Promotion

Fig. 108
Artist Unknown "Charlotte Coliseum, December 10th, 1973"
offset lithograph (44.7 cm x 54.3 cm)

BILL GRAHAM PRESENTS

THE
WHO
&
THE
GRATEFUL
DEAD

OCTOBER 9-10 OAKLAND STADIUM

Fig. 109
Philip Garris "The Who & Grateful Dead"
offset lithograph (73.7 cm x 58.6 cm)

Fig. 110
Philip Garris "Blues For Allah"
offset lithograph (57.7 cm x 55.4 cm)

FIG. 111A
STANLEY MOUSE & ALTON KELLEY "MARS HOTEL"
OFFSET LITHOGRAPH (48.2 CM X 37 CM)

FIG. 111B
STANLEY MOUSE & ALTON KELLEY "MARS HOTEL"
OFFSET LITHOGRAPH (48.2 CM X 37 CM)

FIG. 112
STANLEY MOUSE & ALTON KELLEY "ON THE ROAD"
OFFSET LITHOGRAPH (71.4 CM X 46.9 CM)

GRATEFUL
DEAD
OCTOBER 12
MANOR DOWNS
AUSTIN, TEXAS

Fig. 113
Michael Priest "Manor Downs '77"
offset lithograph (44.3 cm x 29.2 cm)

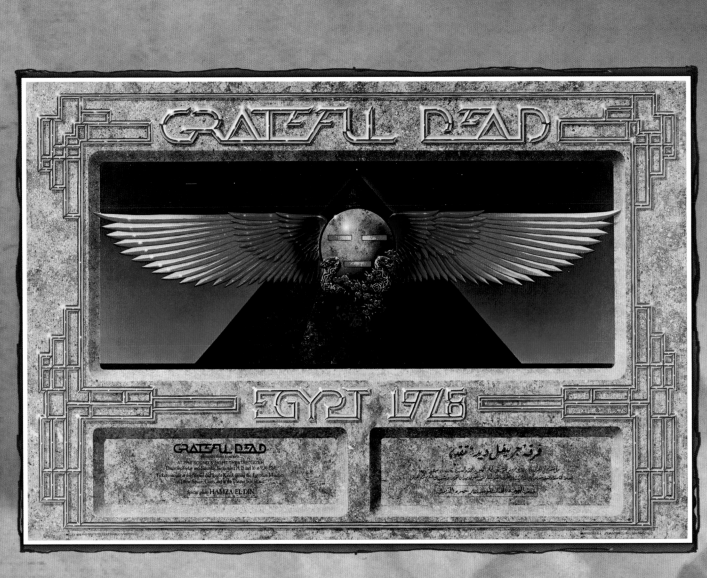

FIG. 115
ALTON KELLEY "EGYPT"
OFFSET LITHOGRAPH (51 CM X 76.2 CM)

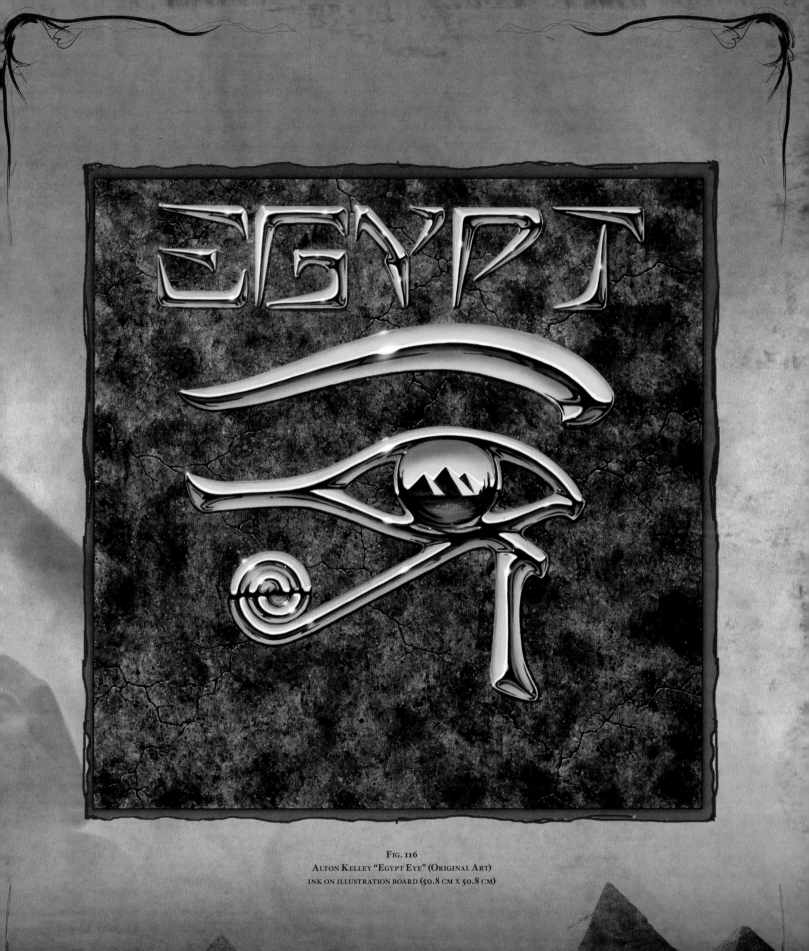

Fig. 116
Alton Kelley "Egypt Eye" (Original Art)
ink on illustration board (50.8 cm x 50.8 cm)

NORTHERN STAGE CO.

PRESENTS

# THE GRATEFUL DEAD

## ALASKA 1980

# JUNE 19, 20, 21, 7:30
# West High Auditorium

TICKETS ON SALE: TEAM ELECTRONICS IN ANCHORAGE
AND FAIRBANKS, AND AT CARR'S MALL IN WASILLA.
FOR MORE INFORMATION CALL 276-4426 EXT. 28

PAULS & RANDYS POSTERS (213) 733-1788

FIG. 117
ARTIST UNKNOWN "ALASKA"
OFFSET LITHOGRAPH (72.5. CM X 52.1 CM)

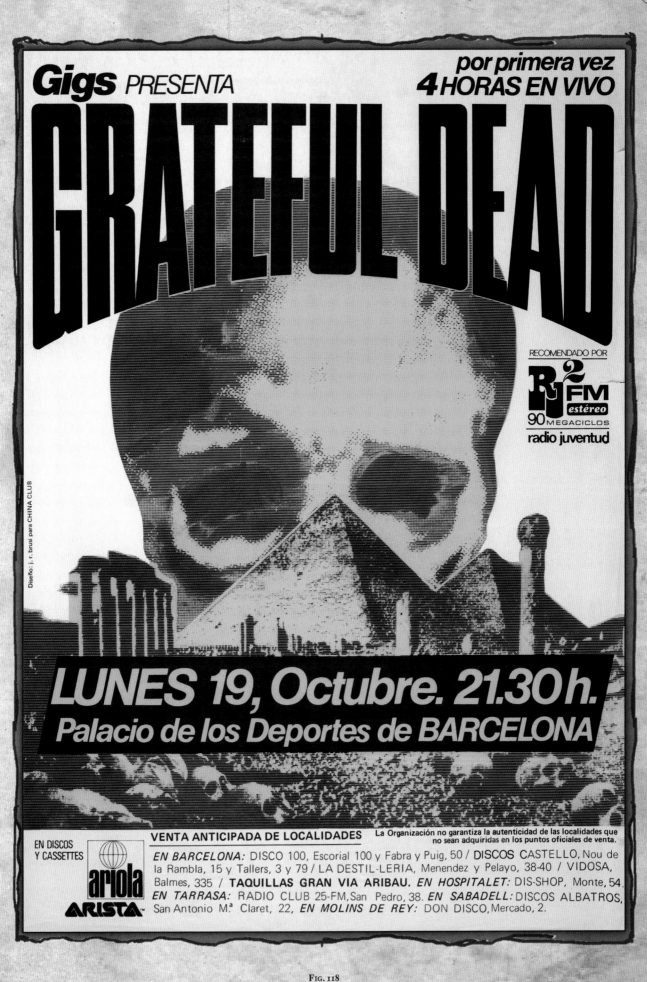

Diseño: j. r. brusi para CHINA CLUB

**Gigs** PRESENTA

*por primera vez*
**4 HORAS EN VIVO**

# GRATEFUL DEAD

RECOMENDADO POR

R2 FM estéreo
90 MEGACICLOS
radio juventud

**LUNES 19, Octubre. 21.30h.**
Palacio de los Deportes de BARCELONA

EN DISCOS
Y CASSETTES

**ariola**
**ARISTA**

**VENTA ANTICIPADA DE LOCALIDADES**   La Organización no garantiza la autenticidad de las localidades que no sean adquiridas en los puntos oficiales de venta.

*EN BARCELONA:* DISCO 100, Escorial 100 y Fabra y Puig, 50 / **DISCOS CASTELLO,** Nou de la Rambla, 15 y Tallers, 3 y 79 / LA DESTIL-LERIA, Menendez y Pelayo, 38-40 / VIDOSA, Balmes, 335 / **TAQUILLAS GRAN VIA ARIBAU.** *EN HOSPITALET:* DIS-SHOP, Monte, 54. *EN TARRASA:* RADIO CLUB 25-FM, San Pedro, 38. *EN SABADELL:* DISCOS ALBATROS, San Antonio M.ª Claret, 22, *EN MOLINS DE REY:* DON DISCO, Mercado, 2.

FIG. 118
J.R. BRUSI "BARCELONA"
OFFSET LITHOGRAPH (90.1 CM X 65 CM)

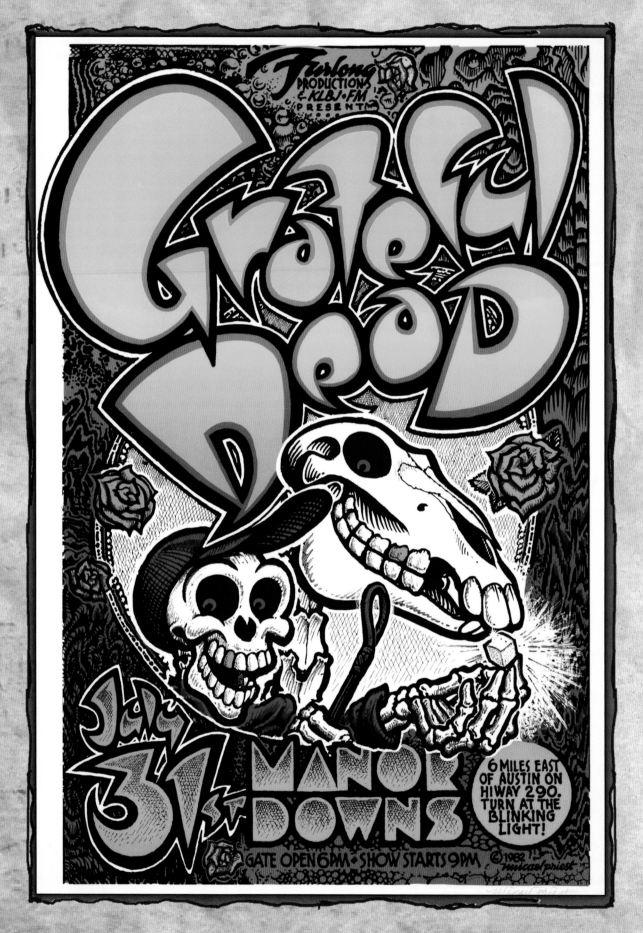

Fig. 119
Michael Priest "Manor Downs '82"
offset lithograph (41.7 cm x 28.6 cm)

CADOGAN LIMITED
PRESENTS AT
THE DOWNS AT SANTA FE

# GRATEFUL

# DEAD

## SUNDAY, OCTOBER 17 AT 1 PM

© 1982 MAIN LINE FINE ARTS/G.D.P.          DESIGN: D. LARKINS D. SAWYER

FIG. 120
DENNIS LARKINS "SANTA FE"
OFFSET LITHOGRAPH (53.4 CM X 40.6 CM)

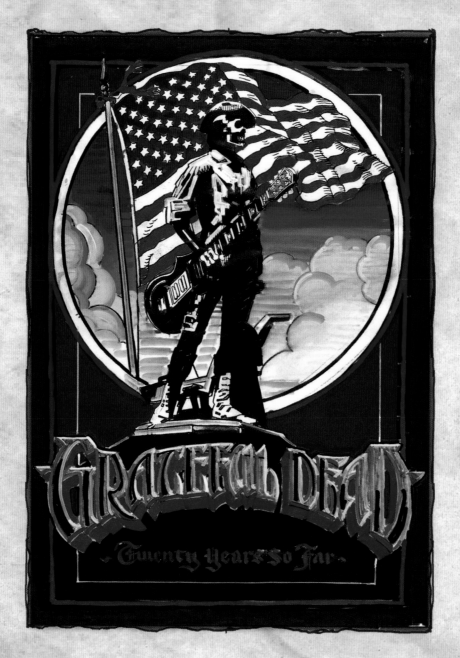

FIG. 121
RICK GRIFFIN "TWENTY YEARS SO FAR"
WATERCOLOR ON ILLUSTRATION BOARD

"In San Francisco, doing posters on a regular basis was like going to my own art school . . .
I was educating myself about the basic principles involved in printing color, how to mix
colors, how to gear the overlays, how to work up tones, and ultimately how to
predict what the final version would look like."

—Rick Griffin

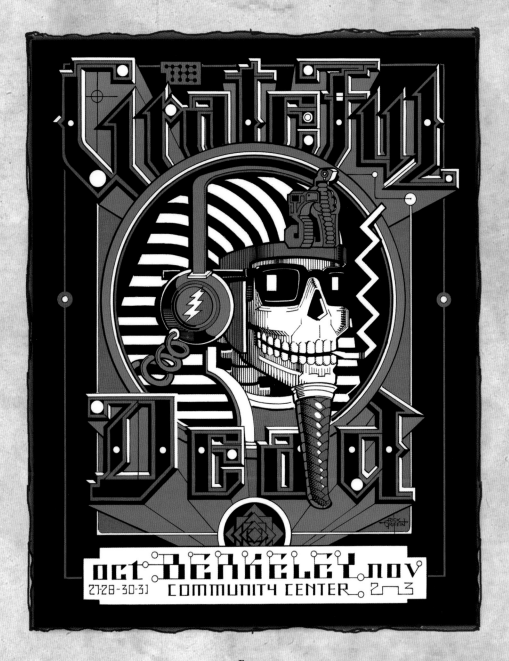

FIG. 122
RICK GRIFFIN "PHARAOH"
OFFSET LITHOGRAPH (58.3 CM X 45.8 CM)

*"We had already done I don't know how many different versions for the Grateful Dead, and now we had to come up with something new and different. It was really difficult. Mostly what we did was to take something Egyptian, from the past, and combine it with modern stuff. This was when high-tech was just starting to become really popular. The patterns on the circuit boards was the idea behind this, with the dots and the lines. And then he's got the earphones and the sunglasses—Rick always wore shades to look cool—and is smoking a joint. So, it's a combination of the past, the future and the present."*

—Ida Griffin

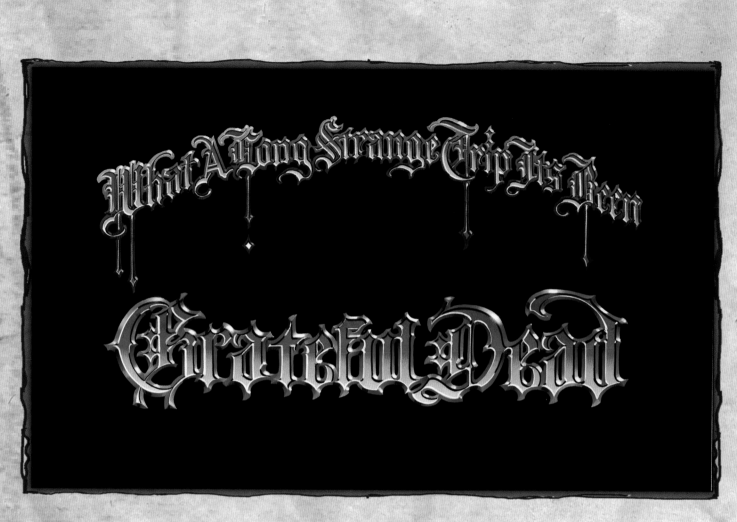

"You can't put a timeframe on how long it takes to do hand lettering. You'd like to do it as fast as possible; you're not talking about one or two hours, you're talking one or two days. Griffin lettering and the quality wasn't done in one or two hours. It took days."

—Randy Tuten

"[Griffin] was so visual. He [could] do lettering . . . freehand . . . He was so amazing. It's very hard to do. You have to have great talent and skill. Otherwise you have to use tools, [but] the tools take the life out of it; the imperfections make them such powerful lettering."

—Steven Heller

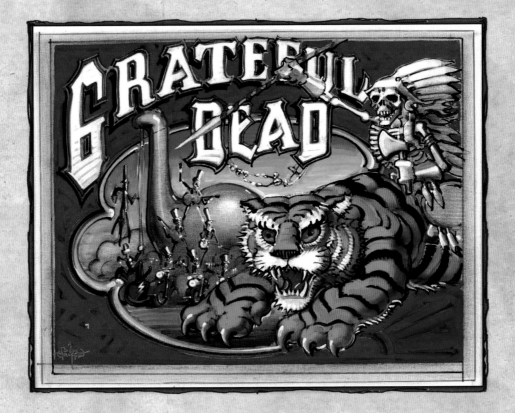

FIG. 124
RICK GRIFFIN, UNTITLED ORIGINAL ART
OIL ON ILLUSTRATION BOARD

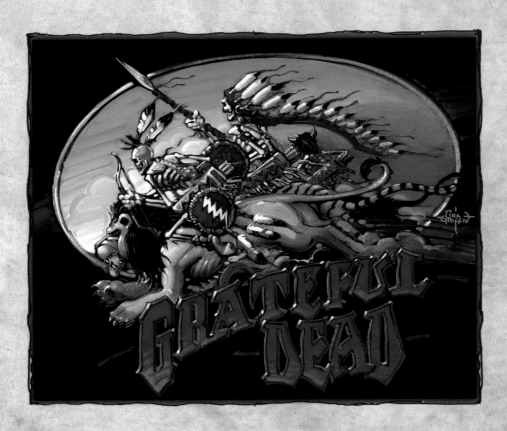

FIG. 125
RICK GRIFFIN, UNTITLED ORIGINAL ART
OIL ON ILLUSTRATION BOARD

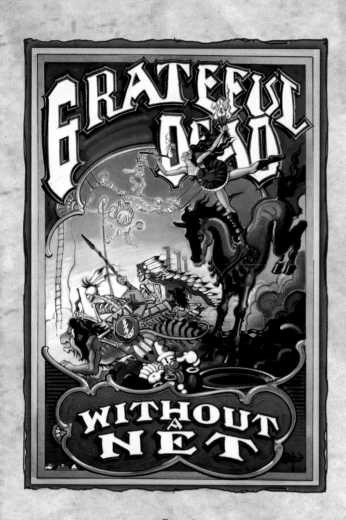

FIG. 126
RICK GRIFFIN "WITHOUT A NET"
OFFSET LITHOGRAPH

*"The very refined quality of album cover artwork is a direct result of the poster movement."*

—Stanley Mouse

*"I think it's undoubtedly true—the Grateful Dead has the best art of any band. They were like an artist magnet; they attracted this enormous body of work created by this wonderful assortment of characters over the years, which created this magnitude of work."*

—Dennis Larkins

FIG. 84
RICK GRIFFIN "WITHOUT A NET" (ORIGINAL SKETCH)
LEAD PENCIL ON PAPER

FIG. 128
RICK GRIFFIN "EUROPE 1990"
OFFSET LITHOGRAPH

*"The posters looked like what we were playing. They were
an open call to come and have fun, which is what we were
all about anyway. The posters didn't just announce the
concerts, they resonated with the styles of the times . . ."*

—Mickey Hart

*"The art of the Grateful Dead is extremely consistent. It is
always inspired, and it is more than a style—it's kind of its
own little thing. And I find it brilliant and
extremely memorable and unique."*

—David Byrd

FIG. 84
RICK GRIFFIN "EUROPE 1990" (ORIGINAL SKETCH)
LEAD PENCIL ON PAPER

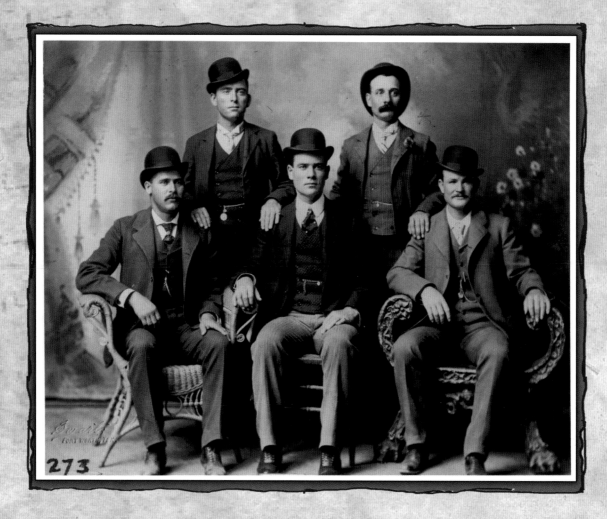

JOHN SWARTZ "THE WILD BUNCH"
GELATIN SILVER PRINT

DURING THE SUMMER of 1987 the rejuvenated Jerry Garcia and the Grateful Dead hit the road high on the success of their *In the Dark* album and chart song "Touch of Grey." Promoter Bill Graham wanted to bring The Grateful Dead to Telluride, Colorado where he had a summer home. As one of the few rock artists in the area and a Deadhead myself, I felt that there just *had* to be a poster and it didn't seem anyone was doing one. I decided to draw up the poster and print it myself, to get it out to area music stores or appropriate outlets to let folks know about the show.

While seeking inspiration, I found an article referring to Butch Cassidy's first bank robbery in Telluride and the classic photo of the famed "Wild Bunch." Instantly I saw a skeletal version as a perfect idea if I added one more character to match the cur-

rent Grateful Dead lineup. The original illustration was all hand drawn—actual size—with the characters in pencil shading and all the lettering and design in pen and ink.

Immediately following the concerts, I got a phone call from David Graham (Bill's son), who thanked me for doing them and told me how much he and Bill liked them. I was honored and personally signed some for Bill, the band and a few others and sent them off. My proudest moment in this story came years later when a friend informed me that when he visited Bill in his office, my Grateful Dead Telluride poster graced the wall right behind his desk. For me to have grown up in awe of all the early psychedelic posters and artists under Bill's wing, to have a spot on the wall was fabulous news.

—Steve Johannsen

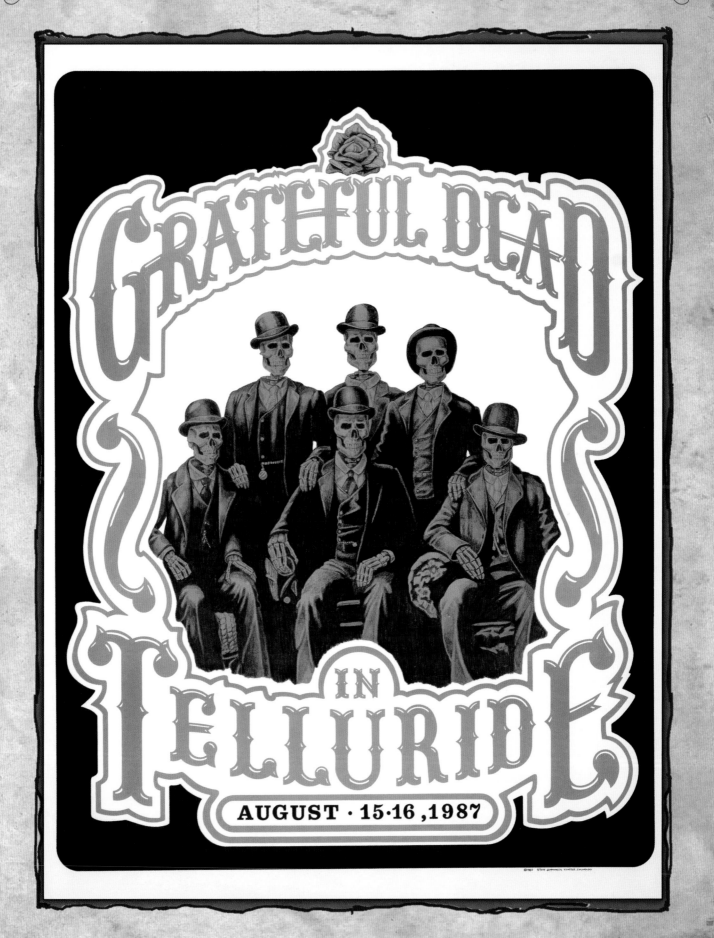

FIG. 130
STEVE JOHANNSEN "TELLURIDE"
OFFSET LITHOGRAPH (60.3 CM X 45 CM)

# GARY GRIMSHAW

**G**ARY GRIMSHAW, born February 25, 1946, in Detroit, Michigan, was the first major poster artist outside of San Francisco to achieve national status. Grimshaw came from a family of graphic artists—many of his relatives were employed at General Motors as designers. He worked in his uncle's print shop in Dearborn, Michigan, where he was introduced to the printing process. In high school, he immersed himself in art projects as he developed his skills as an artist.

From 1964 to 1966 Grimshaw served a tour of duty in the navy where he worked on the USS *Coral Sea*. From 1966 to 1970 Grimshaw traveled frequently between the Detroit area and the San Francisco scene, contributing to West Coast underground press publications like the *San Francisco Oracle*.

For those in the Detroit area, Grimshaw was their introduction to psychedelic art. He was the main poster and light show artist for the famous Grande Ballroom in Detroit, contributing dozens of designs for posters, handbills, and flyers. Due to a lack of money for art supplies, Grimshaw's work was characterized by his use of two to three colors at most.

In 1986, Paul Grushkin published the *Art of Rock: Posters from Presley to Punk*, which featured a number of Grimshaw's posters. The exposure changed the way the poster world viewed Grimshaw and elevated him into the league of the more famous and well-known San Francisco artists.

FIG. 132
GARY GRIMSHAW "HILL AUDITORIUM, DECEMBER 14TH, 1971"
OFFSET LITHOGRAPH (55.8 CM X 42.3 CM)

# PETER MAX

W HEN ANALYZING the career of pop artist Peter Max, "mass appeal" are two words that come to mind. Max's art was rooted in the counter culture and psychedelic movements in graphic design during the late 1960s and early 1970s. He was born on October 19, 1937, in Berlin, Germany, to Jewish parents who fled Nazi Germany in 1938. They moved to Shanghai, China for the next ten years and later to Haifa, Israel. Pushing westward, they stayed in Paris for several months where Peter's interest in art grew while he took classes at the Louvre Museum.

At the age of sixteen, Peter Max arrived in the United States. He began studying art in New York at the Art Students League and continued at the Pratt Institute and School of Visual Arts. Max's lively art reached millions of people, and he won major awards for his work. He often used patriotic American icons and symbols in his artwork, as well as images of celebrities and politicians. He is legendary for his new age style, cosmic imagery and colorful fusions.

In 1962, he opened a small Manhattan arts studio with friend Tom Daly known as "The Daly & Max Studio," where he worked diligently to expand his brand. Max began experimenting with new printing techniques that allowed for four-color reproduction on product merchandise. His art was licensed by seventy-two corporations, and with the incredible success came the national spotlight.

In 1969, Max appeared on the cover of *Life* magazine with an eight-page feature article under the heading "Peter Max: Portrait of the artist as a very rich man." He began appearing on television shows like "The Tonight Show" as his distinctive style became etched into the American psyche. Today, Peter Max continues to create works in multiple media including painting, drawing, collage, and digital imagery.

FIG. 133
PETER MAX "SPRING TOUR 1988"
OFFSET LITHOGRAPH (86.3 CM X 61 CM)

"*If I didn't choose art, I would have become an astronomer.*"

—*Peter Max*

# ROBERT RAUSCHENBERG

**B**ORN IN PORT ARTHUR, Texas on October 22, 1925, Robert Rauschenberg originally studied pharmacology. Fortuitously, he altered his career path, and in 1947, after a brief stay at the University of Texas, he dropped out and entered the Kansas City Art Institute. He travelled to Paris in 1948, where he studied at the Académie Julian, where he met painter Susan Weil, whom he later married. They returned to the United States and began studying under Joseph Albers, the German born American artist, who had once been a professor at the Bauhaus. Later, they relocated to New York and entered the Art Students League.

Beginning in 1950, Rauschenberg's rise in the art world was linked to the worlds of theater and dance and resulted in costumes and set designs for Merce Cunningham, the American dancer and choreographer. His rise was meteoric as his paths crossed with the most famous artists of the time, specifically Jasper Johns and Willem de Kooning. With his exposure to new kinds of art like Pop, Conceptualism, and Process Art, Rauschenberg successfully defied the idea that an artist adopts only one medium or style of art.

Best known for his "Combines" (a combination of painting and sculpture) of the 1950s, Rauschenberg used non-traditional materials and found objects from the streets of New York City to create incredible visuals and textures. As is true of many great artists, underlying some of his work is a manifest darkness. In 1955, at the Charles Egan Gallery, Rauschenberg showed "Bed," one of his most well known Combines. "Bed" featured a quilt, sheet, and pillow, covered in paint, as if soaked in blood, and framed on the wall. Critics remarked that the piece was a commentary on violence and rape. Rauschenberg was also known for his work in political activism, civil rights, and peace. Rauschenberg died on May 12, 2008, on Captiva Island, Florida.

*"The artist's job is to be a witness to his time in history."*

— *Robert Rauschenberg*

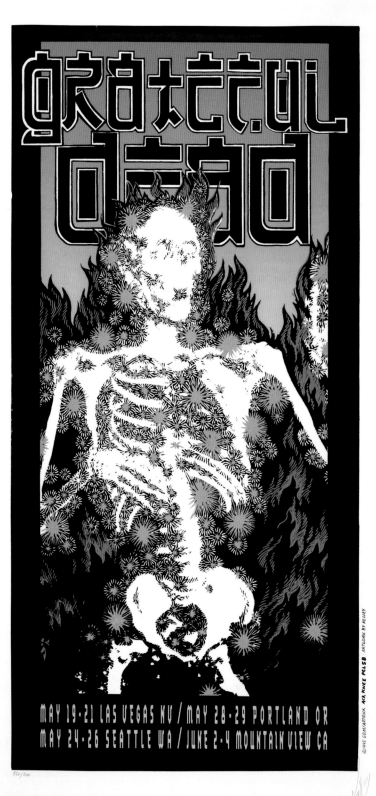

FIG. 135
ALTON KELLEY "FLAMING SKELETON" (UNCUT SHEET)
SERIGRAPH (88.6 CM X 57.3 CM)

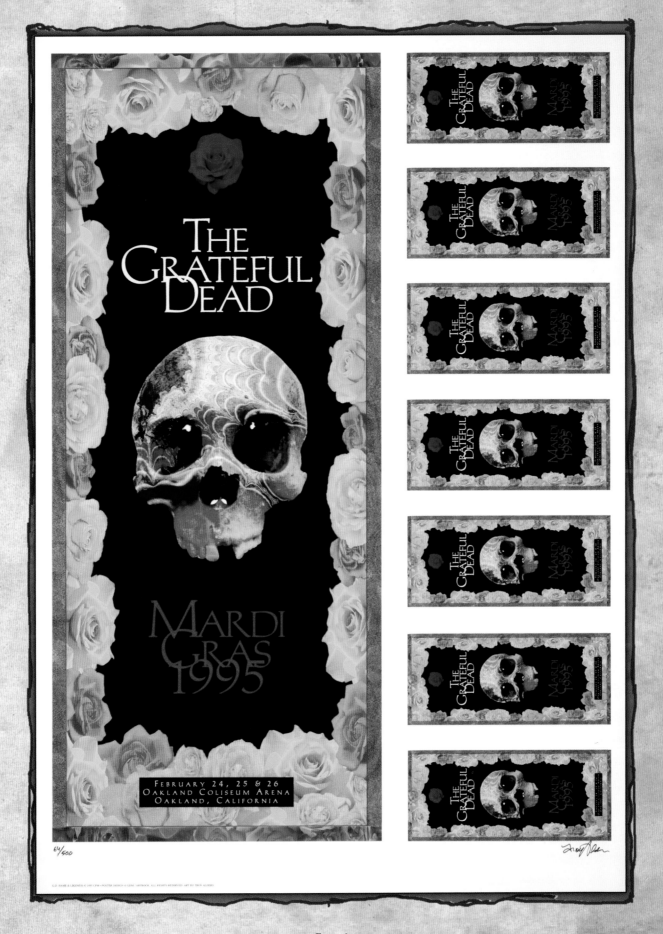

FIG. 136
TROY ALDERS "MARDI GRAS"
OFFSET LITHOGRAPH (62.1 CM X 44.4 CM)

# MARK ARMINSKI

MARK ARMINSKI WAS born in Detroit, Michigan in 1950. Arminski's exposure to fine art began at a young age when his mother took him to art museums in Detroit. While in high school, he designed his first concert posters, influenced in large part by the psychedelic work of local graphic artist Gary Grimshaw. In the mid 1960s, Arminski was offered a stack of posters featuring local acts like the Grateful Dead and Jefferson Airplane. Arminski was captivated by the freshness of this new art.

Entranced by Victor Moscoso's color techniques and Gary Grimshaw's lettering style, Arminski quickly transitioned from a professional draftsman to a poster artist. He attended Detroit's prestigious Center for Creative Studies in 1978 and discovered printmaking and stone lithography at the Kalamazoo Institute of Arts.

As he earned greater recognition, he began exploring figurative art, sharpening his expertise in printmaking and photography to create spectacular nudes. His nudes appeared in books and journals and led to his 1989 one-man show, Untamed Eroticism, which began as a protest against Senator Jesse Helms's war on federal funding for "indecent art."

As Arminski grew into his role as Detroit's best-known counterculture artist, he developed his own style, merging the color palettes of psychedelic posters from the 1960s with the edgy designs representative of 1990s grunge music. Today, he dedicates himself to large format art—murals covering entire walls.

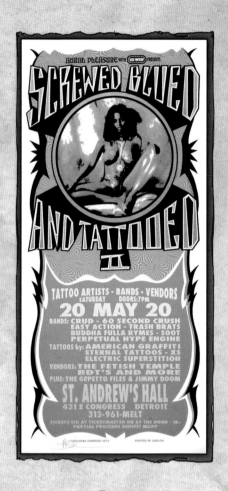

FIG. 137
MARK ARMINSKI "SCREWED BLUED AND TATTOOED II"
SERIGRAPH (56.5 CM X 26.7 CM)

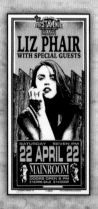

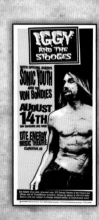

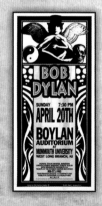

"MAINROOM, APRIL 22ND, 1994"
SERIGRAPH
(56.5 CM X 26.7 CM)

"DTE THEATRE, AUG. 14TH, 2003"
SERIGRAPH
(56.5 CM X 26.7 CM)

"THE ARK, APRIL 8TH, 1995"
SERIGRAPH
(56.5 CM X 26.7 CM)

"AUBURN HILLS, DEC. 29TH, 2001"
SERIGRAPH
(56.5 CM X 26.7 CM)

"BOYLAN AUDITORIUM, APRIL 20TH, 1997"
SERIGRAPH
(56.5 CM X 26.7 CM)

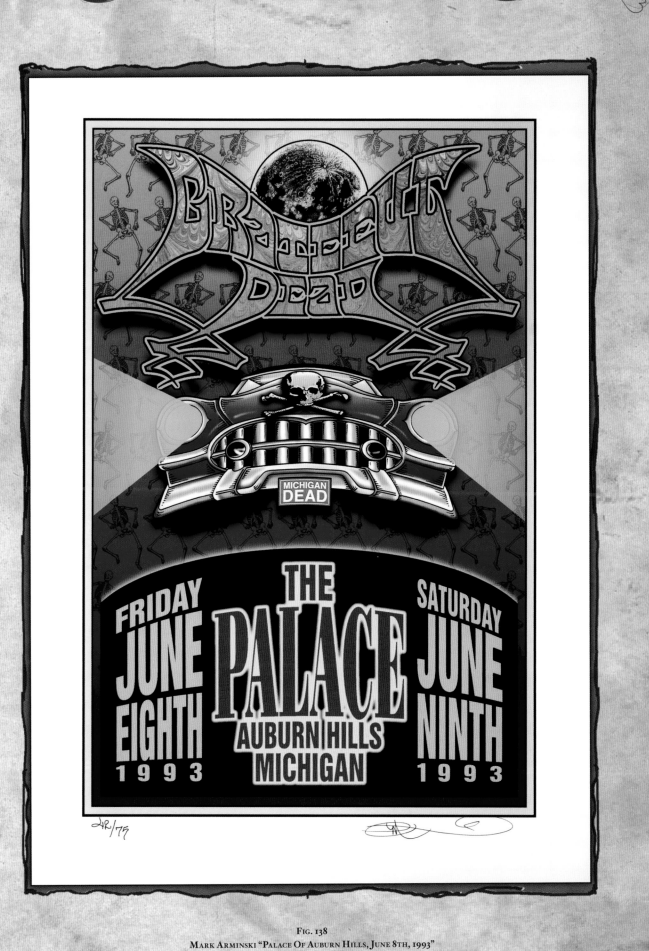

FIG. 138
MARK ARMINSKI "PALACE OF AUBURN HILLS, JUNE 8TH, 1993"
SERIGRAPH (56.5 CM X 26.7 CM)

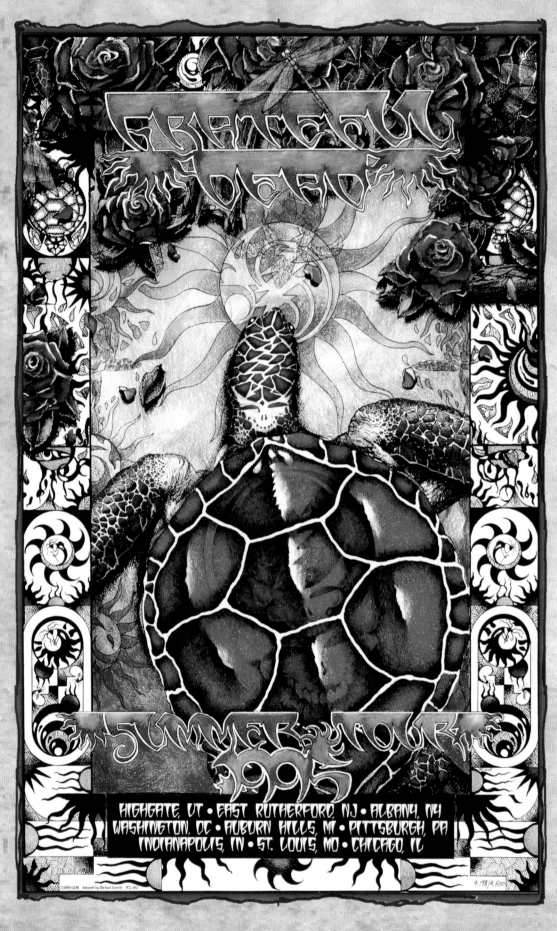

Fig. 139
Michael Everett "Turtle"
OFFSET LITHOGRAPH (61.3 CM X 38.6 CM)

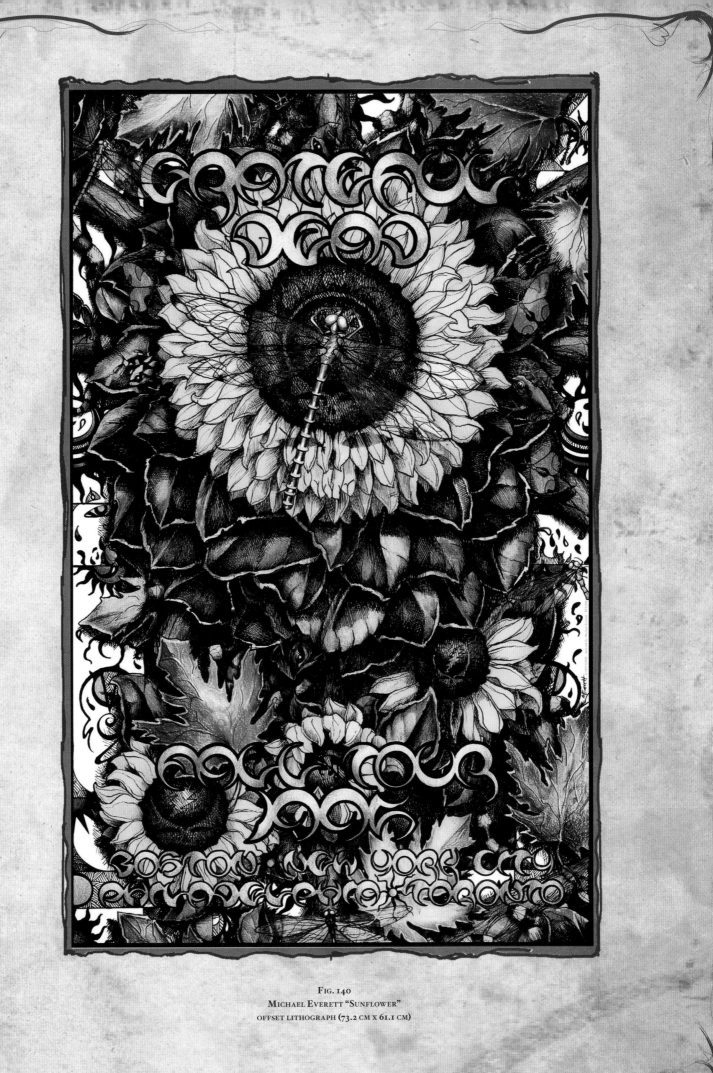

Fig. 140
Michael Everett "Sunflower"
offset lithograph (73.2 cm x 61.1 cm)

# IN CLOSING

HE GRATEFUL DEAD rose from within a Bohemian brew of poets, writers, artists, and musicians in the San Francisco of the mid-1960s. They toured for thirty years, far outlasting their contemporaries. During this time, hundreds of posters were published advertising their gigs. On August 10, 1995, Jerry Garcia, the soul of the Grateful Dead, died of a heart attack in his sleep at Serenity Knolls, a residential drug treatment center in Forest Knolls, California. He was fifty-three years old. With his passing, the band ended.

The two posters in the preceding pages were the last ever commissioned by the band. The art is by Michael Everett, who got the job in a rather unconventional way. The Dead ran their own ticketing operation, and as tickets were always in short supply, many fans adorned their envelopes with original artwork hoping to better their chances. Everett's art on the envelopes he used for his ticket requests got him the job of designing these posters.

The Grateful Dead played their last show on July 7, 1995, at Soldiers Field, in Chicago. Everett had originally meant for the two posters to be part of a triptych, but, due to Garcia's untimely death, only two of the three were completed. Everett designed this artwork to fit together: the design on the right side of the "Turtle" poster flows over seamlessly into the left side of the "Sunflower" print. There is a great deal of subtlety in this art. Looking closely, you will notice the interwoven layers of Grateful Dead imagery and iconography.

At this point we have traced the origin and development of this often-unappreciated genre of art, which thrived on the streets of San Francisco. Over the years, other artists have joined this grand tradition. Randy Chavez, the artist, once said to me, "art writhes." And he's right, it does. Just as rock music has splintered and evolved, generating many different sounds, the artists and the art featured in this book have also followed a similar path.

And so, thanks Rick. Thanks Kelley. And thanks to Mouse, Victor, Wes, Lee and all the other artists who have contributed so much to this genre of art. This book is dedicated to you.

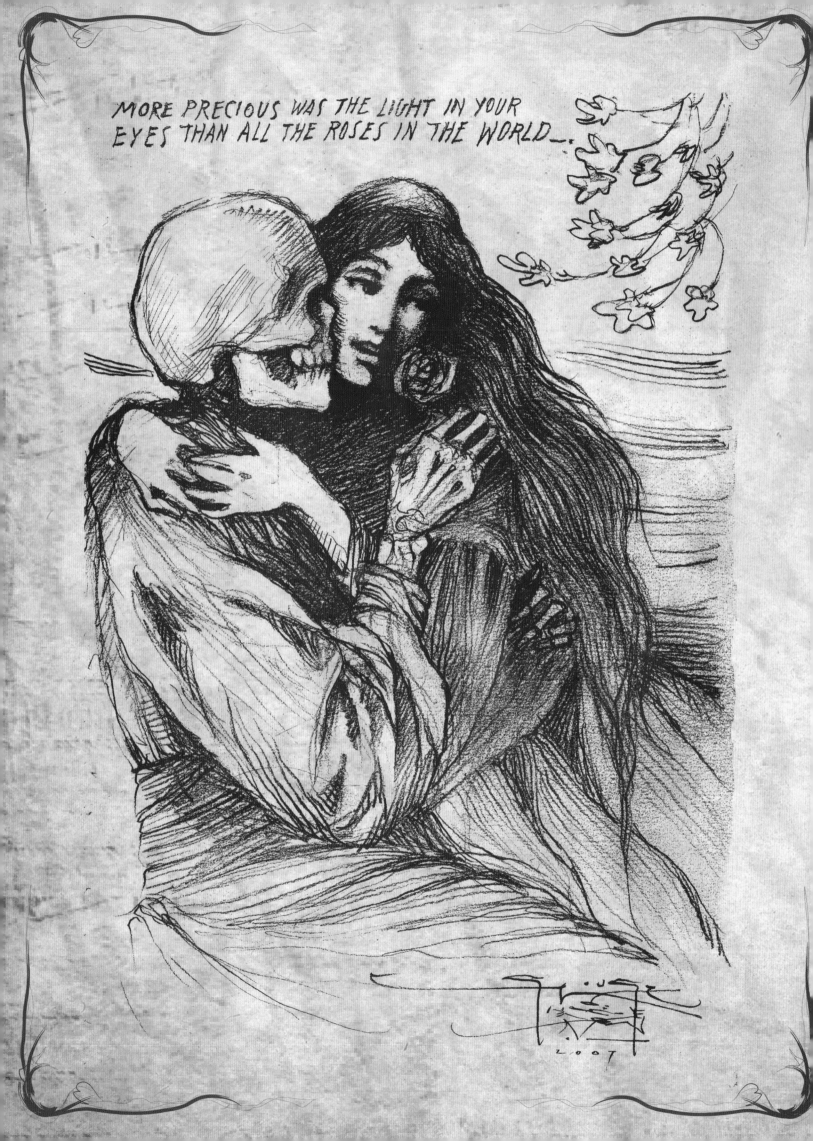

MORE PRECIOUS WAS THE LIGHT IN YOUR
EYES THAN ALL THE ROSES IN THE WORLD—.

# DIRGE WITHOUT MUSIC

*I am not resigned to the shutting away of loving hearts in the hard ground.*

*So it is, and so it will be, for so it has been, time out of mind:*

*Into the darkness they go, the wise and the lovely. Crowned*

*With lilies and with laurel they go; but I am not resigned.*

*Lovers and thinkers, into the earth with you.*

*Be one with the dull, the indiscriminate dust.*

*A fragment of what you felt, of what you knew,*

*A formula, a phrase remains, but the best is lost.*

*The answers quick and keen, the honest look, the laughter, the love*

*They are gone. They are gone to feed the roses. Elegant and curled*

*Is the blossom. Fragrant is the blossom. I know. But I do not approve.*

**More precious was the light in your eyes than all the roses in the world.**

*Down, down, down into the darkness of the grave*

*Gently they go, the beautiful, the tender, the kind;*

*Quietly they go, the intelligent, the witty, the brave.*

*I know. But I do not approve. And I am not resigned.*

*by Edna St. Vincent Millay*

*"I think that time goes on . . . Now that the Dead no longer exist, the images are still walking, walking along . . . and, as time goes on, culture takes these images and gives them new meaning."*

—*Art Chantry*

# ACKNOWLEDGMENT

*Special thanks to:*

JOE ARMSTRONG

RENÉE DE COSSIO

LINCOLN CUSHING

DAVID EWERS

TOM HILL

BRAD KELLY

DENNIS KING

HOWARD KRAMER

CHRIS SHAW

VICTORIA SMITH

CHUCK SPERRY

MIKE STOREIM

DICK WENTWORTH

# BIBLIOGRAPHY

Albright, Thomas. "Visuals: The Death of the Great Poster Trip." *Rolling Stone*. 25 05 1968: 16. Print.

Byrd, David. Personal interview. 14 April. 2008

Chantry, Art. Phone interview with Nels Jacobson. Transcribed from tape, c. 2005.

Davis, Miles. *Miles Davis: The Autobiography*. Twenty-fourth. New York: Simon & Schuster Paperbacks, 1989. Print.

Driscoll, Bob. E-mail interview with Nels Jacobson. August–December. 2006.

Du Lac, J Freedom. "Stanley Mouse talks Grateful Dead." *Washington Post* [Washington, DC] 10 April. 2009. Print.

Griffin, Ida. Telephone interview. Nels Jacobson, 15 August. 2005.

Grushkin, Paul. *The Art of Rock*. First. Artabras, 1993. 512. Print.

Heyman, Therese. "About Posters." *Posters American Style*. n. page. Web. 30 May. 2012. www.americanart.si.edu/posters/essay.html

Hoskyns, Barney. *Beneath the Diamond Sky*. First. New York: Simon & Schuster, 1997. 224. Print.

Hughs, Andrew S. "A Groovy Kind of Art." *South Bend Tribune*. (2007): n. page. Web. 30 May. 2012.

Kelley, Alton. Personal Interview. Michael Erlewine, 11 May. 2001.

Kieser, Gunther. Telephone interview. 2008.

# BIBLIOGRAPHY

Larkins, Dennis. Personal interview. 22 April. 2008.

Lesh, Phil. *Searching For The Sound*. First. New York: Little, Brown and Company, 2005. Print.

Masse, Bob. Personal interview. 7 April. 2008

McDonough, Jack. *San Francisco Rock*. First. San Francisco: Chronicle Books, 1985. 236. Print.

McNally, Dennis. *A Long Strange Trip*. First. New York: Broadway Books, 2002. Print.

Miller, Stanley "Mouse." Personal interview. Michael Erlewine, May 8. 2001.

Moscoso, Victor. Interview. Michael Erlewine, December

Moscoso, Victor. Interview. Nels Ferguson

Perry, Charles. *Haight-Ashbury: A History*. First. Wenner, 2005. 294. Print.

Singer, David. Personal Interview. 4 February. 2008.

Tuten, Randy. Personal interview. Nels Jacobson, 26 July. 2005

Van Hamersveld, John. Interview with Nels Jacobson. Transcribed from tape, 2006.

Whery, Denis. "Rick Griffin." *Comics Journal*. 257. Web. 30 May. 2012. http://archives.tcj.com/257/i_griffin.html.

# ILLUSTRATED INDEX

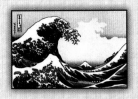

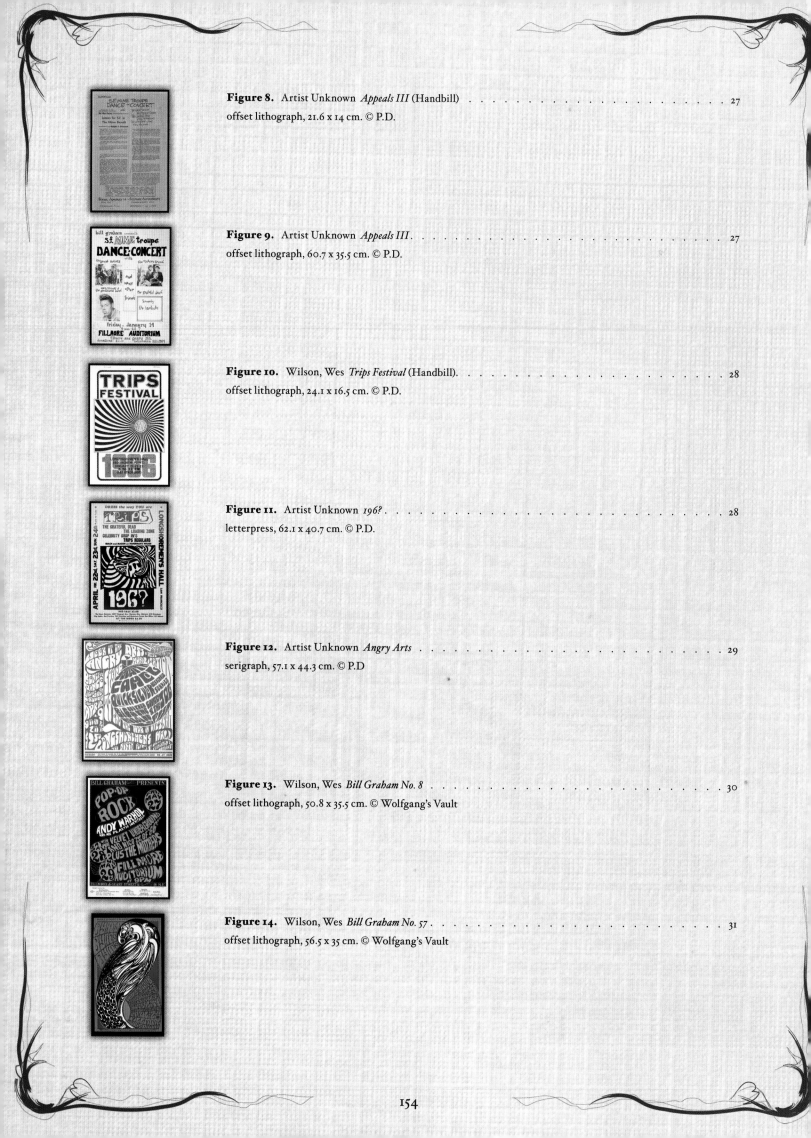

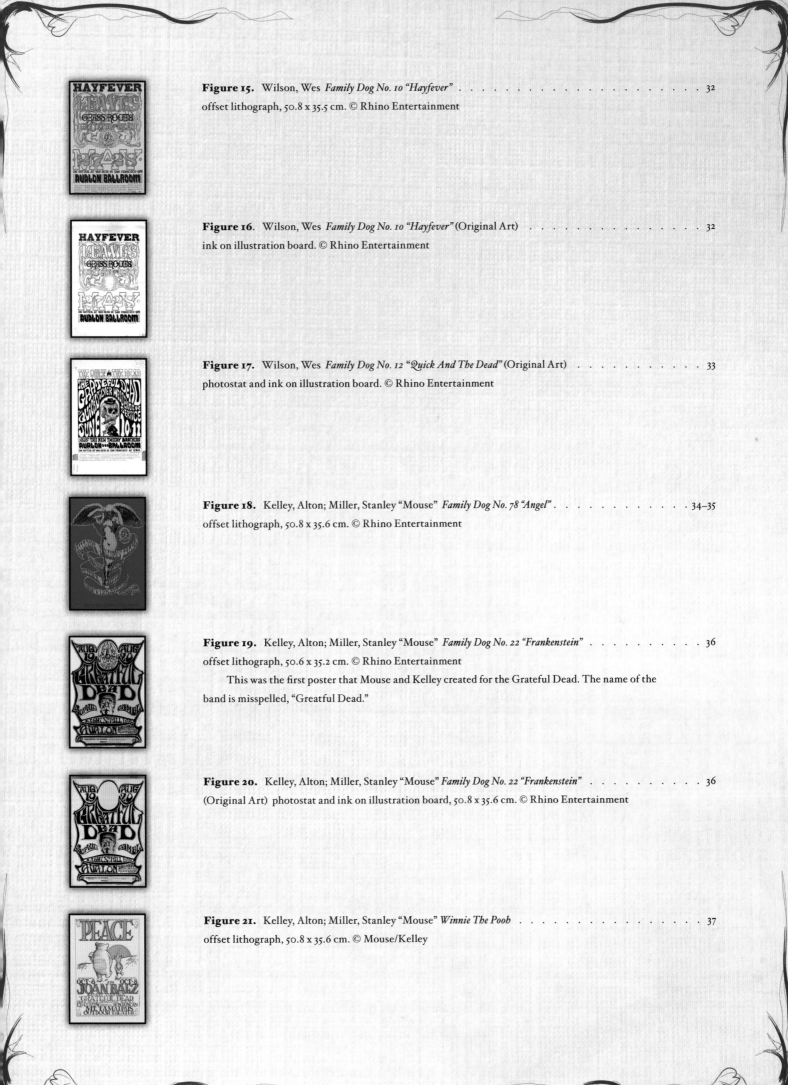

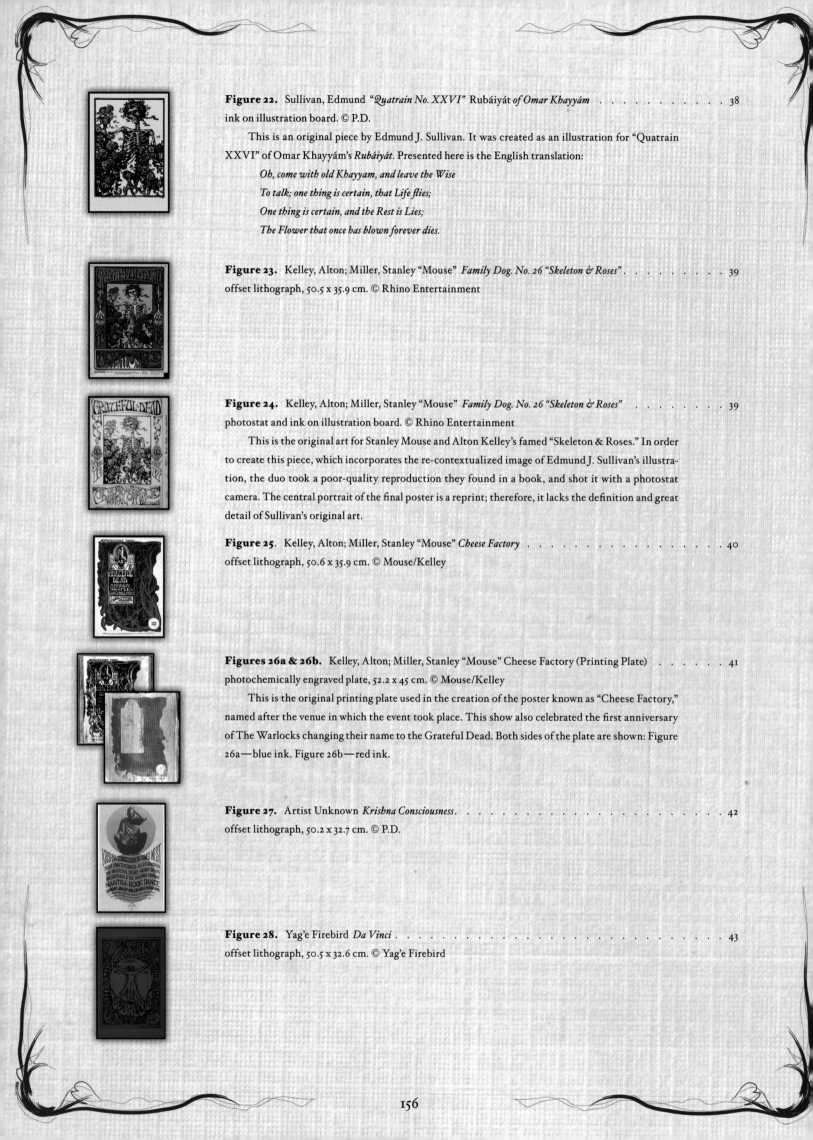

ink on illustration board. © P.D.

This is an original piece by Edmund J. Sullivan. It was created as an illustration for "Quatrain XXVI" of Omar Khayyám's *Rubáiyát*. Presented here is the English translation:

Oh, come with old Khayyam, and leave the Wise
To talk; one thing is certain, that Life flies;
One thing is certain, and the Rest is Lies;
The Flower that once has blown forever dies.

offset lithograph, 50.5 x 35.9 cm. © Rhino Entertainment

photostat and ink on illustration board. © Rhino Entertainment

This is the original art for Stanley Mouse and Alton Kelley's famed "Skeleton & Roses." In order to create this piece, which incorporates the re-contextualized image of Edmund J. Sullivan's illustration, the duo took a poor-quality reproduction they found in a book, and shot it with a photostat camera. The central portrait of the final poster is a reprint; therefore, it lacks the definition and great detail of Sullivan's original art.

offset lithograph, 50.6 x 35.9 cm. © Mouse/Kelley

photochemically engraved plate, 52.2 x 45 cm. © Mouse/Kelley

This is the original printing plate used in the creation of the poster known as "Cheese Factory," named after the venue in which the event took place. This show also celebrated the first anniversary of The Warlocks changing their name to the Grateful Dead. Both sides of the plate are shown: Figure 26a—blue ink. Figure 26b—red ink.

offset lithograph, 50.2 x 32.7 cm. © P.D.

offset lithograph, 50.5 x 32.6 cm. © Yag'e Firebird

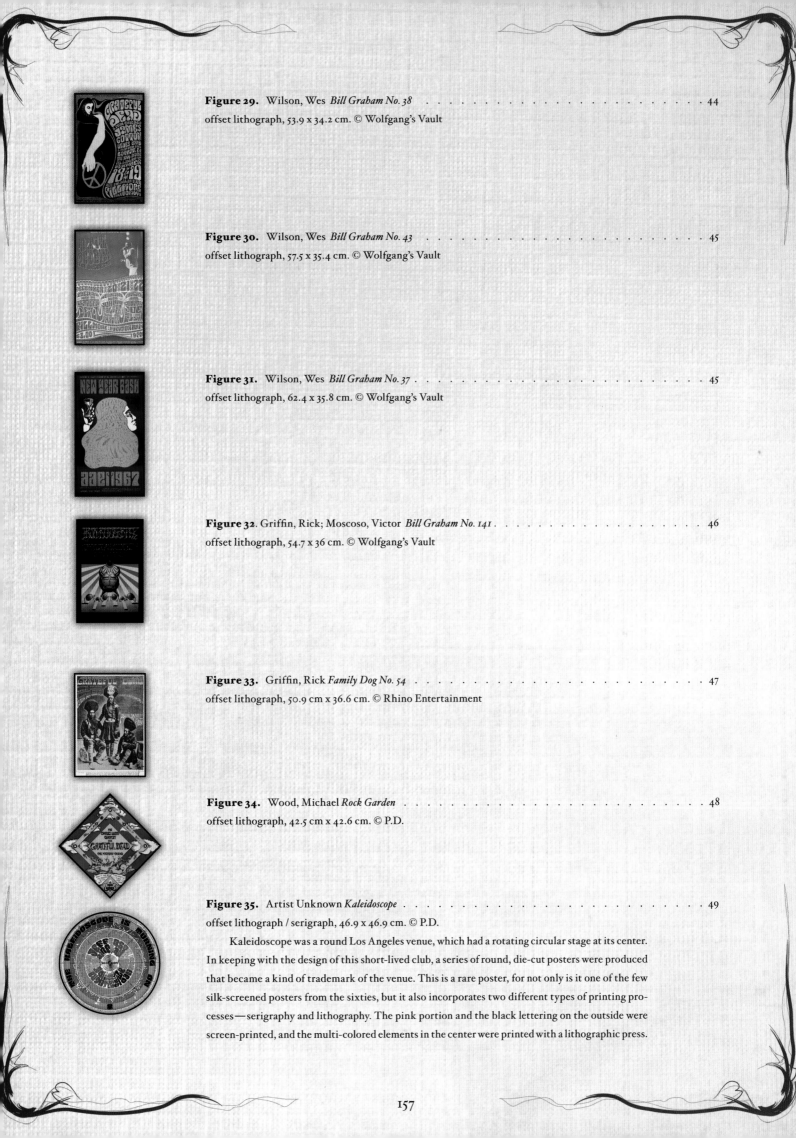

Kaleidoscope was a round Los Angeles venue, which had a rotating circular stage at its center. In keeping with the design of this short-lived club, a series of round, die-cut posters were produced that became a kind of trademark of the venue. This is a rare poster, for not only is it one of the few silk-screened posters from the sixties, but it also incorporates two different types of printing processes—serigraphy and lithography. The pink portion and the black lettering on the outside were screen-printed, and the multi-colored elements in the center were printed with a lithographic press.

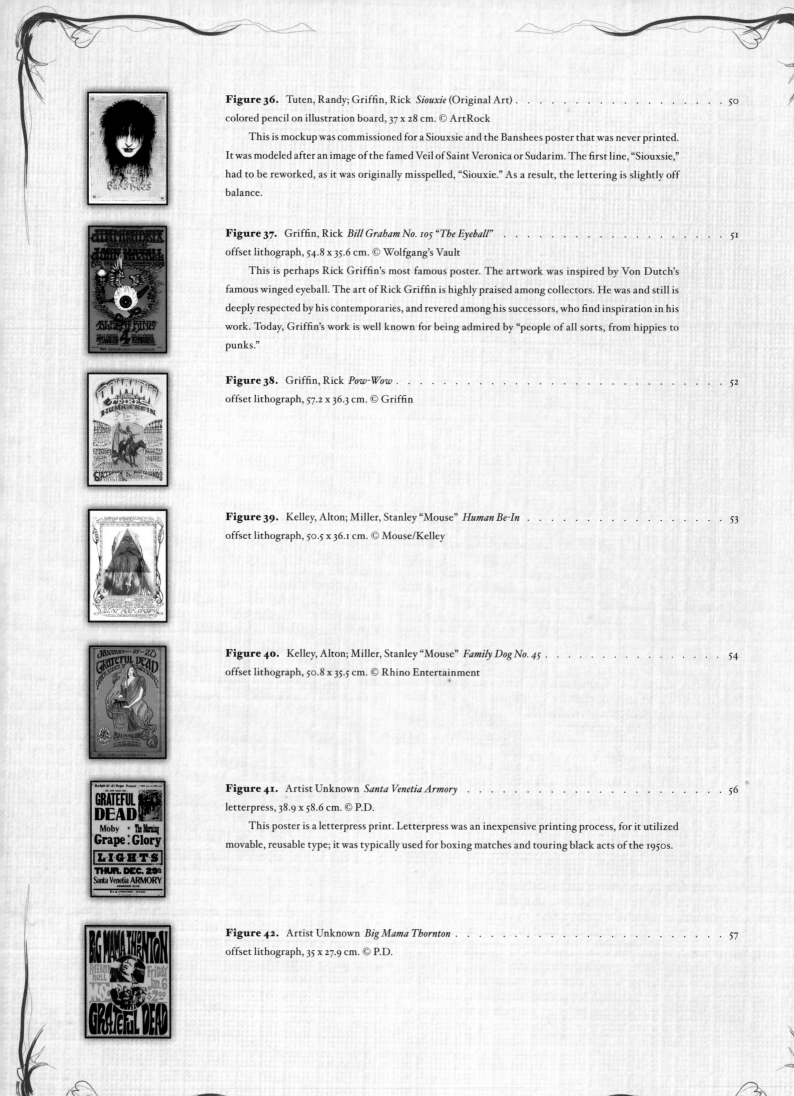

**Figure 36.** Tuten, Randy; Griffin, Rick *Siouxie* (Original Art) . . . . . . . . . . . . . . . . . . . 50
colored pencil on illustration board, 37 x 28 cm. © ArtRock

This is mockup was commissioned for a Siouxsie and the Banshees poster that was never printed. It was modeled after an image of the famed Veil of Saint Veronica or Sudarim. The first line, "Siouxsie," had to be reworked, as it was originally misspelled, "Siouxie." As a result, the lettering is slightly off balance.

**Figure 37.** Griffin, Rick *Bill Graham No. 105 "The Eyeball"* . . . . . . . . . . . . . . . . . . 51
offset lithograph, 54.8 x 35.6 cm. © Wolfgang's Vault

This is perhaps Rick Griffin's most famous poster. The artwork was inspired by Von Dutch's famous winged eyeball. The art of Rick Griffin is highly praised among collectors. He was and still is deeply respected by his contemporaries, and revered among his successors, who find inspiration in his work. Today, Griffin's work is well known for being admired by "people of all sorts, from hippies to punks."

**Figure 38.** Griffin, Rick *Pow-Wow* . . . . . . . . . . . . . . . . . . . . . . . . . . . . . . . 52
offset lithograph, 57.2 x 36.3 cm. © Griffin

**Figure 39.** Kelley, Alton; Miller, Stanley "Mouse" *Human Be-In* . . . . . . . . . . . . . . . . 53
offset lithograph, 50.5 x 36.1 cm. © Mouse/Kelley

**Figure 40.** Kelley, Alton; Miller, Stanley "Mouse" *Family Dog No. 45* . . . . . . . . . . . . . 54
offset lithograph, 50.8 x 35.5 cm. © Rhino Entertainment

**Figure 41.** Artist Unknown *Santa Venetia Armory* . . . . . . . . . . . . . . . . . . . . . . . 56
letterpress, 38.9 x 58.6 cm. © P.D.

This poster is a letterpress print. Letterpress was an inexpensive printing process, for it utilized movable, reusable type; it was typically used for boxing matches and touring black acts of the 1950s.

**Figure 42.** Artist Unknown *Big Mama Thornton* . . . . . . . . . . . . . . . . . . . . . . . . 57
offset lithograph, 35 x 27.9 cm. © P.D.

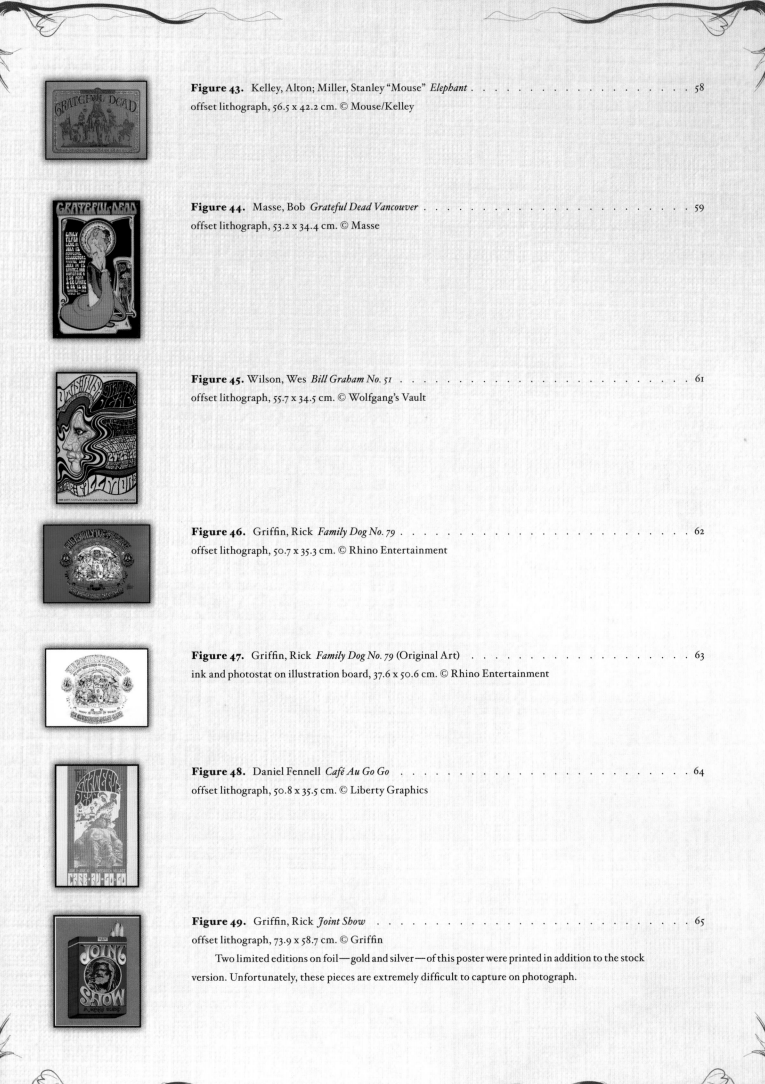

    Two limited editions on foil—gold and silver—of this poster were printed in addition to the stock version. Unfortunately, these pieces are extremely difficult to capture on photograph.

    This extremely rare poster was screen-printed by hand, one color at a time. There are only three copies of this poster known to exist, each containing different colors. Furthermore, the Cheetah Club was only a few blocks away from Andy Warhol's Factory, and there is circumstantial evidence indicating that these posters may have been printed there.

This poster is the collaborative effort of three artists: Rick Griffin rendered the lettering at the bottom—misspelled, "Quiksilver." Stanley Mouse sculpted "Trip or Freak" in the shape of a woman. And Alton Kelley designed the collage background and centerpiece, which features an image of Lon Chaney, from his famous role in the film Phantom of the Opera. It was rumored that the cards (about 5" by 8" in size, and located on the left-hand side of the proof sheet) were dipped in acid—each one of the Lon Chaney heads containing a dose of LSD.

Lofthouse's poster is a tongue-in-cheek creation, which was meant to be worn as a garment by cutting along the dotted line and pinning it to a shirt.

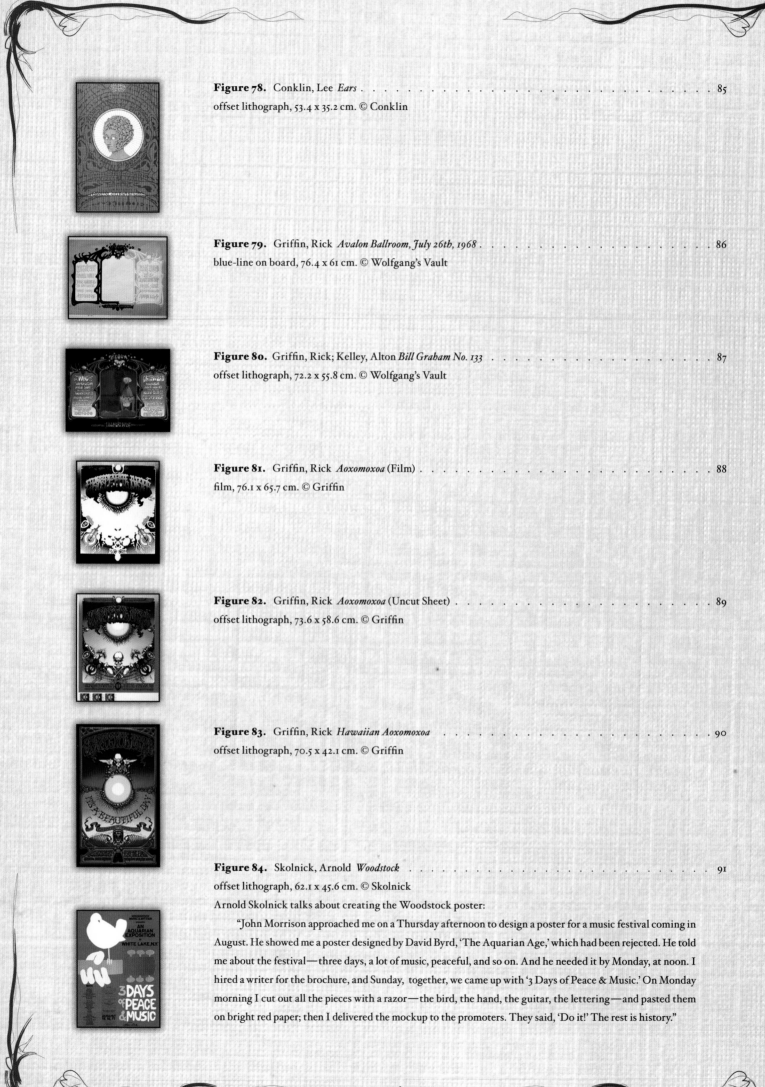

Arnold Skolnick talks about creating the Woodstock poster:

"John Morrison approached me on a Thursday afternoon to design a poster for a music festival coming in August. He showed me a poster designed by David Byrd, 'The Aquarian Age,' which had been rejected. He told me about the festival—three days, a lot of music, peaceful, and so on. And he needed it by Monday, at noon. I hired a writer for the brochure, and Sunday, together, we came up with '3 Days of Peace & Music.' On Monday morning I cut out all the pieces with a razor—the bird, the hand, the guitar, the lettering—and pasted them on bright red paper; then I delivered the mockup to the promoters. They said, 'Do it!' The rest is history."

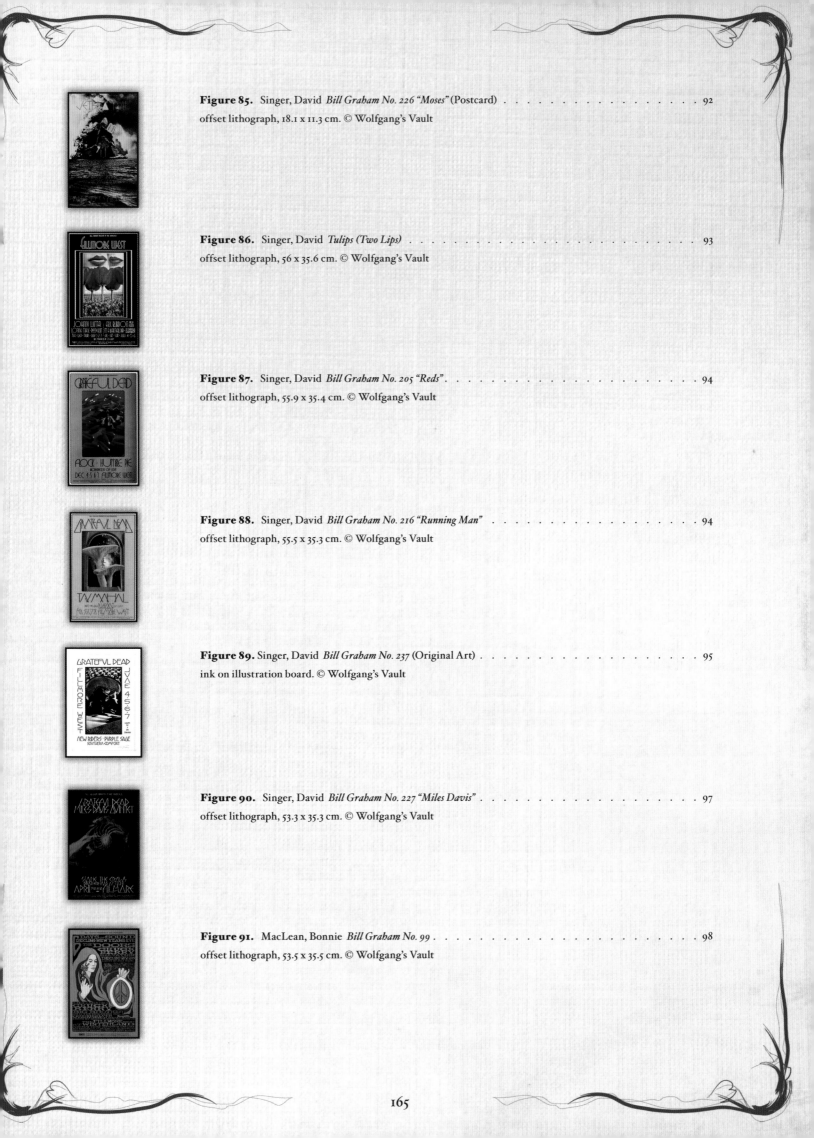

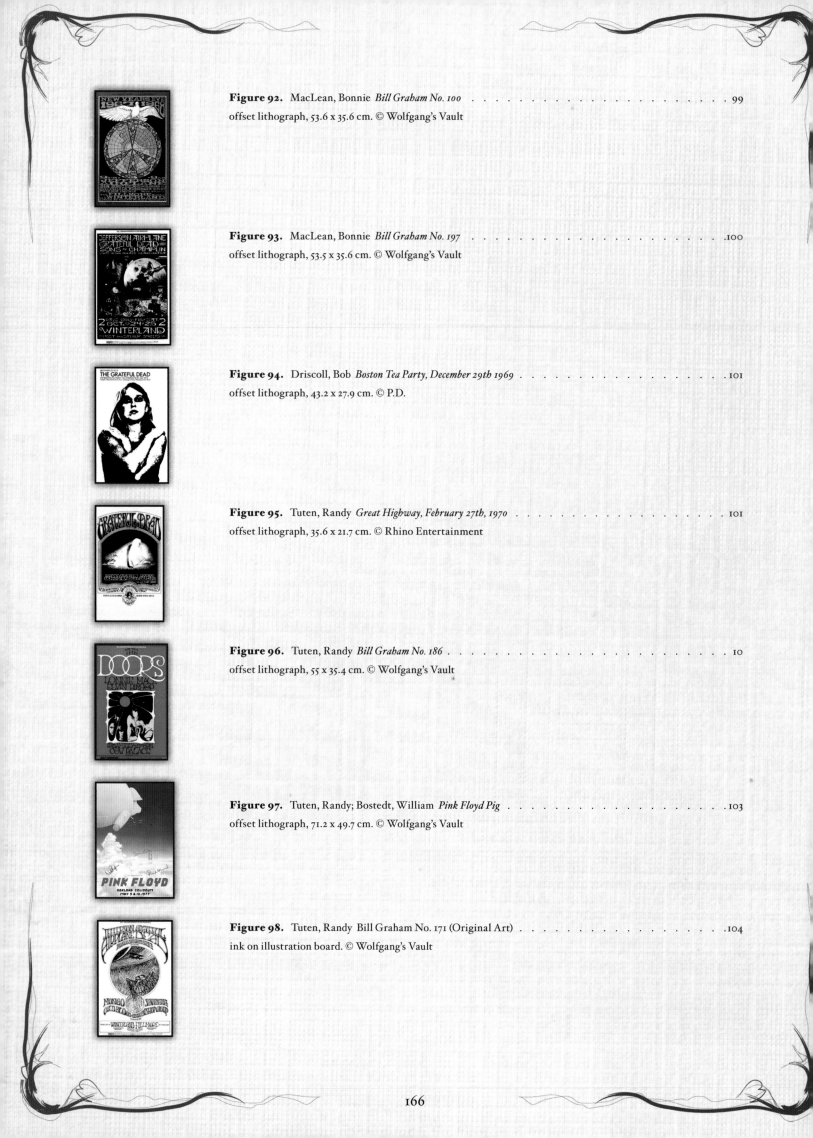

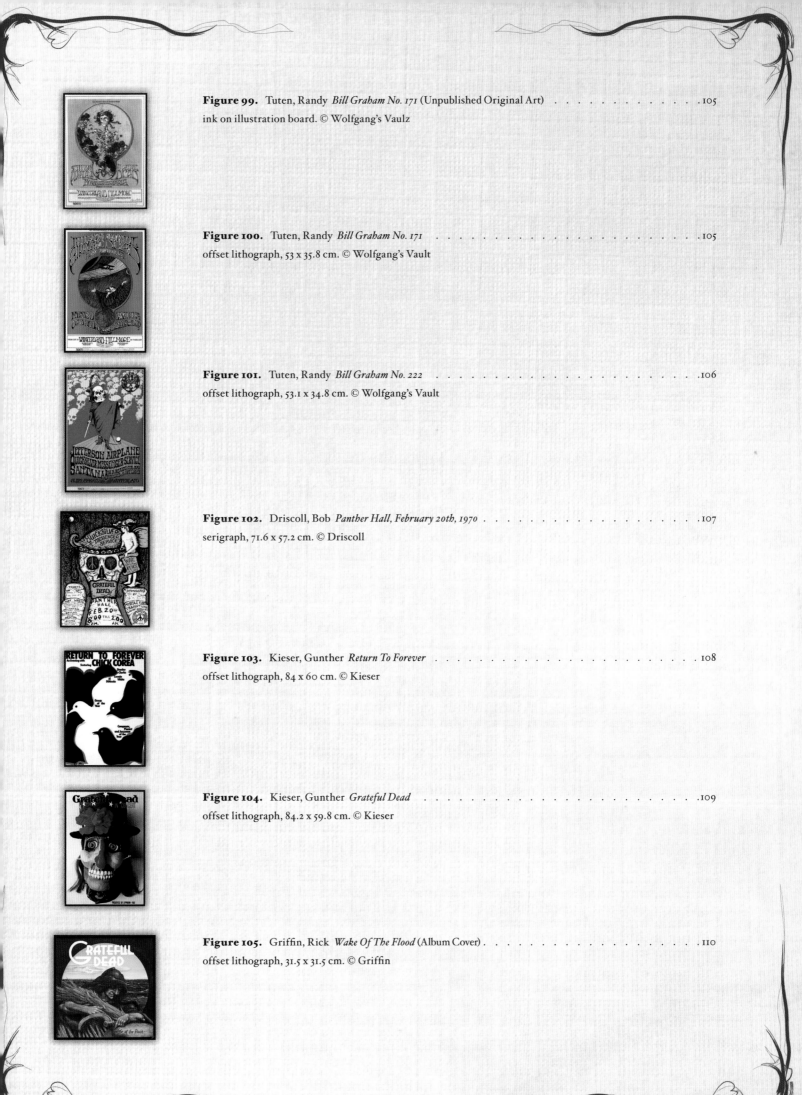

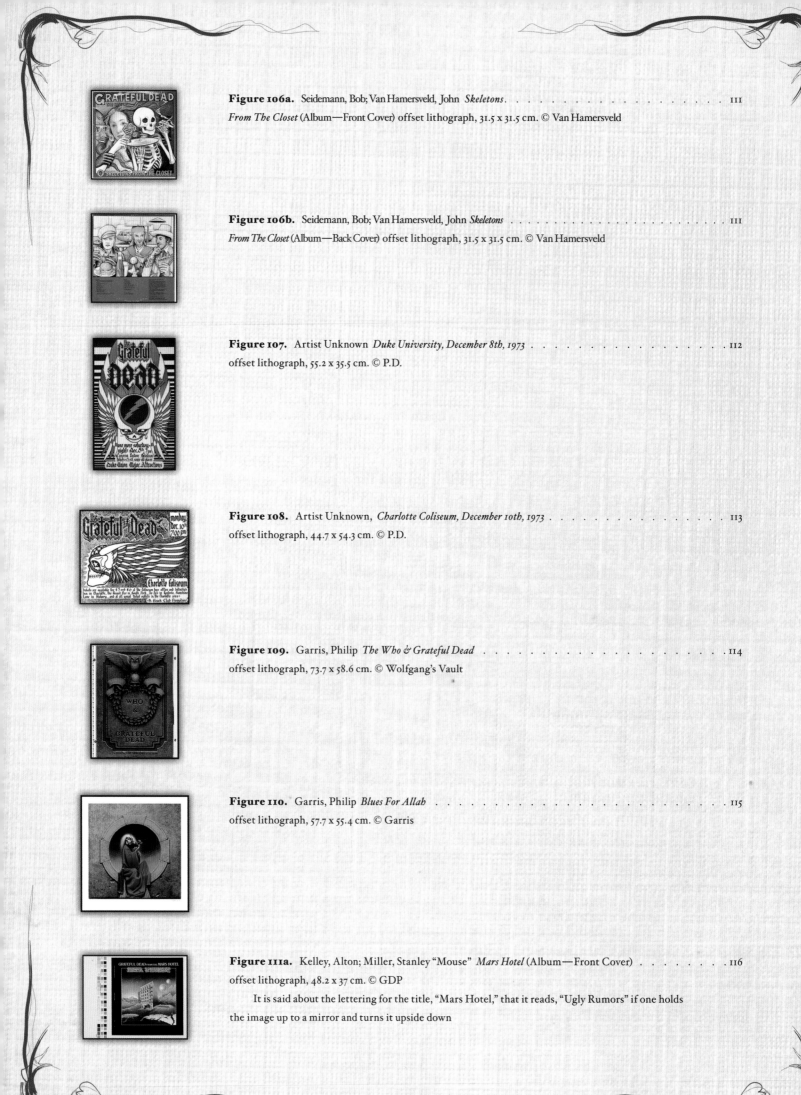

It is said about the lettering for the title, "Mars Hotel," that it reads, "Ugly Rumors" if one holds
the image up to a mirror and turns it upside down

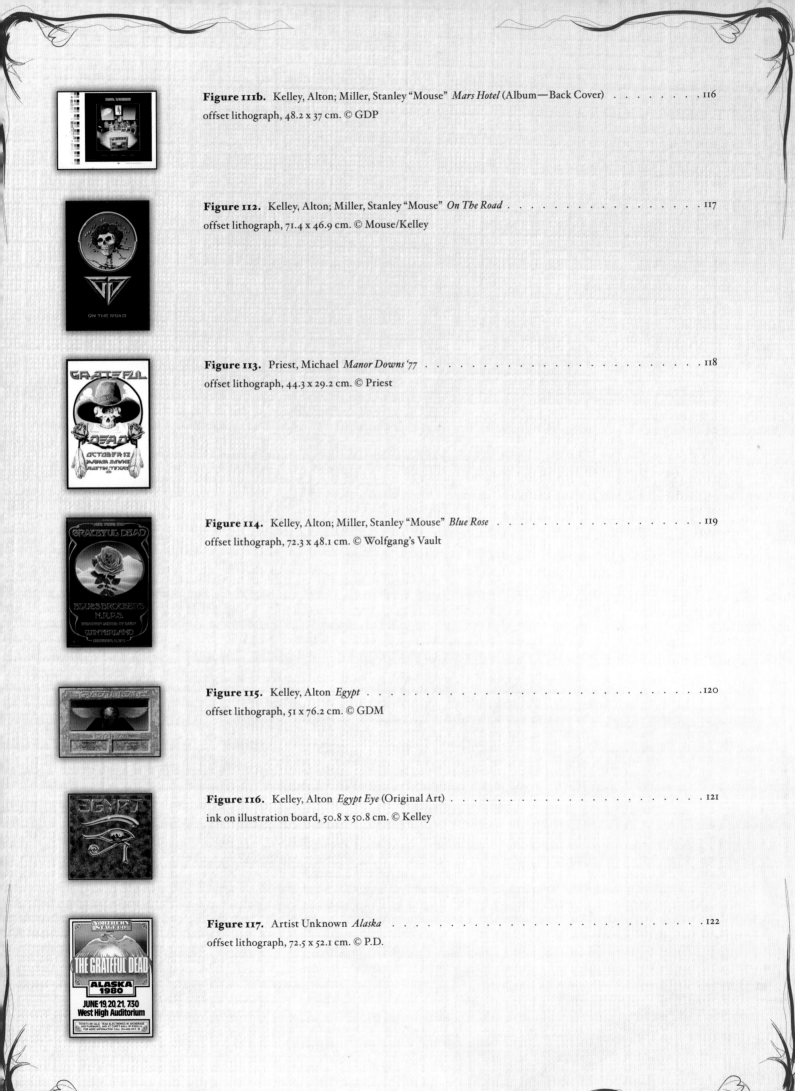

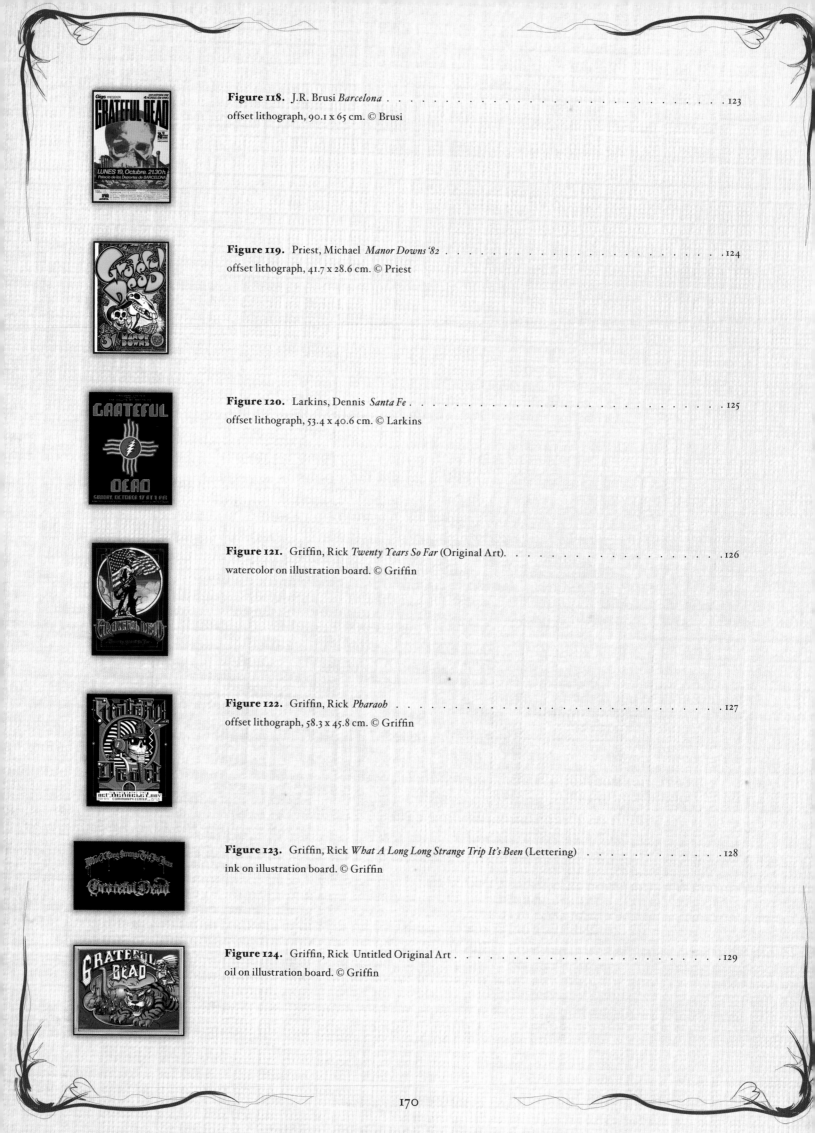

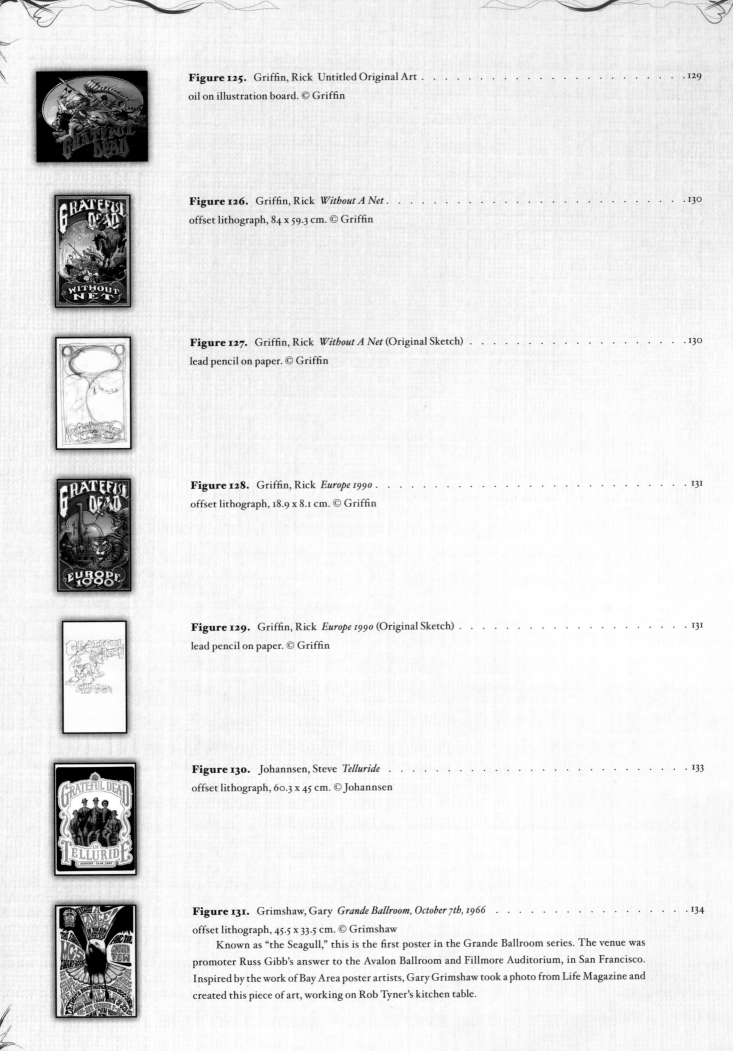

      Known as "the Seagull," this is the first poster in the Grande Ballroom series. The venue was
promoter Russ Gibb's answer to the Avalon Ballroom and Fillmore Auditorium, in San Francisco.
Inspired by the work of Bay Area poster artists, Gary Grimshaw took a photo from Life Magazine and
created this piece of art, working on Rob Tyner's kitchen table.

This was Alton Kelley's last poster design for the Grateful Dead; it was created for the Spring Tour of 1995. Kelley used "Conquest of the Moon Pool," an image by science-fiction artist Virgil Finlay. This silkscreen print has a split fountain background, which is best seen on the uncut cards to the right of the poster.

# INDEX

Page references for illustrations appear in *italics*.

# ART
## OF THE
## DEAD

Soft Skull Press
An imprint of Counterpoint
1919 Fifth Street
Berkeley, CA 94710
www.softskull.com

Library of Congress Cataloging-in Publication is available.
ISBN 978-1-59376-502-6

Art Direction/Design: Mustafa Muwwakkil
Managing Editor: Joseph Benchimol
Contributing Writer: Tamara Cushway

Artist quotes extracted from interviews by Michael Erlewine and Nels Jacobson
Unless otherwise noted, all photography by Lincoln Cushing and Summer Makovkin

We would like to express our gratitude to the following parties for granting us the rights to reproduce the images included in this book. Thank you: Wes Wilson, Victor Moscoso, Stanley Miller, Marguerite Trousdale Kelley, Ida Griffin, Lee Conklin, David Singer, Randy Tuten, Gary Grimshaw, Bonnie MacLean, Mark Arminski, Gunther Kieser. Special thanks to: Wolfgang's Vault, and Rhino Entertainment.

Cover design based on art by Troy Alders
Vintage paper texture by Jamie/MGB Stock
Photo of telephone pole (page 16) by Sebastian Costa
Photo of crowd (page 52) by Gene Anthony
Poster design for Grateful Dead (page 144) © 1989 by T. McCracken
Untitled sketch (page 146) by Stanley Mouse

Please visit us at: www.artofthedead.com

Printed in China
Distributed by Publishers Group West

10 9 8 7 6 5 4 3 2 1